CONTENTS

The author and publishers wish to acknowledge the assistance and collaboration of Miss Hildegard Fritz-Denneville. Thanks are also due to the photographer Mrs Judith Lawton, and to Mr and Mrs Paul Mellon for the generous loan of prints from their very fine collection of English Sporting Art, with particular gratitude to the Curator of Prints and Drawings for the Mellon Foundation, Mr Dudley Snelgrove, for the trouble he has taken both in London and the United States.

SPORTING PRINTS

F.L. WILDER

A STUDIO BOOK

THE VIKING PRESS · NEW YORK

SPORTING PRINTS

INTRODUCTION

To most of us the term 'sporting print' implies the coloured etchings and aquatints of sporting subjects first produced in the second half of the eighteenth century, reaching their zenith less than a hundred years later, and running parallel with the great era of British sporting art, though they retained a certain independence of their own.

Early sporting pictures, up to the middle of the eighteenth century, fathered by Francis Barlow (1626 – 1702), Peter Tillemans (1684–c. 1734) and John Wootton (c. 1686–1765), were mostly commissioned by the nobility and gentry, portraying sedate hunting or racing subjects – often very large pictures to decorate their new mansions – to be engraved in line or mezzotint, and published uncoloured, with suitably pompous dedications.

The fashion for coloured etchings originated in Switzerland, where Johann Ludwig Aberli (1723–86) and others made etched outlines of their watercolour landscapes and Swiss costumes, so that trained assistants could copy a sufficient number to satisfy the tourist trade of the time. The perfection of the aquatint process enabled a wash effect of shading and tone to be given to the plates as groundwork for the colourists, thus providing a quicker and infinitely less laborious method of producing popular prints than line-engraving, mezzotint and stipple, and leading to the introduction of the hand-coloured sporting print, still sometimes serious, but often comic.

Among the first sporting prints to be coloured by hand were small hunting sets and racehorses after James Seymour, Thomas Spencer, Sartorius and Roberts. These were nearly all published in the second half of the eighteenth century, engraved in line or mezzotint, and sometimes covered by body-colour – a mezzotint printed in black can never be effectively coloured by a wash. These prints were produced before the adoption of etching and aquatint for sporting prints.

James Seymour (1702–52) was originally an amateur, one of several successful sporting artists to turn professional after losing their money, in his case after a brief but disastrous career on the turf. Some of his prints, as the late Walter Shaw Sparrow points out, show huntsmen doing flying leaps over brooks and gates, before the 'Flying Childe' and the first Lord Forester worried 'The great Mr Meynell' by not pausing to make sedate standing jumps. 'The Druid' (H.H. Dixon) wrote: 'Mr Childe of Knilet first began hard-riding in Leicestershire, to Mr Meynell's great disgust; and after Lords Forester and Jersey came with "The splittercokation pace", he declared that he "had not had a day's happiness". He and Tom Tit knew no troubles till then, and his horses used to rear on their hind legs, and jump gates and stiles standing, in the most sober and comfortable way. In fact, it was the regular Musters's regime; getting through a country and not over it.'

George Stubbs (1724–1806) was the best of the British animal artists to paint serious sporting subjects, although this was only a branch of his art, nor were they translated into the popular coloured class. From

a print point of view he could be regarded as occupying a transitional place between the early eighteenth-century artists and those of the nineteenth. He and his engravers still avoided the etched outline with aquatint.

Of the plates which he etched or engraved himself, only a third could be considered as strictly sporting, his first commission being to illustrate a book on obstetrics in 1750. It is traditionally said that, in order to acquire the necessary technique in etching, he experimented on a worn halfpenny.

Plate 1

Many of his pictures, particularly those of racehorses, were engraved by his son George Townley Stubbs, a series of these being produced for publication by their Turf Gallery, Conduit Street, London. Both large and small plates were made of them, first published in 1794 and reprinted with the date altered to 1817. At least five engravings were made from two different paintings of the famous Eclipse, the spirited chestnut who fathered three Derby winners, was never beaten, and made a vast fortune for the former sedan-chairman, Colonel O'Kelly.

Stubbs's own etchings and engravings have advanced in value enormously in quite recent years, from a few pounds to as much as £4000 each.

Thomas Rowlandson (1756–1827) was a pioneer of the etched and aquatinted type of print, some being coloured etched outlines, in keeping with his numerous caricatures. The satirical nature of his work extended to his sporting prints: wigs flying in the wind, apoplectic gentlemen overcome by excite-ment. Parsons on horseback, though common enough, were a subject of inevitable mirth.

His inimitable young ladies ride gracefully to and from the chase, side-saddle, in voluminous habits, some of the last to appear in sporting prints until the late 1840s, although contemporary writers describe them at the hunts. 'Nimrod' (C.J. Apperley) goes into suitably ecstatic verbal fireworks at the sight of scarlet costumes mounted on white palfreys. The Marchioness of Salisbury, 'The Diana of Hatfield House', had scarcely hung up her sky-blue habit, and the Empress of Austria had hardly sampled the English hunting country, but, somehow, either frightened by the tearaway Corinthians, or in doubt of its respectability, only ladies of the most unimpeachable reputations dared appear at cover, unless as spectators in carriages.

Harriette Wilson had an open invitation to dine at the Melton Old Club, with the handsome young fox-hunters, but does not say that she attended the Meets, and Lucy Walters had yet to be warned off at the insistence of the Master's wife. Nevertheless there must have been some who regarded ladies out of place in the hunting field. It may have been the risk of trailing skirts catching in the fences, even getting ripped off. In view of this possibility, every conceivable undergarment was worn, including petticoats and breeches, and it was accepted etiquette for bachelors to shout for a married man should one of these disasters eventuate.

Samuel Howitt (c. 1765–1822) was a brother-in-law of Rowlandson, whose influence can clearly be seen in some of Howitt's etchings. He is most famous for having supplied the drawings for the twenty plates in *British Field Sports*, published by Edward Orme, originally in parts, two plates at a time; but only two complete examples have probably survived in this form. The plates are usually found bound together in one large volume and as a sporting work have never been surpassed.

Howitt first lived at Chigwell, in Epping Forest, as a sportsman of independent means, till financial troubles turned him professional artist, even causing him to become a drawing master at Doctor Good-enough's Academy at Ealing.

It is not difficult to see in some of his plates the 'leafy glades' of Epping Forest, though it is not true that he ever went to India, a rumour arising from the finished drawings he made from Captain T. Williamson's sketches for his *Oriental Field Sports*.

George Morland (1763–1804) was the son of a well-known and successful artist, Henry Morland, two of whose pictures are in the National Gallery, London. George's earliest artistic efforts are said to have been made at the age of three, on dusty tables; from four to six years old he was exhibiting, at the Associa-

8

tion of Artists, drawings 'which astonished every spectator', and the Royal Academy accepted his drawings when he was ten.

According to many accounts he was educated at home, his father keeping him hard at work and not allowing him the ordinary toys or diversions of childhood and youth. As a result he would lower drawings from a window, to be sold by his friends for their mutual benefit when he met them in the evening. One is inclined to doubt the truth of these hard taskmaster stories when told in the next breath that, directly his apprenticeship ended, he was racing as an amateur jockey at Margate and driving spirited horses and ladies about London, accomplishments he could hardly have acquired on a sudden breakaway from the influence of the home.

Nathaniel Hone reported seeing George at the age of twelve dressed like a groom or jockey, in green coat, striped waistcoat, tight leather breeches, yellow-topped boots and a coloured handkerchief round his neck. In later life he is said to have favoured a scarlet coat, like a fox-hunter.

Morland was one of the most engraved of artists, many of these prints of country and alehouse scenes bordering on the sporting, but comparatively few capable of being classed entirely in this category.

The set of four Fox Hunting mezzotints by Edward Bell, published in 1800/1, might have been inspired *Plate 33* by Morland's visits to Enderby, where he supplied the landscape to his host's *A Litter of Foxes* (published 1797). One would have expected such a fine horseman as Morland to join in the chase but it is possible that his health was already undermined by gin; the late Major Guy Paget may be right in saying that Morland supplied some sly touches to the Squire of Enderby's pictures when he was out hunting (having previously locked the cellar door), so that he would come back, look at his easel, and say it was the best thing he had ever done.

These Fox Hunting mezzotints should be printed in colours or in black – not hand-coloured. The same must be said of the pair, *Party Angling* and *The Anglers Repast*, and other mezzotints, and the set of stipples of Shooting, by Charles Catton, which were copied and pirated, and another set published by T. Simpson *Plate 63* 1790.

A fine Shooting set of Morland's, intended for hand-colouring, was etched by Thomas Rowlandson, *Plate 64* with an aquatint ground added by Samuel Alken, first published in 1789. Morland's assistant, Thomas Hand, designed a set of Fox Hunting aquatints, which were reissued in 1808 by Edward Orme, with Hand's name altered to Morland.

James Ward (1769–1859), brother-in-law of Morland, was his antithesis in character, being strongly religious and abstemious. His family fell on hard times, so that he had little education, but showed an early ability to draw. His elder brother William was educated at the Merchant Taylors School and then appren- *Plate 6* ticed as an engraver to J.R. Smith; between them they engraved many of Morland's pictures. James, through the recommendation of William, was in turn apprenticed to Smith, but served only two years before William took over his indentures.

Morland married Anne Ward and William married Morland's sister Maria. For a time they occupied the same house, so it would seem that James must have learned a lot from Morland, if only by observation. His earlier pictures were readily bought, to be sold as Morlands, because of their resemblance to the master's style and composition.

He became a very fine painter, as well as mezzotint engraver, his picture of Ralph John Lambton and *Plate 44* hounds being a most imposing equestrian portrait. It was engraved by Charles Turner, though James claimed to have started it and handed it over to William for completion.

His other important sporting work was a series of fourteen lithographs entitled *Portraits of Celebrated Horses*, 1823–24. These were first published in a cover with a dedication, at 10 guineas for proofs, and 5 guineas for print states, or at 8s. each plain, 15s. each coloured, and included four famous chargers – Adonis, Nonpareil, Copenhagen and Marengo – belonging to George III and IV, Wellington and Napoleon.

9

Benjamin Marshall (1767–1835), Leicestershire born, has been rated second only to Stubbs in sporting art. He was a pupil of L.F. Abbott, the portrait painter.

Two prints were made from his paintings of Tom Oldaker, huntsman to the Berkeley, one of which was published by Oldaker himself at The Kennel, Gerrard's Cross, Buckinghamshire. Oldaker (or Oldacre) hunted the pack for over thirty years, and it is interesting to note that the uniform was yellow, so that an example in colours should not have a scarlet coat.

Plate 38
There are no prints after Marshall of a hunt in actual progress, and only five of huntsmen or masters with hounds, one of the best-known being the Earl of Darlington with the Raby pack, which he hunted himself – one reason, perhaps, that he is shown in a professional huntsman's cap.

Ben Marshall painted full-length portraits of two remarkable prize-fighters, John (Gentleman) Jackson and John Gully, engraved by Charles Turner. The former was an athlete who fought only three major battles. On the second occasion, against George the Brewer, he fell and dislocated his ankle, but offered to continue, tied to a chair. His opponent declined. After retiring he opened a school in Bond Street, where he was patronized by the nobility and gentry, including Lord Byron, who was reprimanded by his tutor for walking in public with him. Byron's reply was that Jackson had better manners than many of the college fellows with whom he dined every day. One of Jackson's feats of strength was to sign his name with an 84 lb. weight tied to his little finger. He was one of the eighteen prize-fighters engaged by George IV to guard the entrance to Westminster Abbey at his Coronation.

John Gully was trained early on by the athlete Captain Barclay, one of whose methods was to carry a pocketful of stones to throw at Gully's shins and enrage the boxer into abortive attempts to catch and chastise him. When Gully fought Gregson in 1808 the crowd was so great reports spread that the French had landed and the Volunteers were called out. He made a fortune horse-racing, winning the Derby three times, had 24 children, and became a colliery owner and Member of Parliament for Pontefract.

Some of the earliest designers of coloured sporting prints, particularly of the satirical kind, were amateurs: such as Charles Loraine Smith (1751–1835) and Sir Robert Frankland (1784–1849).

Charles Loraine Smith, Squire of Enderby in Leicestershire, was deputy Master of the Quorn under Hugo Meynell; he was not only an artist, but 'by turn poet, Member of Parliament, musician and carpenter'. *En passant*, he eloped with Lady Frances Manners, wife of Lord Tyrconnel and daughter of the Marquis of Granby.

In artistic circles he is best known as the friend and collaborator of George Morland, who must have found him a convenient and sympathetic refuge on his occasional flights from creditors, and, no doubt, as a fine horseman, he enjoyed one or two of the runs they recorded together in oils.

Plate 46
The whimsical side of the hunting incidents in which they participated appealed exclusively to Smith. The late Major Guy Paget thought Morland had a hand in *The Smoking Hunt*, a set of six plates, published in 1826, but containing descriptions of events as early as 1797. Portraits of Sir Bellingham Graham, Squire Osbaldeston, both Masters of the Quorn, and Dick Knight, huntsman to the neighbouring Pytchley, are introduced; most of the figures are smoking cheroots and one an enormous German pipe, but the reason for this and some of the other incidents has become obscure.

Dick Knight, as 'A distinguished Character in the Pychely Hunt', was immortalized in a set of eight, first published in 1790. In one scene he wins a bet by jumping between the top of a fence and an over-hanging branch.

Plate 35
It has been suggested that another joint Smith-Morland painting, engraved by Francis Jukes and published in 1802, was *The Bilsden Coplow Day*, commemorating perhaps the most famous of all runs, 28 miles from Billesdon Coplow to Enderby Warren, in 1800, but Morland, alas, was at the time a resident 'within the rules' of King's Bench. The Squire of Enderby, however, was in at the finish and expressed his intention of erecting a monument to the event in his grounds. A parson follower composed a poem which ran into six editions, but no mention seems to have been made of Morland.

Sir Robert Frankland (1784–1849) was an early exponent of whimsy, signing himself both 'Billesdon Coplow' and 'Amicus R.F.' His set of six coloured etchings, *Indispensable Accomplishments*, shows some of the crack Meltonians of 1811, galloping and jumping. Henry Alken's *Qualified Horses and Unqualified Riders* was issued as a reply in 1815.

With Henry Alken (1785–1851) we are in the world of the hard-riding squires and huntsmen, the gently ridiculed 'Meltonians', the 'Right Sort', 'the Few', who sail serenely over five-barred gates, swollen streams, 'raspers', 'bullfinches' and 'yawners'. Their riding feats caused no admiration in the eyes of the old-timers, who accused them of ruining the pleasure of hunting.

Stories that Alken had been a professional huntsman or groom have been exploded. He studied, in fact, with John Thomas Barber (1774–1841), a very competent miniature artist, a pupil at the Royal Academy, who took the name of Beaumont, because he claimed kinship with Sir George Beaumont, amateur artist and art patron. Barber Beaumont was a crack shot and organized the Duke of Cumberland's Sharp-shooters, became a magistrate in 1820, and founded the Provident Insurance and County Fire Office.

Alken was the artistic counterpart of his friend Nimrod, whose writings he illustrated, and the most prolific of sporting artists, in painting, drawing and etching, touching every variety of sport with a beauti-fully firm brush, pencil and etching needle.

The first print attributed to him is a plate with fifteen sporting subjects on it, about 1810; in 1813 he had sets of Fox Hunting and Shooting published, and after that a constant stream of prints, at first often using the pseudonym of 'Ben Tally-Ho!'

Some sets ran into over forty plates, many with several small vignettes to a plate, on the 'microcosm' principle, caricaturing various sports. In his *Ideas*, *Notions* and *Difficulties* these words appear in the titles, as the participants get into every kind of predicament. *Plate 86*

The *Beaufort Hunt* and the *Quorn Hunt* were his most famous sets of hunting prints, each a set of eight, published in 1833 and 1835, in paper wrappers, though few sets indeed have survived in this original form.

The drawings for the Beaufort Hunt were by a Dorsetshire amateur, Walter Parry Hodges, the com-positions being very good, but the drawing poor. To correct this Alken redrew them before etching the outlines into the copper plates. Both the Hodges drawings and some of the Alkens have appeared in sales, but only one set of prints in wrappers, as published, has appeared for many years: this set, with four of Alken's drawings, now belongs to Mr and Mrs Paul Mellon. *Plates 52, 53*

The Quorn Hunt illustrated an article written by Nimrod for the *Quarterly Review*, naming several of the best riders of the day, though their riding did not always please the Master, Squire Osbaldeston, any more than that of the first Lord Forester suited Hugo Meynell. *Plates 56, 57*

One can almost hear 'The Squire' shouting 'hold hard!' as too impetuous followers over-ride the hounds. Nobody referred to Osbaldeston as anything but 'The Squire'; only one man is reported to have asked 'Squire of what?' to receive the answer, 'Why, Squire of all England!'

The names of the other riders in the Quorn Hunt are Lord Alvanley, Sir Harry Goodricke, Mr Holy-oake, Mr Maher, Captain Berkeley, Dick Christian, Sir Francis Burdett, Lord Gardner, the second Lord Forester. Lord Alvanley is wearing the Horse Guards-style boots with the tops extending beyond the kneecaps, for protection through hedges. Although in the avant-garde in Leicestershire, in London Alvanley was an arbiter of fashion, so his invention is not surprising. Sir Harry Goodricke kept a house and fine stud at Melton and left his large fortune to Francis Holyoake. Mr Maher was an Irishman and one of the leading members of the Old Club at Melton.

The odd man out is Dick Christian, professional jockey and horse trainer. One is accustomed to seeing him riding in steeplechases, where many of the others are thinly disguised professionals, but here he is in a friendly fox chase, and for nothing – or is he trying to sell his mount by exhibiting its capabilities? Nimrod himself made money that way, as did many of the neighbouring farmers; even Thomas Assheton Smith, one-time Master, could not always resist a good offer.

Was this the dawn of democracy, when everyone was welcome at a hunt? Was there not a hunting sweep, and even Hastings the tailor, who followed the hunt on foot?

Plate 57 Here, too, we have poor Snob, who can afford only one horse, beaten and obliged to commit the ultimate degradation, in this company, of opening a gate.

But no one can stop, nor even pause – if not for Dick Christian, upside down in the Whissendine, how much less for Snob. They are following a straight-running 'gallant reynard', whom Thomas Assheton Smith, that greatest rider of them all, would have spared had he run to earth; but woe betide those dirty varmints who ran in circles.

Woe also to the vulpecides, who destroyed foxes by other means. Surely they deserved the death penalty: no greater denunciation could there be than 'This man shot a fox!'

Many of these hunting men appear again in steeplechases, the Squire and Dick Christian in particular.
Plate 23 In the match between Clasher and Clinker the Squire came within a few yards of losing his unbeaten record, had not Clinker failed the last fence through exhaustion.

Dick Christian was a regular competitor in the steeplechases, although he had no means of disguising his professional status, unlike men such as Captain Becher, cloaking their commercialism under yeomanry
Plate 29 military titles. In the first Grand National the Captain won immortality by falling at 'Becher's Brook'. Some controversy seems still to exist as to the manner of his fall, but a print shows his horse Conrad stopping
Plate 27 at the fence and throwing him over. He was the jockey when poor Grimaldi fell dead in the St Albans Steeplechase of 1837 after passing the winning post, and there is no reason to suppose that the histrionics with which he expressed his concern were entirely hypocritical.

Some of the professionals appear to have been more considerate of their horses than the gentlemen, whose behaviour few would have tolerated today. It has been supposed that steeplechasing may have started with the challenge, 'Who's for home?' regardless of the horses being tired after a long day's hunt.

Plate 20 At any rate, the set of prints after Henry Alken, *The First Steeple Chase on Record*, can no longer justify that claim; in fact, it is the current view that the whole thing was just a fiction, not meant to be taken seriously at all. Even the tearaways of 1803 would have needed a lot of port wine to race across country by moonlight, clad in nightshirts.

Few of these steeplechase jockeys raced on the flat as well. The Squire was an exception, losing his large fortune riding and backing horses that he bred himself. His earliest experiences on the flat were at hunt races, and it was at Heaton Park that he incurred the wrath of Lord George Bentinck, turf reformer, who accused him of pulling his horse on the first day, in order to get better odds in the cup race.

The Squire, in his *Autobiography*, confesses to disguising the potentialities of an imported horse named Rush. This he did with the approval of friends, because they claimed that bias was always shown by the handicappers towards Lord Wilton's guests staying at Heaton Park.

A duel was the outcome, with odds on the Squire, one of the best pistol shots of his time. Until his own account appeared, the bullet was said to have cut a neat hole in his Lordship's hat; but he later reported that everyone was so anxious to preserve Lord George's life, he doubted, from the feel of the recoil, if there was even a bullet in the pistol at all.

The recording of racing events led to a conventional style of treatment for a group of horses galloping – the 'rocking-horse' attitude, all at full stretch, fore and aft, at exactly the same moment. The movements of a horse were too quick for the eye to grasp, until the invention of moving pictures, so that the most suc-cessful prints are those of standing or walking horses, and the St Leger and Derby winners are the best of these, made from the paintings of J.F. Herring, Harry Hall and Charles Hancock.

J.F. Herring (1795–1865) was a remarkable man, apparently partly self-taught, apart from some lessons from Abraham Cooper. Marrying early and emigrating to Doncaster, he noticed the clumsy efforts of a coachmaker decorating his vehicles and nudged him aside, but his main source of livelihood for years was as a stage-coachman.

12

He started painting the St Leger winners annually in 1815, missing only one year till 1843. After ten of *Plate 16* these prints had been issued, it was possible to buy the series in wrappers, and it is when found in this state, unfaded by exposure, that their beauty can be appreciated.

In these early editions a lot of printing in colours is to be seen. Aquatints of sporting and landscape subjects were frequently printed in two colours – a pale blue for the sky and distance and brown for the foreground – before the application of the watercolour, but in the early editions of the racehorses the jockeys' jackets and caps were also printed in the owners' colours.

Curiously, Herring's coaching prints are negligible, apart from coach- and post-horses and a Royal Mail Coach going to or from Glasgow. There is also a very large print, *The Return from the Derby*, a racing-coaching subject at Clapham Common, showing a crowded scene with vehicles of all descriptions, and unlucky walkers *ad misericordiam*.

Herring's sets of large fox-hunting prints show, after an interval of many years, the ladies who, we know, were often present following the hounds, though not visible in prints. Nimrod's swooningly ecstatic descriptions have been mentioned; Dick Christian, as the father of twenty-one children, expressed more admiration for their prowess. 'Miss Milbanke, what a clipping rider she was with the Rufford! Such a seat and hands; I never see her beat by none of them. That reminds me of poor Lady Eleanor Lowther. What a thing I once see her do! She come to the very steepest part of Burrow Hill, close to the hounds; and she says to me, 'Richard! if you will go up here with the hounds, I'll follow you.' Near the top, hang me, if I didn't think she and the horse would be over backwards. I says, 'Do, my lady, catch hold of your horse's mane, and lean forwards more.' So we gets up safe, and they all went round, and my word, the gentlemen did stare when they see us.'

Harry Hall (*fl.* 1838–86) was the chief follower of Herring in painting St Leger and Derby Winners. He *Plate 17* painted the Flying Dutchman and Voltigeur, both singly and on the occasion of their 'Great Match' in *Plate 19* 1851. Voltigeur had one of those touching stable attachments to a cat, and was painted by Sir Edwin Landseer, 'with his head down, whispering sweet nothings to his furry friend'.

Another of Hall's famous sitters was West Australian, who won the 'triple' of the 2000 Guineas, Derby and St Leger in 1853.

Jacques Laurent Agasse (1767–1849), although born in Geneva and trained under Jacques-Louis David in Paris, worked the greater part of his life in England, so that his sporting prints are always classed unquestionably in the English school. About 1790 he was brought to England by Lord Rivers to paint at Strathfieldsaye, and returned a few years later when Napoleon annexed the republic of Geneva.

Although he still enjoyed the patronage of Lord Rivers, Agasse does not seem to have been very success-ful in selling his paintings, being obliged to send a number of them back to Geneva for his family to sell. Some twenty-three prints were issued in London, including the *Wellesley Arabian*, which he published himself in 1810. This was engraved by Charles Turner, who both engraved and published a number of others. There is a touch of whimsy about these, including a set of racecourse scenes, that he must have *Plate 5* imbibed perhaps from Rowlandson; they were published in 1807, before the appearance of Henry Alken.

His most important print is a coaching one, *The Road-Side*, published in 1833 by J. Watson, and *Plate 92* reissued with the title altered to *The Last Journey on the Road*. A noticeable feature is the woman on the box-seat holding the reins for the coachman. In 1820 he had produced another plate of a Mail Coach with a woman on the box-seat, to be succeeded in 1824 by an identical print with a man replacing her. The proprieties are the only reason given for this, but the 1820 plate was reprinted, so does not appear to have been withdrawn.

John Ferneley (1782–1860) was a Leicestershire artist and made his headquarters at Melton, after serving three years as a pupil to Ben Marshall – also Leicestershire-born – in London. He was one of the most important sporting artists, although prints after him are not so numerous as those after others less gifted. Several racehorses were engraved, including Priam, who won the Derby in 1830, after being 'left at the

post'; St Giles; Dangerous, Spaniel, Cadland, Phosphorus, and other Derby winners, published at fifteen shillings each, coloured.

All his published prints were singles, apart from a pair of stag-hunting and the set of ten *Count Sandor's Hunting Exploits in Leicestershire*, the adventures of a Hungarian Count enjoying the hospitality of Lord Alvanley in Melton, which were published at £3. 3s. the set coloured, in paper wrappers, with a leaf of descriptions, and copious descriptions of his comic and often hazardous acts below the prints themselves. They were reprinted with 'Hunting Recollections' on top. The original paintings were brought over from Hungary and sold in London after the First World War.

Plate 51

James Pollard (1792–1867) is the most interesting of the coaching painters, not only for his individual style, but also for his obviously exact representations of travel before the establishment of the railways. He was the most prolific producer of prints next to Henry Alken, covering racing, hunting, steeplechasing and other sports, although not a very good animal painter, some of his Derby winners being unmistakably 'Pollards', but barely recognizable as racehorses.

Plate 73

His prints of fishing are the best of their kind, all scenes on the river Lea, and perhaps the New River, where he himself was a practitioner.

James's father was Robert Pollard, who had been a pupil of Richard Wilson in painting, and became a first-class professional engraver. It was he who etched the outline for Rowlandson's *Vauxhall*, a masterpiece of print-making. He taught his son both painting and engraving, and also published the prints up to 1829.

We are indebted to Mr N.C. Selway for three volumes on James Pollard's paintings and prints, and for the long and interesting research into his life. His father came to London from Newcastle, and was a friend of Thomas Bewick, the famous wood-engraver, of that city. The correspondence between them shows that James as a boy copied Ben Marshall and that Bewick gave him advice about the legs of horses at full speed. It also reveals that in 1819 James was showing signs of revolt against parental authority and that in 1820 he was commissioned by Edward Orme, the printseller and publisher of Bond Street, to paint a signboard of a mail coach for an inn on the Norwich Road. This was much admired when exhibited in Orme's window, and led to further orders.

In 1821 the Royal Academy exhibited his large painting of North Country Mails at The Peacock, Islington, from which the engraving by Thomas Sutherland was made. James 'might have had 50 guineas for it': in 1960 it sold for £19,000 and now belongs to Mr and Mrs Paul Mellon.

He acquired first-hand knowledge of the sports he portrayed, having been thrown off a stage-coach on his way to Goodwood Races. His hunting experience was gained in part by following the Essex Hunt, though he does not mention any particular hunt in fox-hunting sets. One of the best of these is the *Celebrated Fox Hunt*, engraved by R. Havell, with the last plate *Returning Home by Moonlight*.

Plate 40

Racing and steeplechasing formed a considerable part of his work, including Squire Osbaldeston riding against time at Newmarket and 'taking a cooler' when favourite in the Northampton Grand Steeple Chase of 1833. 'This was a rasper for them the brook varying from five to ten yards over. George Osbaldeston, Esq.'s horse Grimaldi, sliding to the edge of the bank, leaped short and went head foremost in, the rider and the horse finding it an easier job to get in than get out.'

The family residence and publishing business had been at Islington, and a number of James's prints show inns in the neighbourhood: Royal Mails at the Peacock, Islington; Royal Mails at the Angel Inn, Islington; The Birmingham Tally-Ho! coaches passing The Crown at Holloway; The Woodman on the Highgate Road; Highgate Tunnel; Waltham Abbey, Ilford, Snaresbrook, and, one of his masterpieces, *The Approach to Christmas*, with the 'Norwich Times' in the Mile End Road.

Plate 90

Plate 91

Other views of London show the busy streets, where it was quite a task to ease a four-in-hand through the traffic, and one can sense the continual roar of noise created by countless iron tyres and myriads of shod hooves rattling over metalled or cobbled roads at the Elephant and Castle, The Gloucester Coffee House, Piccadilly, Hyde Park Corner, or Kennington.

Plate 89

14

James, in fact, is most famous for his coaching prints, in which he shows events as they truly were: summery and blissful – though too hot, perhaps, when the outside passengers had to alight and walk up steep hills; floods, with the inside passengers apprehensive lest the wheels might find the hidden ditch; snowdrifts and freezing outside passengers; night scenes, with glowing lamps and sleepy pikemen.

Twenty-nine of these prints are of mail-coaches, the earliest being compact vehicles – one would think better balanced than the later vehicles, certainly more so than the stage-coaches, with ten or eleven passengers outside, against five on the mails. For this reason the so-called safety coaches were invented – the outsiders seated in a well in the middle – though they were never more than experimental.

One of the *Incidents in Mail Coach Travel* shows the 'Norwich Mail' in a storm on Newmarket Heath, *Plate 88* the very mail on which David Copperfield travelled to Yarmouth – paying an extra 2s. 6d. for the box-seat – during the mighty storm that shipwrecked Steerforth: 'There had been a wind all day; and it was rising then, with an extraordinary great sound. . . . It still increased, until our horses could scarcely face the wind . . . the leaders turned about, or came to a dead stop; and we were often in serious apprehension the coach would be blown over. Sweeping gusts of rain came up before the storm, like showers of steel; and, at those times, when there was any shelter of trees or lee walls to be got, we were fain to stop, in a sheer impossibility of continuing the struggle.'

These coaching prints cover the years 1812 to 1838 – most of the period known as the great coaching era – showing stage-coaches, mail-coaches, private drags, the 'yellow bounder' postchaises, safety coaches, and finally a parade of the amateur Four-in-Hand Club, Hyde Park.

Mail-coaches were the aristocrats, if not the despots of the roads, where other vehicles had to give way to a fanfare of the guard's horn, turnpike keepers to open their gates in advance, postmasters to stand by as the mail was thrown down, and horse-keepers to have the change of horses ready. When the twenty minutes allowed for the passengers' lunch or breakfast was up, the guard sounded his horn again outside the window: it was his duty 'to prevent delay in all cases whatever'.

The guard, in fact, was responsible. He went right through sometimes to the journey's end with his mails, under pain of imprisonment if he let them out of his sight, loitered at inns, or failed in a dozen other duties. He it was who carried the box of tools and spares should the coach break down, 'also a blunderbuss and case, a pair of pistols and holsters, a powder horn, bullet mould, screwdriver, touch-hole picker, and lock for the mail-box, and also a double or long spreading bar; and if they do not keep them clean and in the most perfect repair, the inspector will report it, and he will be punished for his neglect.'

The passengers were allowed only three articles each, being portmanteaus or carpet bags, the largest not exceeding 2 ft 4 in. by 1 ft 6 in. A portmanteau was described as any article made of or covered with leather or hair; all boxes, bundles, baskets, etc., were to be rejected. The top of the coach was only to be used if the boot were full, and then no article to be placed on top of another, presumably so that the guard from behind could menace the passengers with his blunderbuss if necessary. No person of any description whatever, not being an inspector of the Mail-Coach Department, was suffered to ride with the guard, on pain of dismissal.

The guards, in short, had to be of impeccable character, appointed by the Postmaster General, through local MPs. They were responsible even for the condition and cleanliness of the coach, and for running repairs, though, if these were likely to delay the mail for half-an-hour, they were to unharness one or more of the horses and ride on with the mail bags to the next stage. Their wages were half-a-guinea a week, but it was said they often made three or four pounds extra, not so much as the coachmen, but a lot of money when labourers could be lured into the army for a shilling a day.

Coachmen were paid two shillings for 50 miles, when they would change to the next coach back home, but with perquisites – at least on stage-coaches – they made as much as £300 a year.

One of the stage-coachman's 'perks' (forbidden on the mails) was teaching young gentlemen to handle a four-in-hand, an indispensable qualification for aspirants to gentility. It was necessary to be able to control

horses, whether in or out of harness, and coaching became an essential part of this education and sporting activities, some of the richest enthusiasts running stage-coaches of their own, such as the 'Age', and the 'Beaufort' to Brighton and the 'Taglioni' to Windsor, making no charge, but pocketing their tips with great satisfaction.

In fact, until Lord Chesterfield laid down the rule that coaching-club members should drive like coachmen but look like gentlemen, it had become fashionable both to drive and to look like coachmen. One of the earliest, Sir John Lade, friend of the Prince of Wales, certainly looked the part. To him Dr Johnson, his tutor, addressed the famous lines 'One and twenty', and other words to the effect that he had come into his estate and could go to the devil in his own way, unhampered by any more tutorial authority. He even married a highwayman's mistress, not that he was ever waylaid on Hounslow Heath or in Epping Forest, but he could almost have been one of those amateurs who aspired, in the words of Captain Gronow, to spit like the professionals.

Nevertheless in few, if any, of Pollard's prints do the coachmen bear any resemblance to Sam Weller, said to be a fair portrait of the Jehus of the time, red-faced from potent elements without and within, the stout and hearty 'monarchs of the road'. Pollard's coachmen are mostly very elegant and slim, scarcely distinguishable from famous amateurs, like the Earl of Chesterfield, the Marquis of Worcester, Count Bathyany, or even the wasp-waisted Count d'Orsay.

The nearest approach to the Wellerian tradition would be the multi-caped, great-coated figures – clad in 'benjamins' and 'upper benjamins' – in a pair of prints published in 1819, *Stage Coach Passengers at Breakfast* and *Cottagers' Hospitality to Travellers*, the former a delightful interior identified as the Bull Inn at Redbourn on the way to Rugby, where Tom Brown breakfasted 'till his little skin was as tight as a drum'. The twenty minutes are up and, though it is obvious the passengers have not all finished, the guard is sounding his bugle outside the window and the coachman has entered the room, respectfully tipping his forehead to remind them of the time.

In the second plate of this pair the rigours of winter travel are dramatically shown, with cottagers helping a woman on the verge of freezing to death, not an unknown occurrence. The straw put down for the passengers' feet can have had little effect. A much better tip was given to a box-seat passenger, stamping his feet, by the coachman: 'Do you wash your feet, sir?' said he. 'Why, of course,' was the surprised reply, 'don't you?' 'No, sir, I oils 'em.'

The names of the coach owners often appear on stage-coaches: Benjamin Worthy Horne, William Chaplin, Sherman, Mrs Mountain, Mrs Nelson and her son Robert.

Horne succeeded to his father's business at the early age of twenty-four, with seven hundred horses and two inns – The Golden Cross, Charing Cross, and The Cross Keys, Wood Street, Cheapside, to which he later added a third, The George and Blue Boar, Holborn. Fifty-six coaches left the Golden Cross daily.

Plate 90

Horne had the reputation of a keen, even jealous business man, eager to cut in on any of his rivals' routes if they appeared profitable. Thus we see him starting the Independent Tally-Ho! against Mrs Mountain's Tally-Ho! to Birmingham. The racing on the roads caused by this policy led to one of his coachmen being thrown off and killed. The usual time for the journey was 11 hours, but one May Day, when the coaches paraded and raced against time, with a few friends instead of paying passengers, the Independent Tally-Ho! performed a feat considered almost unparalleled in the history of coaching, travelling the distance of 109 miles in 7 hours and 39 minutes. The original Tally-Ho! did the same distance in 7 hours and 50 minutes.

Benjamin Horne was eventually among the owners wise enough to join the railways. On his death the *Sporting Magazine* paid him the tribute of saying he was 'the largest proprietor by far in England, and one of the best that ever put a horse to public conveyance . . . conducted the whole of his immense concern in a most creditable and spirited manner; and his coaches, taken altogether, were better horsed than those into any other yard in London, my own ally Mrs Nelson's being always excepted.'

William Chaplin, another of the largest owners, also had the foresight to leave the coaches and invest his

money in the Southampton Railway, later the South Western, eventually becoming chairman. He owned The White Horse, Fetter Lane, whence started 'The Cambridge Telegraph', shown again in a print after Pollard. It was driven by 'Hell-Fire Dick' Vaughan, 'scientific in horse-flesh, unequalled in driving', who was killed in an accident.

The Spread Eagle in Gracechurch Street, and The Swan with Two Necks, Lad Lane, also belonged to Chaplin. In the latter were stabled the mail-coaches for the West of England. From there they proceeded to The Gloucester Coffee House, in Piccadilly, to pick up passengers and the mail, which the guards had collected from the General Post Office. Pollard produced prints of The Swan with Two Necks and The Gloucester Coffee House, and another of a mail-cart carrying the guard with his mail from the G.P.O.; these small mail carts were drawn by fast-trotting blood horses.

Sherman owned The Bull and Mouth, St Martin's-le-Grand, where four hundred horses were stabled. His coach the 'Wonder' was one of the earliest fast coaches to run to Shrewsbury in a day.

Mrs Mountain kept The Saracen's Head, Snow Hill, mentioned in *Nicholas Nickleby*. She made her own coaches in a factory behind the inn, and started the Tally-Ho! fast coach to Birmingham, 109 miles in 11 hours.

Mrs Nelson's inn was The Bull, Aldgate, a famous old hostelry, where Charles Dickens was once a guest of her coachmen and guards in their special room. Her son Robert kept The Belle Sauvage, *Plate 91* Ludgate Hill.

Nimrod placed it on record that these stage-coachmen were paid about half-a-guinea a week, those of the highest attainments in their art not getting more than eighteen shillings or a pound. This was by no means bad money then.

> 'Although the certain income of a coachman appears small, yet those on swell coaches that load well, with two a day, and consequently only one home, make a very comfortable livelihood – say from two to four hundred pounds a year. Perhaps I could name a few who top the latter sum, but not many. Those who drive into and out of London are allowed the privilege of not entering on the way-bill the passengers they may take up on the first stage off the stones. These they call their short shillings.
>
> 'When I first knew the road, shouldering was very much the fashion – ten times more than it is now. Perhaps there may be some of my readers who do not know what shouldering is; if so, I am obliged to tell them that it is only a genteel term for robbery: it is putting into our own pockets what ought to go into another person's. A little of it, however, is generally winked at by coachmasters – particularly on the night coaches; for without it, tongue and buckle would not always meet – or, in other words, guard and coachman would sometimes be starved. . . .
>
> 'I was on the box of one coach, when we met another. "That is little Billy Burton", said I, "is it not?" – "Yes, d–n him", said my brother whip; "I wish he would break his neck, for the d–d rascal will spoil our road." – "What has he been doing?" I asked. – "What!" replied coachee; "why, he books every shilling; our road will be worth nothing in a short time".'

'No man,' says Nimrod, 'should give the coachman less than a shilling.' In fact he advocated one shilling under and two shillings above 30 miles. On the principle of big fleas and little fleas, the coachmen had in turn to tip their horse-keepers every week, to make sure they did their best.

Nimrod does not say what tip was expected for the box-seat passenger being allowed to take the reins, but implies that the increased speed of vehicles made the coachmen often reluctant to entrust them to amateurs unknown to them, and then only in the country.

The fastest coaches were advertised to average 12 miles an hour including stoppages, and the long-distance ones averaged 10 or $10\frac{1}{2}$ miles per hour. The famous Quicksilver Royal Mail to Devonport reached Exeter, 175 miles, in 18 hours, mostly by night. Pollard made a print of it passing The Star and Garter at Kew Bridge, driven by Charles Ward, who took it to Bagshot and then returned by the up coach,

in the small hours. The Quicksilver, as the railways advanced, was lashed to a flat truck behind a train and taken as far as Basingstoke, and was retired completely only in 1847.

The Telegraph day coach for Exeter left London at 5.30 in the morning, every day except Sunday throughout the year, reaching Exeter at 10.30 in the evening, 17 hours including stoppages, with 20 minutes each for breakfast and dinner. Four coachmen drove it in relays. The fare was £3 to £3. 10s. inside, and £2 to £2. 10s. outside, the same guard going all the way. The London-Carlisle run took a continuous 36 hours. The fare was six guineas inside, and £3. 5s. outside, but tips and meals brought the cost up considerably, 'cramped and sleepless for thirty-six hours, in rain, dew and hoarfrost'. How did the out-siders avoid dropping off to sleep and falling off the coach? On the stage-coaches they sat knee to knee, thankful, perhaps, for the funny stories of a Mr Jingle.

Hundreds of horses were kept at London inns belonging to the big coach-owners, and at nearby stables, some of these being even in Bond Street. They ran in stages of about 10 miles, galloping where conditions allowed. Changing horses at the end of each stage attained an incredible efficiency. Fresh horses would be waiting, warned of approach by the guard's horn or bugle, to be off in 40 seconds, though fresh, spirited horses could be difficult to harness and delay the start for two to three minutes. The passengers had no time to alight, however, except for breakfast and lunch, nor were these always the old-time feasts of modern imagination: 'hot, stained water, passing for soup, tough steaks, underdone mutton, potatoes, hot without and hard within.'

F.C. Turner (*fl.* 1820–45) was another prolific designer of sporting prints, about whose life nothing is known, though he illustrated the 'Billesdon Coplow' poem. In a set of four *Female Equestrians*, published in 1844, he introduces ladies at Riding School, in the Park, Going to the Meet and jumping a hedge. In the first edition of these plates, 1844, the titles are *The School, The Park, The Road, The Field*; in the second edition, 1878, the titles are altered to *The Riding School, Ladies' Mile, Going to the Meet* and *Well Done*.

Turner also designed the print *The Late Georgiana Charlotte Theobald* jumping a five-barred gate, while a huntsman tries to open it for her. The caption reads, 'This celebrated Lady was the perfect Diana of the Hunting Field, the Star of the Assembly Room, the Ornament of the Race Course, the Pride and Admir-ation of all who knew her. Being out one day with the Surrey Stag Hounds she found herself in a lane terminated by a very high Five barred Gate, in company with several Gentlemen: upon one of them courteously rushing forward to open it for her, she, merely saying "by your leave Gentlemen!", cleared the Gate beautifully while he was endeavouring to open it, and took the lead in the most brilliant style.'

Plate 55 Favourite hunting sets by Turner are *A Southerly Wind & A Cloudy Sky*, illustrating the poem by William Somerville, and *The Noble Tips*, the Tipperary Hunt, showing the Marquis of Waterford, on a grey horse, in each of the four plates.

The Marquis was an incorrigible practical joker, some of whose escapades were decidedly in bad taste. He and some drunken friends beat up the night-watchmen in Melton and 'painted the town' with red paint, next assailing the tollgates. These exploits were the subject of prints by Henry Alken, called *Spree at Melton Mowbray*. Quite inexcusable was Waterford's buying a pint of treacle from a dear old lady in the village shop, coaxing her to pour it very reluctantly into his hat, then clapping it on the poor old lady's head. Like John Mytton, another well-known eccentric, he was said to be half mad without drink and quite mad with it. He finally broke his neck.

Plate 12 Among F.C. Turner's racing prints is *Faugh-a-Ballagh*, for which he gives the translation 'Clear the Way', and *Heaton Park Races*, in which the Squire is seen beating Lord Wilton. It was this race that led to the duel between the Squire and Lord George Bentinck, who accused him of pulling or deliberately disguising the form of his horse Rush.

Plate 29 *The First Grand National*, 1839, was another of Turner's sets, republished in 1852, with the dates altered to cover that year. There is a print, too, of the trotting horse Artaxerxes, who was controlled by reins attached to the bit, the shafts of the match-cart being fixed to a girth round the body of the horse, who otherwise

18

had no bridle or harness. The Squire is seen driving his celebrated Tom Thumb, trotting $16\frac{1}{2}$ miles in an hour. This horse was actually put by his previous owner to draw the match-cart by a rope to the bit, because he was a desperate puller, till a backer, seeing the horse was tiring, rode up and cut the rope.

Dean Wolstenholme (1757–1837) painted pictures which were translated into prints in considerable numbers, his son Dean Wolstenholme junior being responsible for engraving many of them. The father was born in Yorkshire, but lost his money in litigation over a property at Waltham, Essex; as a result he came to London and took up sporting art professionally. He had real pictorial gifts, often coupled with autumnal colouring and an individual technique cleverly captured by his engravers. Together the Wolstenholmes produced some of the most attractive sporting prints, usually managing to disguise the technical immaturity that appears sometimes in the paintings.

Wolstenholme's first set of fox-hunting prints appeared in 1806, and in 1811 another set was published, with a night scene, the hunt going home by moonlight, which might well have inspired Pollard's similar plate in *A Celebrated Fox Hunt*. The most imposing Wolstenholme set was *The Essex Hunt* of 1831, showing views of Matching Green, Hatfield Broad Oak, Leading Roothing and Dunmow Highwood, 'with portraits of the Huntsman and Hounds belonging to H.J. Conyers Esq. with the Characters of several Members of the Hunt'. The name of the Huntsman was Holmes; among the Members Lords Maynard and Chetwynd and a Mr Surtees. Reproductions of these have been made, the same size, *circa* 48 by 66 cm.

Somerville's poem 'A Southerly Wind and A Cloudy Sky', was again illustrated by two different sets of four, in 1817; and both large and small sets of *Colonel Jollyffe's Hounds* in 1824. Here Wolstenholme has strayed from his favourite haunts of Essex and Hertfordshire to Surrey, meeting at Chipstead Church and crossing the Brighton Road at Merstham. Colonel Jollyffe was MP for Petersfield and hunted his own pack between the territories of the Surrey Union and the Old Surrey. Large and small sets were engraved, both very attractive and rare, though perhaps most attractive of all are the *Hertfordshire Village Scenery*, with *Plate 50* views near Welwyn. These have been attributed entirely to the son, both as painter and engraver; in fact, the father's activities may have ceased about 1826. By this standard the *Essex Hunt* would also be the son's work, though the styles are so alike they could hardly be distinguished except by date.

Dean Wolstenholme junior (1798–1883) was born near Waltham Abbey, Essex, and was a trained artist and engraver. It may be assumed that his father instructed him in painting, but who taught him engraving is not recorded. He prepared some of the aquatinted ground plates for George Baxter, the colour-printer, and it has even been suggested he originated the process.

A popular subject by Wolstenholme junior was *The Death and Burial of Tom Moody*, the whipper-in to George Forester, of Willey, commemorating in the 1830s an event of 1796. Tom's eccentric wishes for his funeral, expressed to his bibulous friends at The Stag's Head, were duly carried out at Barrow, near Wenlock, Shropshire. As his employer said: 'He had every Sporting Honour paid to his Memory. He was carried to ye grave by a proper number of Old Earth Stoppers, and attended by many other sporting friends, who heartily mourned for him. Directly after the corpse, followed his old favourite Horse . . . carrying his last Fox's Brush in ye front of his Bridle . . . with his Cap, Whip, Boots, Spurs and Girdle, across his saddle.' The ceremony was concluded over the grave by three 'clear, rattling View Halloos'.

Another odd post-dated print of the younger Wolstenholme is *Reynard seeking Refuge in the Church*, published in 1834, but dealing with a much earlier incident in 1785, in which that colourful character the Rev. Sir Henry Bate Dudley was hunting near Crickseth church, when the fox climbed an ivy-covered broken buttress and reached the roof.

Sir Henry was 'the Fighting Parson', proprietor of the *Morning Post* and *Morning Herald*, journalist and playwright, immortalized by Gainsborough, duellist and 'champion of beauty in distress' (referring to his encounter with three ruffianly gentlemen in Vauxhall Gardens, when he was escorting his sister-in-law Mrs Hartley, the actress). The discomfited trio later dressed up a professional pugilist as a 'gentleman' only to foot the expense of a hackney coach to take him home, after a severe drubbing by his reverence.

ASSHETON SMITH AND OSBALDESTON

Plate 48
Among the many characters who appear in hunting and sporting prints, Thomas Assheton Smith (1776–1858) stands out as the acknowledged master in the chase – *le premier chasseur d'Angleterre*, as Napoleon called him. From the time he pitted himself at Eton against another prospective M.F.H., Jack Musters, in a memorable one-and-a-half hours set-to, his feats of daring in the field were even applauded on the spot.

He gained the first eleven at Eton and the Bullingdon Club at Oxford and frequently played at Lords. For twenty years a Member of Parliament, he was otherwise devoted to hunting from November to March and yachting for the rest of the year.

Plate 35
He was a participant in the famous Billesdon Coplow run of 1800, and was in the fore till his horse fell in the brook at Enderby. This was his second horse, Furze-cutter, whom he bought for £26 and sold to Lord Clonbrock at the end of the day for £400.

The inimitable Druid reveals that horse-dealing was not confined to yeoman-farmers, who hunted in blue coats:

> Putting up horses for auction at the Old Club was quite a business each night. Parties were often made on purpose, and after a couple of bottles of claret, business became quite brisk. Each owner had one reserve bid, and it was quite a sight the next morning to watch the different horses change stables, to the great bewilderment of the grooms. Several were very sweet on The Widow the first day she came out, and *'four hundred'* was put under the candlestick. Captain White's reserve bid was a hundred above that sum, and after the Billesdon Coplow day, Lord Middleton did not scruple to close for her. Mistakes frequently arose from the habit of having hunters of the same colour and style. Sir James Musgrave, who would give good prices at the end of the season for horses he had seen go well, had three greys, by Fitzjames, (for which he paid a thousand guineas to a Shropshire man), so alike that the grooms and their owner only knew them; and Captain White had two equally 'winsome marrows,' in his dark chestnuts. The Quorn had had a very fast forty minutes, and The Captain had been in the front rank as usual with one of them, and came a tremendous cropper into a green lane. Luckily his groom was close at hand with the other, and as not a soul knew of the change, it was sold for four hundred that night.

Dick Christian said, 'The biggest leap ever done in Leicestershire Smith did on Jack o'Lantern, across a big cut and laid fence with a guard rail on the far side down by Rolleston.' Smith's motto was, 'Throw your heart over, and your horse will follow it.' For all his 'falling in every field in Leicestershire', he suffered no serious injury, having, from much practice, acquired the art, like Dick Christian himself, of placing his hands on the horse's withers and throwing himself clear. Dick even claimed, in his younger days, to turn a somersault and land on his feet. This was quite an acrobatic performance, when one had also to hang on to the reins, lest the horse should immediately make off for the distant stables.

Smith's friend Tom Edge saw him fall with a horse named Screwdriver, when he lay on the ground with the horse kicking and plunging around him, still refusing to let go of the reins. Edge himself was a 16-stone heavyweight, who, when living with Smith, was rationed by him to a pint of port a day, in an effort to keep down his weight. He could usually keep with the field on a remarkable horse named Gayman, 'a queer-looking creature; thin neck, large head, raw hips and a rat tail'. Assheton Smith said he was the greatest-hearted horse in the world, and Edge refused one thousand guineas for him.

Assheton Smith had estates at Tedworth and in Carnaervonshire, where in the summer he turned to yachting. For many years he was a member of the Royal Yacht Squadron, resigning when they refused to admit steam yachts. Five sailing and eight steam yachts were built for him. One of the latter, built in 1840, was named the Fire King, perhaps after his horse of that name, a tough customer originally aptly named The Devil.

Smith actually hunted up to the age of eighty and took riding exercise under an enormous conservatory which he had built at Tedworth. He was a lifelong patron of the Melton artist John Ferneley and 'his first sitter in a pink coat'.

George Osbaldeston (1787–1866) – accent on the penultimate – was a Yorkshireman, a Justice of the Peace, and High Sheriff in 1829, but his fame as a sportsman was acquired in Lincolnshire and Leicestershire as a master of Fox Hounds, and later on the racecourses, where he lost his large estate and fortune. He may have acquired his nickname 'The Squire' when he was Master of the Quorn, to distinguish him from the titled Masters of neighbouring packs.

Though a small man, possibly 5 ft. 6 in., he was strongly built and one of the outstanding all-round sportsmen of the nineteenth century – one of the best cricketers, with a notably fast underarm delivery, a fine runner, a famous shot with gun and pistol, unbeaten in his single steeplechase matches, though in 1830 he was only placed in the second class in a list of the best riders, Tom Assheton Smith being cited as first.

This may have been because of his reputation as an M.F.H. His first pack was bought from The Earl of Jersey when he was still at Oxford. Next he bought the Burton hounds from Lord Monson and hunted them for five years. He became Master of the Quorn from 1817 to 1828, except for 1822–23, when he was recovering from a badly broken leg, and later of the Pytchley; but some people did not have a high opinion of his ability when he hunted his own pack after letting Tom Sebright go to Earl Fitzwilliam.

Everyone agrees that he was a most successful breeder of foxhounds, often taking out two packs a day for six days a week. Another example of his stamina was to ride 200 miles in under 10 hours for a bet of 1000 guineas. This he did by using several different horses in heats of 4 miles, at a rate, allowing for stoppages, of 26 miles an hour. To train for this event he galloped 80 miles a day.

The set of eight prints after Alken of The Quorn were made when the Squire was Master, and show him wearing the cap of a professional huntsman. Perhaps it was this, with his loquacity, that made Dick Christian describe him as the queerest man you ever saw at a cover. Elsewhere he was called the worst huntsman of them all. But this may have been because he would not allow the daredevils to over-ride his hounds. He purchased The Quorn from Assheton Smith for £20,000, including the house Quorndon and farm.

His racing career appears to have started in 1831 after one or two intermittent attempts. Generally he acted as his own jockey, but the expense of breeding and racing ruined him.

SPORTING WRITERS

Charles James Apperley (1779–1843), who wrote under the pseudonym of 'Nimrod', was born in Denbighshire, went to Rugby and served as a cornet in Sir Watkin Williams Wynn's Light British Dragoons during the suppression of the Irish rebellion. He returned to England in 1801, when the regiment was disbanded.

Nimrod hunted with the Quorn and the Pytchley, and toured all over the country visiting and hunting with various packs. His *Hunting Tours* eulogizes numberless members of these hunts; he appears at first glance to be sycophantic, but it must be remembered that the hunt members would all be likely buyers of his book.

His articles increased the circulation of the *Sporting Magazine* enormously, and the paper paid him a liberal salary and provided a stud of hunters. When the editor died, however, in 1830, both he and the paper got into financial difficulties, leading to his exile in Calais. From there he wrote for the *Sporting Review* and the *Quarterly Review*, and also published a series of books, some of which contained illustrations by Henry Alken.

He was a fine rider, a coachman and an all-round sportsman, and joined in the accepted practice of taking any profit offered to him for his mounts after a run.

Henry Hall Dixon (1822–70), 'The Druid', the son of a cotton-spinner in Cumberland, was educated at Rugby and Trinity College, Cambridge. While still a schoolboy he wrote sporting articles and, although he started as an attorney's clerk at Doncaster, it was not long before he became manager of the *Doncaster Gazette.*

After being called to the Bar in 1853, he continued his sporting work, but the success of his book *The Law of the Farm*, in 1858, caused him to devote his attention largely to cattle and farming matters. In 1865 he won a bet of a sovereign by returning from the Orkneys to Kensington on a small pony, without staying at any hotel.

His recordings of the reminiscences of Dick Christian make the most entertaining reading, a minor Boswellian biography, forming a priceless addition to sporting literature.

Robert Smith Surtees (1803–64) was a qualified solicitor, educated at Durham grammar school, and began contributing to the *Sporting Magazine* when in rooms in Lincoln's Inn Fields, London. In 1831 he started the *New Sporting Magazine* with Rudolph Ackermann and edited it till 1836. It was here that he originated 'Jorrocks', the Cockney sporting grocer, whose popularity is said to have inspired Pickwick. The first collected edition of *Jorrocks's Jaunts* was published in 1838, when, his father having died, Surtees succeeded to the estate Hamsterley Hall, in Durham, and became a JP, a major in the Militia and High Sheriff in 1856. Nimrod and the publisher Lockhart persuaded him to write his first novel *Handley Cross*, in which Jorrocks is raised to the status of a country gentleman and Master of Fox Hounds.

PROCESSES

Etching

In this process the lines are bitten into the plate by acid. All grease is first removed from a polished copper plate, which is then warmed and covered with a very thin layer of wax, by dabbing with a dabber or using a roller. The back of the plate is then covered with Brunswick black, so that the whole plate is impervious to acid. It is customary to blacken the wax ground by passing it to and fro over a bunch of lighted tapers, causing the copper to show up brightly as the artist exposes the lines with his etching needle. The plate is immersed in a tray (or 'bath') of dilute nitric acid, which attacks only the exposed copper lines. When these have been bitten deeply enough, all the wax and Brunswick black are removed with turpentine and the plate is ready for printing.

Soft-ground Etching

Tallow is mixed with the wax before it is dabbed on the plate, so that it does not harden, but remains soft when cool. A sheet of thin paper is laid over this soft wax ground and a drawing made on the paper with a lead pencil. When the paper is peeled off, some of the wax adheres to it where the pencil has pressed. The lines are then bitten into the plate as in ordinary etching, the result, when printed, being a quite re-markable resemblance to pencil drawing.

Aquatint

Aquatint is also an etching process, but the ground laid on the polished copper plate is porous and allows the acid to percolate through it. The ground used for the sporting prints of the late eighteenth and nine-teenth centuries was obtained by dissolving resin in alcohol and pouring it over a warm copper plate, when

the spirit evaporated leaving the resin adhering to the plate in minute globules. The plate was then immersed in the acid, which bit into the copper, all round the little impervious specks of resin, making lines which appear like a fine network. Where this network was required to give only a faint tone to the plate, as in the sky and distance, this area was painted over with Brunswick black, so that the acid could not attack it any more, and the plate could be reimmersed for further biting of the darker parts. When combined with etched outlines, as in most sporting prints of the period, the wax ground was completely removed after the etched lines had been bitten in, and the porous aquatint ground was then laid on the plate.

Stipple Engraving

This is another etching process, but instead of lines, dots are pricked though the wax ground. When the work is sufficiently advanced, the plate is placed in the acid bath and the dots bitten in. After this the ground of wax is removed and the dots reinforced where necessary with a tool ('graver') similar to that of the line-engraver, but curved to facilitate the work. Etched lines and dots were, of course, frequently combined.

Line-Engraving

The engraver uses a tool like a short bradawl with a flat wooden handle so that he can push it with the palm of his hand. The steel end is filed off to give it a three-cornered or diamond-shaped point, with the sharp corner of which the engraver digs his lines into the soft copper, lightly or deeply as required.

Mezzotint

Here the engraver works from dark to light. The surface of the plate is roughened all over to raise a burr to hold the ink and print a rich, velvety black. The lighter parts of his picture are produced by scraping away the burr where neccessary, until he comes to the highlights, where it is removed entirely.

Lithography

Lithography was used quite frequently for sporting prints, H.B. Chalon being one of the first to try it in England, in 1804, for a drawing of two horses, Samuel Alken's *Delineations of British Field Sports* (1822), James Ward's *Portraits of Celebrated Horses* (1823/4), F.C. Turner's *Bachelor's Hall*, Pollard's *Scenes in the Snow Storm of 1836*, a Fox Hunting set after him, and R.B. Davis's *Hunter's Annual*, a series of professional huntsmen, are a few that come to mind. Some of the better known aquatints, such as *The Essex Hunt*, by Wolstenholme, have been copied or faked by lithography.

Soft-ground etchings have often been mistaken for lithographs, the most noticeable difference being that a soft-ground would have the platemark indented where it has been pressed into the damp paper when printing, but a lithograph would not, because it is a surface process, requiring only a light pressure.

The principle of lithography is that grease and water will not mix. The artist draws his design on a smoothed slab of limestone, usually with a special greasy chalk, the stone being then washed with weak acid and kept moist during the printing, so that when an inked roller is passed over it the ink will adhere only to the parts greased by the chalk, to be picked up by a sheet of paper pressed on to it.

Printing

To print from a plate where lines are cut or bitten to hold ink below the surface, it is dabbed with ink all over while warm to make sure the lines are filled. The ink on the surface, however, must be removed, and

this is done by 'rag-wiping' with muslin and gauze cloths, any ink still left being removed by 'hand-wiping' with the side of the palm of the hand. The plate is then placed face upwards on a bed running between two rollers working like a mangle, and a damp sheet of paper is placed over the up-turned face of the plate; on top of these are smoothed two or three thicknesses of blanket, and the bed – with plate, paper and blankets – is rolled through the mangle-like press. The only spring or give is provided by the blankets, which force the damp paper into the lines of the plate and pull out the ink.

Colouring of Prints

The practice of hand-colouring the vast number of sporting prints, caricatures, landscapes, book-illustrations, etc., produced in the eighteenth and nineteenth centuries, must have been a very considerable industry. Some of it was probably a 'cottage industry', with people working at home, but the larger firms undoubtedly spent great care in selecting and training colourists able to put on a flawless wash, with fully ground colours, perfect paper and dust-proof conditions, copying a pattern by the artist or engraver.

Both Turner and Girtin coloured prints when young. According to an unconfirmed story Girtin, when indentured to Edward Dayes – himself a beautiful watercolourist as well as mezzotint engraver – complained to his master of the time he had to spend in this way, only to be hauled before the magistrate as a refractory apprentice and sent to prison.

Rudolph Ackermann, noted for his philanthropy, befriended the émigrés from the French Revolution, and Martin Hardie tells us, in *English Coloured Books*, that 'He had seldom less than fifty nobles, priests and ladies engaged in manufacturing screens, card-racks, flower-stands and other ornaments.' The ladies, at least, would all have learnt to draw and watercolour as an accepted part of their education, and only needed some further training. The mind springs unwillingly to the gifted reprobate Thomas Rowlandson, with his French aunt, Paris training and fluent French language, who worked a great deal for Ackermann.

C.A. Pugin, émigré architect, collaborated with Rowlandson on the plates for Ackermann's *Microcosm of London*, drawing the buildings, while Rowlandson etched them and peopled them with tiny figures. One thousand copies were published of this three-volume book, with 104 plates – 104,000 prints to be coloured – giving some idea, from just one example, of the work entailed.

In this book – as often in the aquatinted sporting prints – the plates were printed in two colours: light blue or green for the sky and distance, and brown for the foreground. An etched outline, or a very lightly bitten aquatint, could be coloured without difficulty, but mezzotints, line-engravings and stipples printed in black were hardly ever intended for hand-colouring, any colour added being nearly always of a later date. An exception might be made for the small sporting prints and racehorses after Seymour, Spencer, Sartorius and Roberts, sometimes to be found with contemporary colour, but mezzotints, line-engravings and stipples should be printed in colours.

A hand-coloured print can be distinguished from one printed in colours, because the lines, dots or grain will show black underneath the wash, whereas they too will be in colours if printed.

We can only guess at what methods of hand-colouring were employed in those hives of industry, the publishers, but one account has been given us of the great American producers of coloured lithographs, Currier & Ives. The late Mr Harry T. Peters, in his catalogue of their publications, tells us that 'the stock prints were colored by a staff of about twelve young women, all trained colorists and mostly of German descent. They worked at long tables from a model set up in the middle of the table, where it was visible to all. The models, many of which were colored by Louis Maurer and Fanny Palmer, were all first approved by one of the partners. Each colorist applied only one color, and, when she had finished, passed the print on to the next worker, and so on till it was fully coloured. The print would then go to the woman in charge, known as the "finisher", who would touch it up where necessary. The colors used were imported from Austria and were the finest available, especially valued because they did not fade in the light.'

THE PLATES

PLATE I

ECLIPSE

Thomas Burke after George Stubbs, 1773, *mezzotint*, 43 × 56.5 cm. (17 × 22¼ in.).

Eclipse, a chestnut with a white blaze and stocking, was perhaps only a pony compared with modern animals, yet he stood a hand higher than most of his contemporaries at an inch under sixteen hands, was never beaten and earned a vast fortune for his rather disreputable owner, Denis O'Kelly.

Foaled in 1764, the year of an eclipse, in the Duke of Cumberland's stables, he was bought on the Duke's death a year later by a Smithfield cattle salesman and then by O'Kelly, who started his career as a chairman and billiard-marker and appears to have gained the money for his shrewd investment by marrying a well-known courtesan.

Before Eclipse's first race O'Kelly coined a famous phrase when he prophesied, 'Eclipse first, the rest nowhere.' This meant that the other horses finished 240 yards behind and were thus ignored by the judge. Eclipse's form made it difficult to match him and he earned most at stud, enabling his master to become a colonel in the Westminster Volunteers and to purchase Cannons, a valuable estate near Edgware, from the Duke of Chandos.

Sons of Eclipse, two of them belonging to O'Kelly, won the Derby in 1781, 1783 and 1784.

We are told that O'Kelly was famous also as the owner of a talking parrot, which whistled the 104th Psalm, 'and was among parrots what Eclipse was among racehorses'. 'The Druid' (H.H. Dixon) writes in *Saddle and Sirloin*: '"Count O'Kelly", the owner of Eclipse, divided his attention between the mighty chestnut and a parrot, for which he gave 50 guineas, besides paying the woman's expenses with it from Southampton. It was a wonderful musician, and they do say that it would go back to the erring bar if it made a mistake in whistling a tune.'

George Stubbs (1724–1806) painted Eclipse more than once. There are five engravings by his son G.T. Stubbs and others, taken from two paintings. In spite of his authoritative work on anatomy, his horses have been criticized by experts like the sporting writer 'Nimrod' (C.J. Apperley).

From a print in the collection of Mr and Mrs Paul Mellon

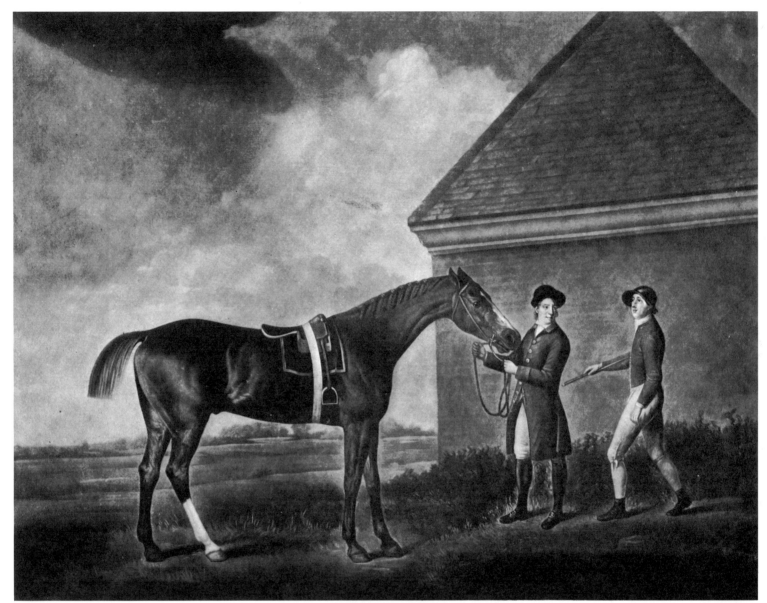

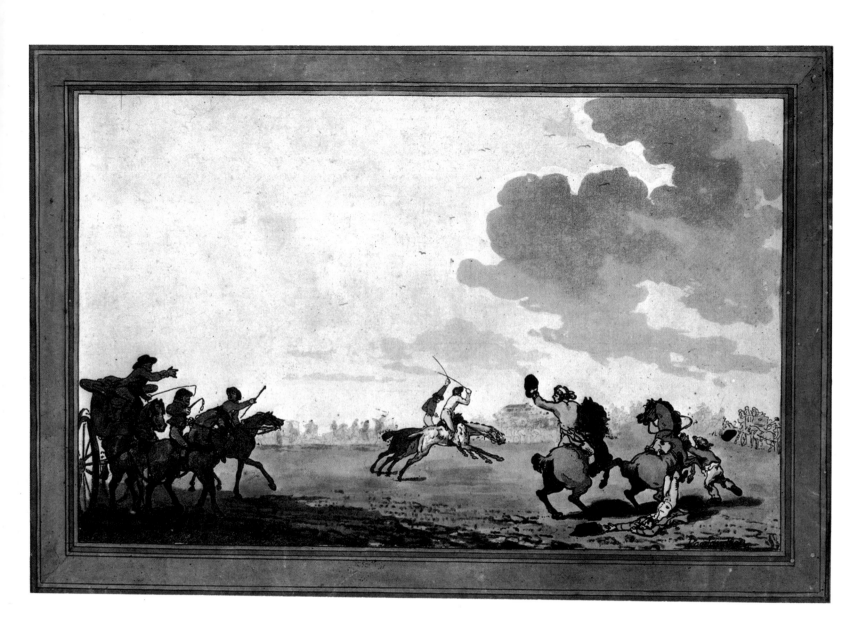

PLATE 2

A HORSE RACE

Thomas Rowlandson, 1785, *coloured etching*, 19 × 30.5 cm. (7½ × 12 in.)

Only Rowlandson, or one of the gifted gentlemen who formed an *entourage* of amateurs, could have drawn and etched this animated race between two horses, no doubt the result of an extravagant bet on their merits by their owners – the horses wagered against each other, the jockeys chosen afterwards.

Here one appears to strike the other's horse, not at all improbable in those days, while the owners shout instructions, one falling from his horse in the excitement.

These events usually acquired enough publicity to attract a large crowd of spectators, cleverly indicated in the background.

Thomas Rowlandson (1756–1827) had an excellent education as artist at the London Royal Academy Schools and in Paris, devoting his brilliant gifts mostly to satire and caricature. An insatiable gambler, he, like his friend George Morland, seems to have spent his life producing a constant stream of drawings and etchings to satisfy his creditors, and was a pioneer of the coloured sporting print.

This print was first published in 1785; again in 1794; and later with aquatint shading added.

From a print in the collection of Miss Hildegard Fritz-Denneville

PLATE 3

THE HIGH METTLED RACER

Thomas Rowlandson, 1789, *coloured aquatint with etched outline*, 26.5 × 36.5 cm. (10½ × 14⅓ in.)

The Life of a Racehorse, or The High Mettled Racer, was a subject treated by several artists, usually in sets of four or six, showing episodes from the foal to the demise, in declining stages.

Thomas Gooch, Charles Ansell, Dean Wolstenholme and Henry Alken all did similar sets. Rowlandson's consisted of four plates, showing the racer, the hunter, post-horse and cart-horse. Henry Alken's set included two more scenes: the foal and the racehorse in training.

These crocodile tears do not disguise the fact that the majority of the hard-riding Meltonians and huntsmen of that time in general were callous towards their horses when carried away by the exhilaration of a long, straight run. After describing one such run, Nimrod adds laconically 'three horses died'.

From a print in the collection of Mr and Mrs Paul Mellon

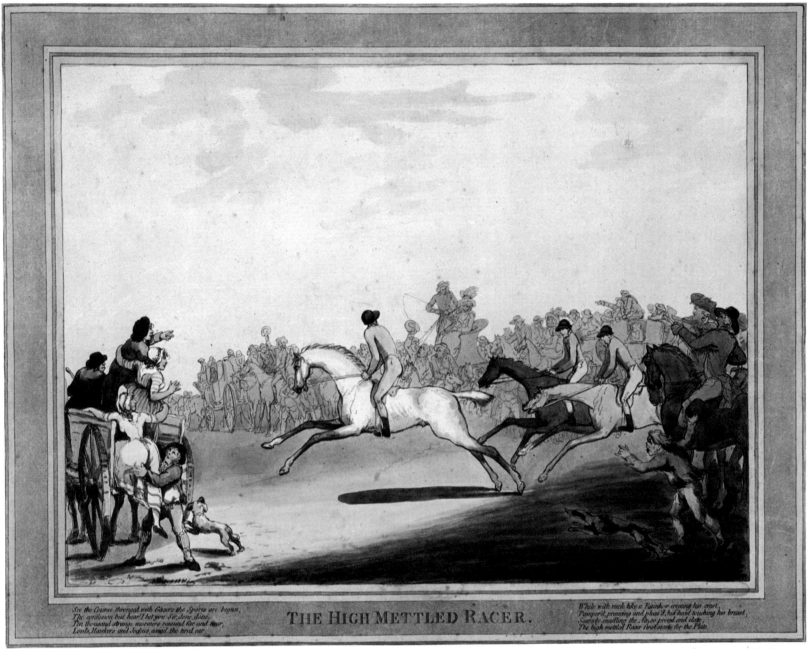

See the Course throng'd with Gazers the Sports are begun,
The confusion but hear! I bet you Sir, done, done,
Ten thousand strange murmurs resound far and near,
Lords, Hawkers and Jockeys, assail the tired ear.

THE HIGH METTLED RACER.

While with neck like a Rainbow erecting his crest,
Pamper'd, prancing and pleas'd, his head touching his breast,
Scarcely snuffing the Air, so proud and elate,
The high mettled Racer first starts for the Plate.

Rowlandson feet

I. Wabell aquatinta

Pub. July 20. 1789 by S. W. Fores. N.3 Piccadilly.

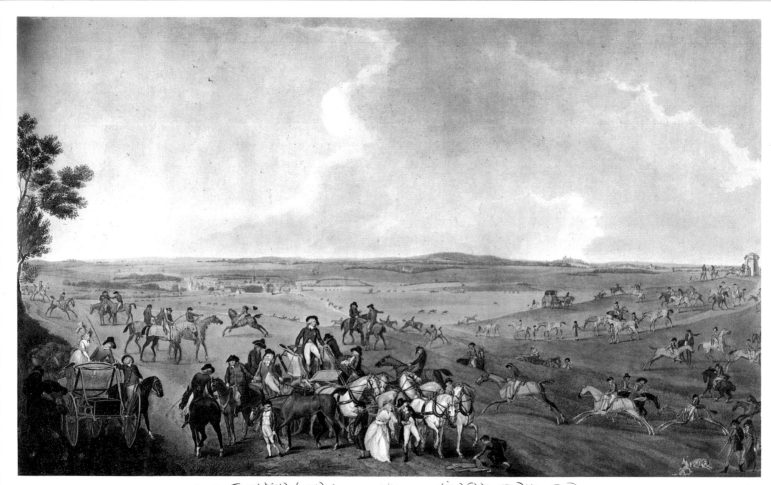

PLATE 4

TRAINS OF RUNNING HORSES, NEWMARKET

J. Bodger, 1791, *coloured aquatint with etched outline,* 39 × 66 cm. (15⅓ × 26 in.)

In this attractive scene on the Warren Hill, with its slight touch of caricature, the handsome Prince of Wales stands in his phaeton, possibly the one painted by Stubbs, drawn by six beautiful greys, booking a bet with the shrivelled Duke of Orleans, on horseback at his side.

The Duke of York has alighted and offers his arm to a lady (said to be Mrs Fitzherbert). On the extreme left the Countess of Barrymore balances in a phaeton beside her eccentric husband and listens to Charles James Fox extolling the merits of his horses Seagull and Put. Other characters in the group are the Duke of Bedford, Haggerston, George Hanger, Wyndham, Captain Grosvenor, Bullock and Colonel Thornton.

Ely Cathedral is visible; nearer is the town of Newmarket.

Reproduced from a second state of the plate, the date having been erased from the publication line. The original painting or drawing for the print has been erroneously attributed to James Seymour, deceased many years before the event.

From a print in the collection of Miss Hildegard Fritz-Denneville

PLATE 5

HORSES TAKING THEIR GALLOP

Charles Turner after J.L. Agasse, 1807, *coloured aquatint with etched outline*, 21.5 × 28.5 cm. (8$\frac{1}{2}$ × 11$\frac{1}{4}$ in.)

This is the first of a set of four coloured aquatints of racing, after Jacques Laurent Agasse, the Genevan artist who settled in England after Napoleon had overrun the little republic of Geneva in 1800.

His first visit to England had been about 1790, when Lord Rivers brought him there to paint at Strath-fieldsaye in Berkshire, an estate later given to the Duke of Wellington.

His sporting and coaching prints (see plates 87 and 92) have been classed as English school, and are undoubtedly influenced by the whimsical tendency of many sporting prints of the time, contrasting with the serious animal studies and portraits which he also painted.

From a print in the collection of Mr and Mrs Paul Mellon

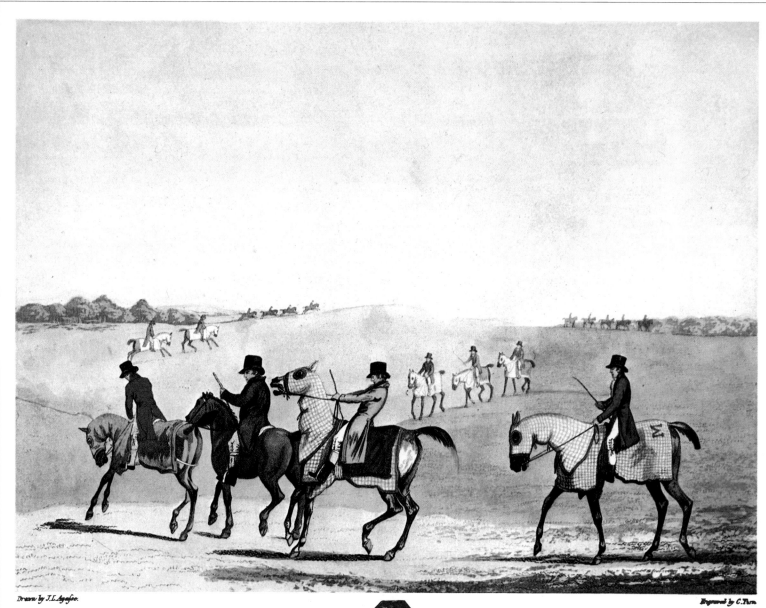

HORSES TAKING THEIR GALLOP

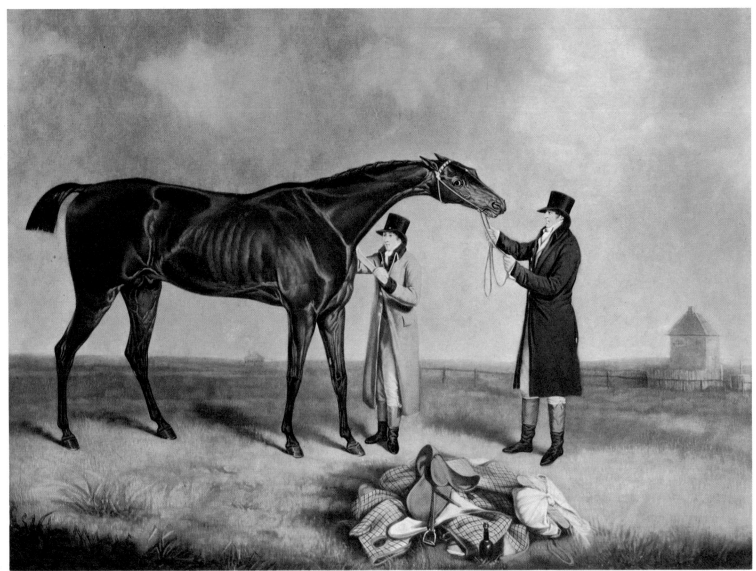

Painted by H.B.Chalon, Animal Painter to their R.H. the Prince of Wales & Duke & Dutchess of York. London, Published March 23, 1809 by Colnaghi & Co. 23, Cockspur Street, Charing Cross. Engraved by William Ward, Engraver to their R.H. the Prince of Wales & Duke of York.

ORVILLE.

Orville, a Brown Horse, foaled in 1799 was bred by Earl Fitzwilliam & was got by Byningbrough out of Evelina was got by Highflyer out of Termagant by Tantrum Regulus. Marske's Dam, in 1801 won at 2Y old 80 G at Doncaster, in 1802 at 3Y old, the St. Legers Stakes at Doncaster in 1803 at 4Y old 100L at Doncaster in 1804 at 5Y old 100 G at York 174 G & 200 G at Doncaster in 1805 at 6Y old the Somerset Stakes & the Gold Cup with 200 G at Brighton, the Kings Plate 100 G at Lewes in 1806 at 7Y old 150 G 50 G & 200 G at Newmarket 150 G & 90 G at Lewes in 1807 at 8Y old 300 G & 50 & 150 G at Newmarket the Somerset Stakes at Brighton 200 guineas two others.

TO HIS ROYAL HIGHNESS THE PRINCE OF WALES. This Plate is most humbly Dedicated by His Royal Highnesses very grateful & devoted Servants COLNAGHI & Co.

PLATE 6

ORVILLE

William Ward after H.B. Chalon, 1809, *mezzotint, printed in colours*, 40.5 × 55.5 cm. (16 × $21\frac{7}{8}$ in.)

Below the print are the horse's pedigree and list of achievements, including the winning of the St Leger in 1803. He was a bay colt bred for Earl Fitzwilliam at Milton in 1799, and, although his jockey Will Edwards said he had never ridden a better horse, was accounted difficult to ride, with a very insensitive hide.

'The Druid' said 'there was a great deal of the coach-horse about him, and his son Don Juan, who was put to Cleveland mares near Catterick Bridge, got some of the best coaching stock that ever went to a Yorkshire fair.' His most noted son was Emilius, the jockey Buckle's last Derby winner.

This print is an engraving in the mezzotint manner, and a rare example printed in colours.

From a print in the collection of Mr and Mrs Paul Mellon

PLATE 7

JOHN MYTTON

W. Giller after W. Webb, *mezzotint*, 47 × 61 cm. ($18\frac{1}{2}$ × 24 in.)

John Mytton (1796–1834) was the outstanding example of a spoilt child inheriting the physique and constitution of a prizefighter and a vast fortune, yet dying of delirium tremens in a debtors' prison at the age of thirty-seven.

A man of foolhardy courage, his exploits were immortalized by the illustrations of Henry Alken and T.J. Rawlins to Nimrod's *Life*. He stalked wild duck on the ice, clad only in his shirt; lay naked in the snow waiting for the wild-fowl to come over at dusk; drove a tandem across country in the dark; jumped a toll-gate in another, which was dragged over the gate; deliberately upset a gig, when the friend he was driving happened to remark that he had never had that experience; swam rivers and lakes on his horse, although he could not swim himself.

But how many of these feats were done under the influence of his four to six bottles of port a day? His biographer said the mischief started when he took to brandy – then he was drunk for twelve consecutive years.

The print records that he was an M.F.H. (Master of Fox Hounds) in Shropshire, where he kept and bred horses, his money being mostly lost in breeding and running racehorses. At gambling he seems to have been lucky, the crooks saying 'it was no use playing against the squire when he was drunk.'

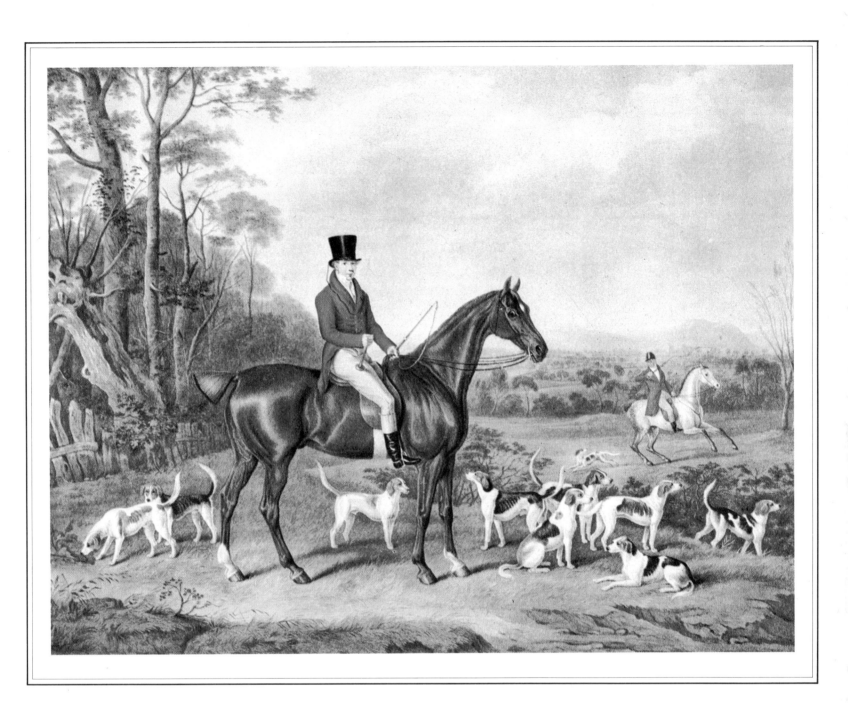

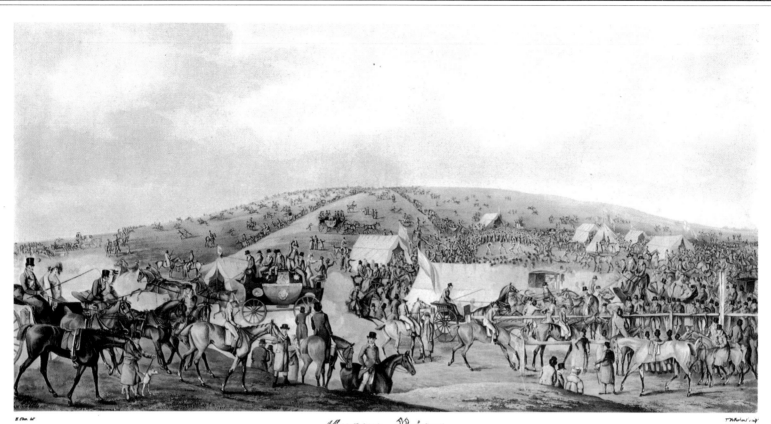

Epsom Races.

TO THE NOBLEMEN & GENTLEMEN SUBSCRIBERS, This Plate representing THE EPSOM RACE COURSE, With the Horses preparing to Start for the Two Mile Heat

PLATE 8

EPSOM RACES: Preparing to Start for the Two Mile Heat

Thomas Sutherland after Henry Alken, 1819, *coloured aquatint with etched outline*, 32 × 62 cm. (12½ × 24½ in.)

From this animated scene it is possible to realize how totally dependent transport was on the horse, apart from the sport of horse-racing.

A curious feature is the prizefight going on in the middle distance, evidently an organized affair, in spite of the illegality of bare-knuckle contests, with a ring 'beaten out' by hired professional fighters, and the seconds in the ring with the principals.

Fights were commonly held at secret rendezvous, their location being passed by word of mouth in inns, racecourses being used sometimes but only when deserted. A set-to was liable to be stopped by magistrates, though some were reluctant to interfere with 'the noble art'.

Police would certainly have been present to preserve order at a race meeting, but not at a prizefight, about which they were supposed to know nothing. Squire Osbaldeston (universally known as 'The Squire'), in his *Autobiography*, complains illogically at their absence when he refereed a match during which a violent gang of pickpockets ransacked spectators with impunity, even invading the privacy of a gentleman's carriage.

PLATE 9

BAREFOOT

By and after James Pollard, 1823, *coloured aquatint with etched outline*, 31.5 × 44.5 cm. ($12\frac{3}{8}$ × $17\frac{1}{2}$ in.)

Barefoot was a chestnut colt bred by Richard (Dicky) Watt, of Bishop Burton, Yorkshire, in 1820, and won the St Leger at Doncaster in 1823, when twenty-seven horses went to the post and, after three false starts, twenty-three of them went away without the order to go being given. Although called back by the bugle, they ran the whole course, with Rosanne finishing first, Barefoot second and Comte d'Arthois third. It was declared a false start and in the re-run, fifteen horses had to be withdrawn, Barefoot finishing first.

Dicky Watt was a noted Yorkshire breeder and won the St Leger five times, from 1813 to 1845.

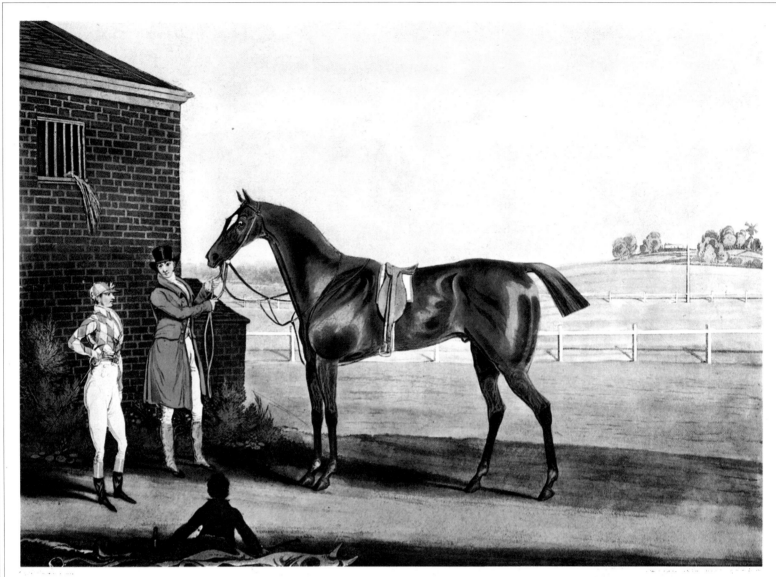

BAREFOOT

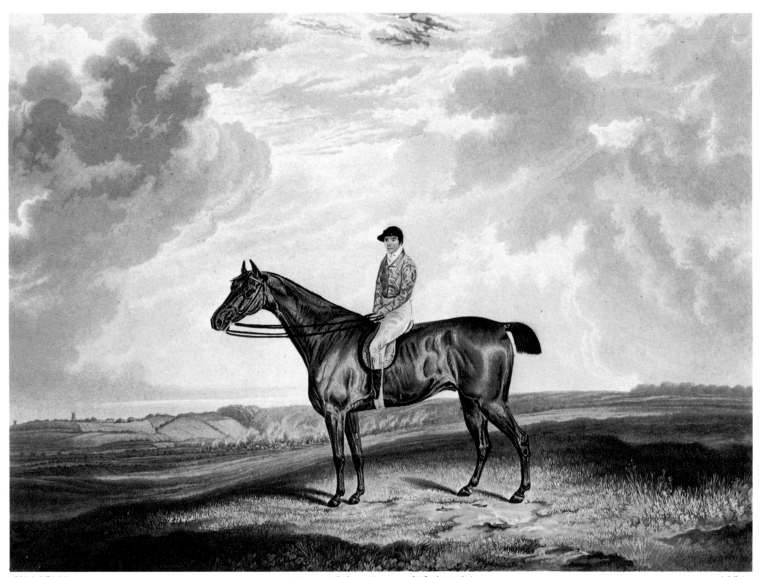

PORTRAIT OF DRIVER.

This hitherto unrivalled Trotting walk-way (under fourteen hands) late the Property of His Grace the Duke of Gordon, Trotted on his Trial in the presence of some persons, over Sudbury Common, 16 Miles within the hour, carrying 10 Stone 7 lb. After which he was matched to Trot 17 Miles, which distance he performed with apparent ease, between Croydon and Horsham. He was then matched to Trot the American Horse Rattler, supposed to be the fastest and stoutest Horse in the known world, the distance was 34 Miles, the road chosen upon, the most difficult for the competitors. This Match ended in the Death of Rattler, while the Stamina of Driver was such, that he was perfectly convalescent within half an hour after the termination of the match

PLATE 10

PORTRAIT OF DRIVER

R.G. Reeve after Dean Wolstenholme, 1833, *coloured aquatint with etched outline*, 31.5 × 43 cm. (12$\frac{3}{8}$ × 17 in.)

Driver was the opponent of Squire Osbaldeston's Rattler – an American trotter he had purchased together with Tom Thumb (see Nonpareil, plate 14) – in a 36-mile match on the Newmarket road during the July Meeting of 1832.

Rattler won, but the effort, in intense heat, killed him. The Squire also blamed a zealous friend, who had put wine, brandy and other stimulants into his gruel. The race was run 'under saddle', Driver's jockey being a professional, Macdonald, who had won the Derby.

'The Squire' wrote in his *Autobiography*: 'I was as fond of that horse as some people are of their children; he was such a beautiful animal and so docile that he would lick your hand and give you his foot like a dog. I am not ashamed to say that I dropped a tear over his grave.'

The elder Wolstenholme, though Yorkshire-born, did much of his work in Hertfordshire and Essex, where he lost money in lawsuits over property, obliging him at the age of forty to turn an amateur talent for painting to a means of livelihood. A self-taught artist, his gift for composition, originality and beauty had not been trained out of him. His son, of the same name, was professionally trained, particularly as an engraver, and succeeded in cleverly capturing the effect of his father's work; he also assisted the colour-printer George Baxter. Amongst his original work was a series of engravings of prize pigeons.

From a print in the collection of Mr and Mrs Paul Mellon

PLATE II

EPSOM RACES: Here they come

Smart & Hunt after James Pollard, 1834, *coloured aquatint with etched outline*, 35 × 61.5 cm. (13$\frac{3}{4}$ × 24$\frac{3}{8}$ in.)

This print was published on 2 June 1834, so is probably intended for the Derby of 1833, won by Dangerous.

A very similar view after Henry Alken (or Henry Alken junior), published in 1871, shows the course lined by policemen in the present-day uniform, for whom the spectators are showing a wholesome respect and not attempting to encroach on the course before the horses have passed. One feels that the police and stewards in this print after Pollard are in some danger from the approaching horses, especially those on the left of the course.

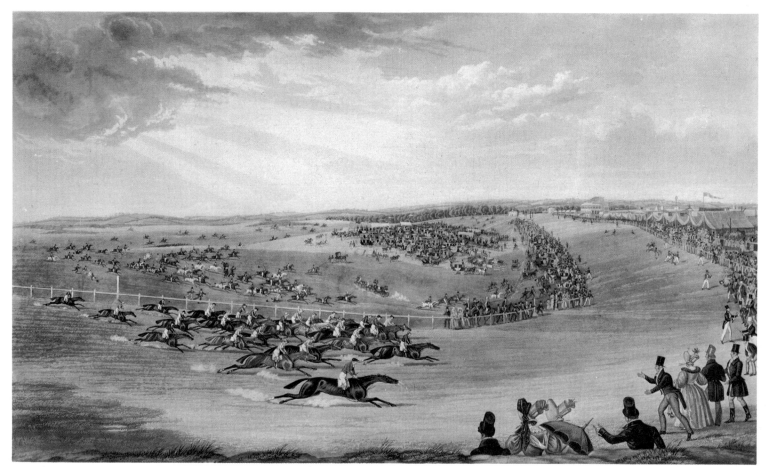

EPSOM RACES.

HERE THEY COME

To the Noblemen and Gentlemen of the Turf and the Subscribers, this Print representing the Horses passing Tottenham Corner for the Derby Stakes,
is most respectfully dedicated by their obedient and much obliged Servants. S & J Fuller.

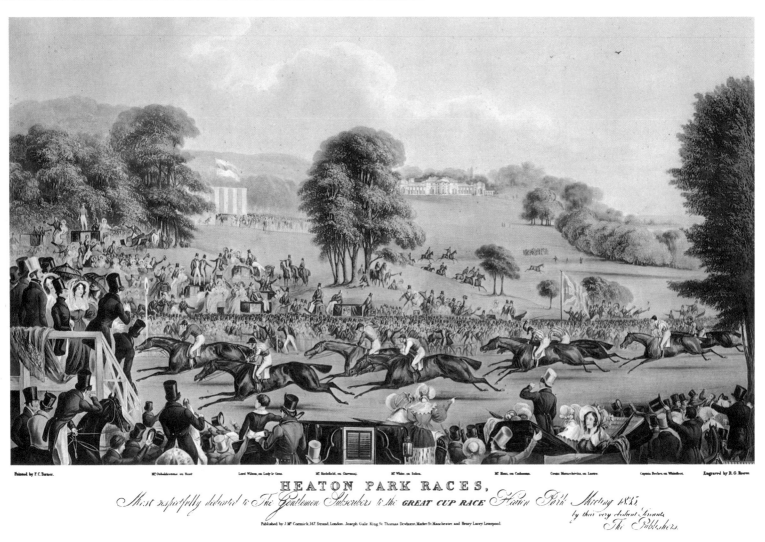

Painted by F.C.Turner. Mr Orleaddeventue on Rust Lord Wilton, on Lady le Gros. Mr Rishfield, on Clarence. Mr White, on Solon. Mr Hunt, on Catherine. Count Montrachivins, on Lustre. Captain Becher, on Whitefoot. Engraved by R.G. Reeve.

HEATON PARK RACES,

Most respectfully dedicated to The Gentlemen Subscribers to the **GREAT CUP RACE** *Heaton Park Meeting 1835,*

by their very obedient Servants

The Publishers.

Published by J. McCormick, 147 Strand, London. Joseph Gale King St Thomas Dewhurst, Market St Manchester and Henry Lacey Liverpool.

PLATE 12

HEATON PARK RACES

R.G. Reeve after F.C. Turner, 1835, *coloured aquatint with etched outline*, 36 × 61.5 cm. (14$\frac{1}{6}$ × 24$\frac{3}{8}$ in.)

A hunt race showing the beautiful house and park, with George Osbaldeston, 'The Squire', winning on Rush, from Lord Wilton, on Lady Le Gros.

According to the account in his *Autobiography*, 'The Squire' and other gentlemen jockeys had long been incensed by unfair handicapping of their horses against those belonging to guests for the annual race staying at Heaton Park, Lord Wilton's residence near Manchester. After a conference with his friends, he bought an Irish horse named Rush, knowing that Irish horses were then considered inferior and would be lightly handicapped.

On the first day he claims to have won, though Lord Wilton was declared the winner, and only he and other gentlemen jockeys saved the judge from a ducking by angry backers. Lord George Bentinck claimed that 'The Squire' had pulled his horse.

In the race shown here, the 'Cup', he is again beating Lord Wilton and, in doing so, winning a £200 bet from Bentinck.

Bentinck was the great reformer of the Turf and, probably through not knowing the whole circumstances, paid up with ill-grace at the next Spring Meeting at Newmarket, publicly accusing the Squire of cheating.

Inevitably this led to a challenge and duel on Wormwood Scrubs, and one must admire Bentinck's pluck in standing up against one of the crack pistol shots of his day, who could hit a playing card ten times out of ten at twenty paces.

However, the Squire reveals it was almost a farce, everyone being anxious to preserve his Lordship's life. The words 'Ready, fire' were given so quickly one after the other he was totally unprepared. Bentinck having missed, the Squire had no option but to shoot wide. 'Even if I had been so disposed I could not have shot him, because I am perfectly convinced from the trifling sounds and the sensation when the pistol exploded that there was no ball in it.'

Later on the antagonists were reconciled.

F.C. Turner (*c.* 1795–1846) painted a number of interesting sporting pictures, many of which were engraved, but the facts of his life are totally unknown: even his Christian names. The only undisputed discovery seems to be that he had a wooden leg.

From a print in the collection of Mr and Mrs Paul Mellon

PLATE 13

ASCOT HEATH RACES

R.G. Reeve after F.C. Turner, 1836, *coloured aquatint with etched outline*, 36 × 61.5 cm. ($14\frac{1}{6}$ × $24\frac{3}{8}$ in.)

This is a companion plate to Heaton Park Races, and is described as the last meeting attended by His late Majesty Wm. 4th. who is in the stand on the right, opposite the judge's box on the left, showing the trophy.

The horses are Touchstone, Rockingham, Lucifer, Aurelius and Valentissimo.

Touchstone, foaled in 1831, was a descendant of Eclipse, won the St Leger in 1834, and fathered two Derby and three St Leger winners.

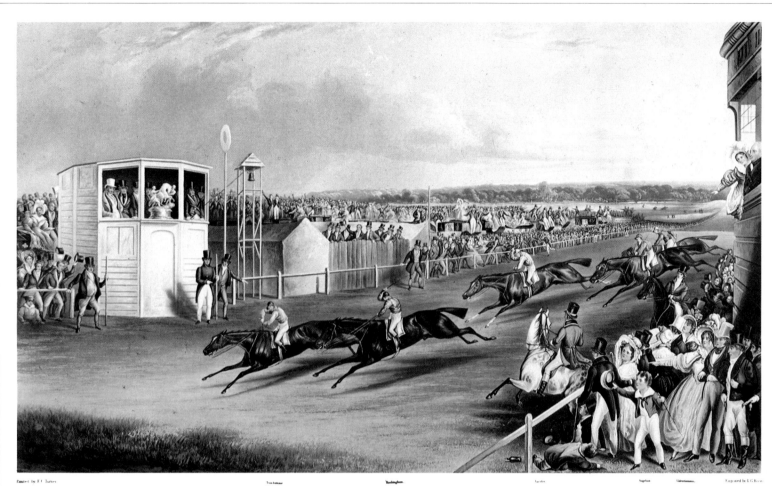

Painted by J.F. Tayler

Tattersall

Buckingham

Landor

Napolem

Intreriminus

Engraved by E.G. Hester

ASCOT HEATH RACES.

To the Earl of Erroll, this representation of the last meeting attended by **HIS LATE MAJESTY** Wm 4th. June 2d 1830. is most respectfully dedicated.

by his Lordship's Obedient humble Servant.

London, Published June 1837, by J.McCormick 117. Strand.

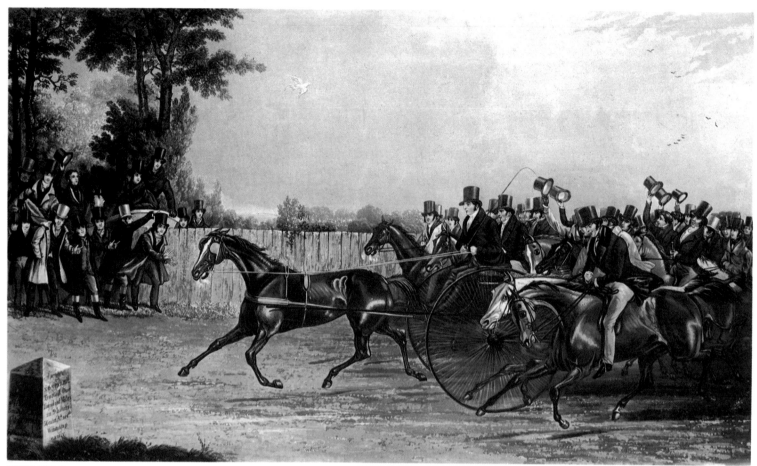

PAINTED BY F. C. TURNER. London Published Aug.25th 1836 for J. MOORE at his Picture Frame Manufactory corner of West Street Upper St Martens Lane ENGRAVED BY GEORGE HUNT

NONPAREIL,
The Property of Mr JOHN DIXON, of Knightsbridge.

This Wonderful Creature Performed the unprecedented Match of TROTTING 100 Miles in harness on SUNBURY COMMON on Wednesday the 27th April 1836. The Bet was for £200 to £100 against her doing it in 10 hours, and an even £100 that she did not do it in 10 hours and a half. She accomplished it with comparative ease, in 9 hours, 30 minutes & 7 seconds, deduct 1 hour 9 minutes, for refreshments, to the admiration of an immense crowd of persons who hailed the event with loud cheers, thus eclipsing the celebrated American Trotter TOM THUMB. Nonpareil is 8 years old, barely 15 hands high and was bought of Mr WEDD of Penlow, about 3 years since, for £32. before she started for this Match Mr DIXON was offered £200 for her. She was trained and driven by Mr WILLm STACEY, of Hook whose weight was nearly 14 stone. The MATCH CART, built by Mr SAMl HITCHCOCK, of Lambeth weigh'd 108lb. During the performance she encountered three heavy showers of Hail, an hour afterwards she was led back to her training place a distance of 7 Miles. A Challenge has since been offered to do the same distance in 9 hours. She can also be match'd to do 15 miles within the hour. NONPAREIL accomplish'd 100 Miles on the 9th June 1835 in 10 hours 5 minutes and 15 seconds over this same ground

PLATE 14

NONPAREIL, trotting 100 Miles on Sunbury Common

George Hunt after F.C. Turner, 1836, *coloured aquatint with etched outline*, 32.5 × 55 cm. ($12\frac{3}{4}$ × $21\frac{2}{3}$ in.)

As usual, the feat of the mare Nonpareil trotting 100 miles in ten hours was done for a bet, described below the print. This type of race was known as a match against time, not another horse. The 'match-cart' was called a 'sulky' in America.

Tom Thumb, referred to in the description, was an American trotter, bought by Squire Osbaldeston after he had already, in 1829, trotted – on the same Sunbury Common – 100 miles in 10 hours 7 minutes, but Nonpareil was unharnessed every 20 miles and fed with cordial and gruel. The Squire, in his *Auto-biography*, says Tom Thumb was a very hard puller indeed, so that the former owner, to prevent his tiring or tiring the driver and breaking into a gallop, in a 40-mile race on the Brighton road, 'tied a rope to the driving bit and attached it to the match-cart, so that the poor animal was actually pulling the vehicle by his mouth', till one of the backers, seeing he was tiring, rode up and cut the rope, allowing him to recover and win.

From a print in the collection of Mr and Mrs Paul Mellon

PLATE 15

GRAND STAND, GOODWOOD

Charles Hunt (possibly after F.C. Turner), published 1 January 1839, *coloured aquatint with etched outline,* 51 × 74 cm. (20 × 29⅛ in.)

Charles Hunt was an engraver who sometimes worked with his brother George as C. & G. Hunt, and later as C. Hunt & Son. It is to be feared that he occasionally engraved pictures by other artists without giving them the credit. This plate was first published in 1839, showing Harkaway winning the Gold Cup in 1838. It was republished in 1853 and 1870 and used to represent events at Goodwood in those years, by an alteration in the date of the title and the erasure of the horses' names.

Harkaway was a chestnut Irish horse who won the Goodwood Cup twice. According to 'The Druid' he was hired by Richard Tattersall, a breeder of bloodstock as well as an auctioneer, for stud at Dawley or Willesden, with Charles XII and Sir Hercules. He sired King Tom, second in the Derby, and ancestor of the Duke of Portland's famous unbeaten St Simon.

From a print in the collection of Mr and Mrs Paul Mellon

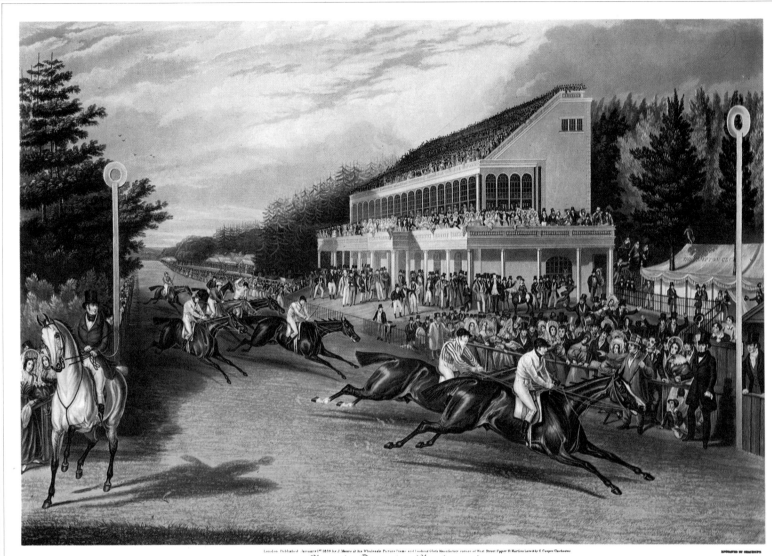

London. Published January 1st 1838 by J. Moore at his Wholesale Picture Frame and Looking Glass Manufactory corner of West Street Upper St Martins Lane & by E Cooper Chichester

Grand Stand, Goodwood.

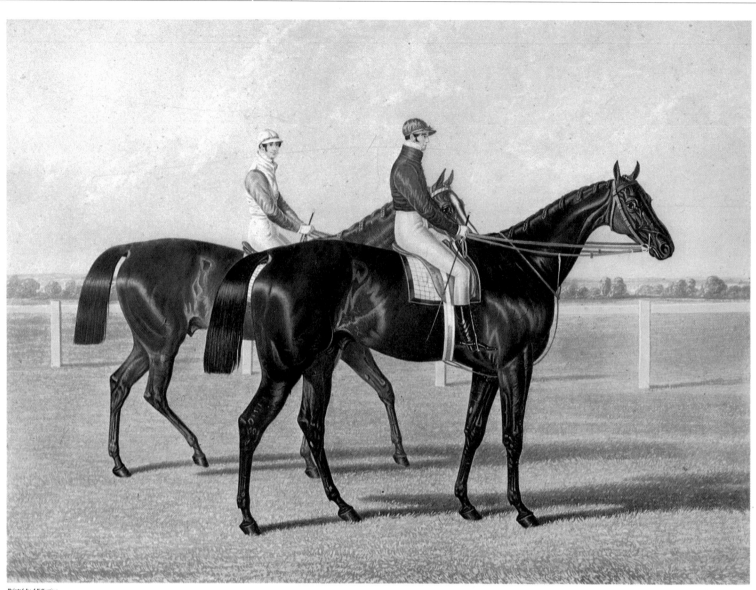

Painted by J.F. Herring.

Engraved by C. Hunt.

CHARLES XIITH

THE WINNER OF THE GREAT S^T LEGER STAKES AND THE GOLD CUP AT DONCASTER, 1839.

107 Subscribers, 14 Started.

Was bred by Major Yarburgh, he was got by Voltaire out of Wagtail Guards dam, bred by the Major in 1818, by Prime Minister; her dam by Cavell, out of Miss Grimalkin &c. by Bonnet her dam Tweeder, Sam Arabian, Sampson Coranch Sister to Bizju.

THE PROPERTY OF MAJOR YARBURGH.

To whom this Plate by permission is most respectfully dedicated by the Publishers.

S^R C. CULLER

PLATE 16

CHARLES XII and EUCLID

Charles Hunt after J.F. Herring, 1839, *coloured aquatint with etched outline,* 31.5 × 43 cm. (12$\frac{3}{8}$ × 17 in.)

These thoroughbreds were both foaled in 1836 and ran a dead heat in the St Leger of 1839. In the run-off Charles XII just won by a head.

He was afterwards sold for 3,000 guineas, but later for only £50, the lowest price at which the winner of a selling handicap could be offered, and even then the purchaser forfeited his deposit of £20 rather than take him.

PLATE 17

NUTWITH

Charles Hunt after Harry Hall, 1843, *coloured aquatint with etched outline,* 31 × 42.5 cm. ($12\frac{1}{4}$ × $16\frac{3}{4}$ in.)

Nutwith was a bay colt, 15 hands $2\frac{1}{4}$ inches, bred by S. Wrather, foaled in 1840. He won the St Leger in 1843, with Job Marson up, beating Cotherstone by a short head, 'one of the finest contests ever witnessed on the Town Moor'.

A good idea is given here of the method of printing racehorse prints of this period, after Herring and Harry Hall, the foreground being inked in brown and the distance and sky in a light blue or green. There was a deal of colour-printing in the jockey's jacket and elsewhere, and the final finish was in watercolour by brush.

The original plate is in the possession of Messrs Fores Ltd., 123 New Bond Street, London.

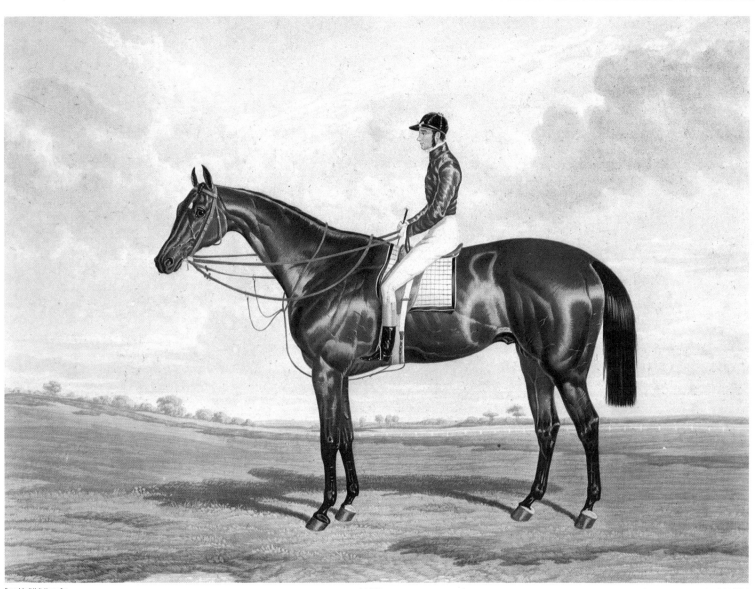

Painted by H Hall Newmarket.

Engraved by C Hunt.

NUTWITH,
THE WINNER OF THE GREAT St LEGER STAKES AT DONCASTER 1843.

17 Subscribers 9 Started

Bred by the late Captain Wrather by Tomboy out of a Cervus Mare bred by M Wrather in 1840 her dam Plumpers dam by Selpine out of Miss Muston by
King Fergus Caperzykes Hackfull and Colchicum are out of the same Mare.

THE PROPERTY OF S WRATHER ESQ.

To whom this Print by Permission is most respectfully dedicated by the Publishers FX J FULLER.

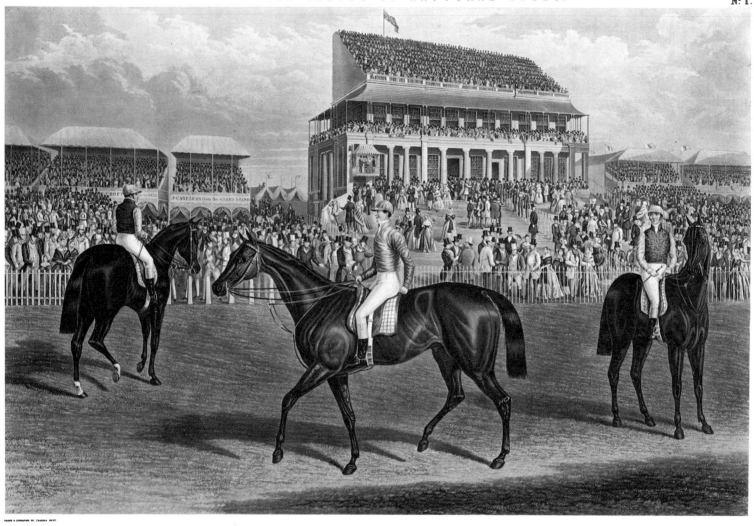

THE DERBY, 1847.

191 Subscribers. Value £5450. 32 Horses started.

WAR EAGLE, Second, the Property of E. Bouverie, Esq.
Ridden by W. Boyce; Brown, Orange sleeves & cap.
got by Lanercost

COSSACK, Winner, the Property of T. H. Pedley, Esq. Ridden by S. Templeman.
Orange, Scarlet sleeves and cap.
Trained by John Day; got by Hetman Platoff, out of Joannina, &c.

VAN TROMP, Third, the Property of Lord Eglinton.
Ridden by J. Marson; Tartan Yellow sleeves & cap.
got by Lanercost

PLATE 18

ACKERMANN'S SERIES OF NATIONAL RACES, No. I: The Derby

By and after Charles Hunt, 1847, *coloured aquatint with etched outline, 51 × 76 cm. (20 × 30 in.)*

Won by Cossack, in the centre; War Eagle, on the left, came second; and Van Tromp, on the right, third. Cossack also won the Oaks and was said by 'The Druid' to be 'a delightful horse to ride, never pulling and always as ready as a shot, when he was wanted. A strong pace was his delight, and he could make it for himself, and except when War Eagle headed him coming down the hill, he led in the Derby from the Warren to the winning post.' He was sold to France for stud.

War Eagle was a leggy horse, fully sixteen-one: 'He pitched in his slow paces, but for a mile he was immensely fast.'

Van Tromp, though 'an exceedingly idle horse', was not at all deficient in speed. 'The St Leger [1847] was his best... Never did horse win an Ascot Cup in such unflinching style as Van....'

From a print in the collection of Mr and Mrs Paul Mellon

PLATE 19

THE GREAT MATCH, BETWEEN THE FLYING DUTCHMAN AND VOLTIGEUR

Charles Hunt after Harry Hall, 1854, *coloured aquatint with etched outline*, 53 × 108 cm. ($20\frac{5}{8}$ × $42\frac{1}{2}$ in.)

This match between two horses was run at York on 13 May 1851 for £1000. Both horses had won the Derby and St Leger – The Flying Dutchman in 1849 and Voltigeur in 1850 – and met in the Doncaster Cup, 1850, when Voltigeur won by half a length.

Their respective owners, the Earls of Eglinton (of The Flying Dutchman) and Zetland (of Voltigeur), matched them to run at York a year later, Admiral Rous, the famous Turf 'dictator', deciding, when appealed to, that the four-year-old Voltigeur should have an eight-and-a-half pounds advantage over the year older Flying Dutchman.

The race created great public excitement, The Flying Dutchman winning by 'a short length'.

His daughter Flying Duchess and Voltigeur's son Vedette were ancestors of St Simon, whose winnings were always given to charity. St Simon's skeleton stands beside Eclipse in the Natural History Museum, London, and Voltigeur is commemorated by one of the permanent fixtures in the racing calendar.

The print was first published 1 May 1854 by Baily Brothers, Cornhill; a later issue has 'National Sports' on top, and the publication line altered to 'London Published at 31 Ely Place E.C.'.

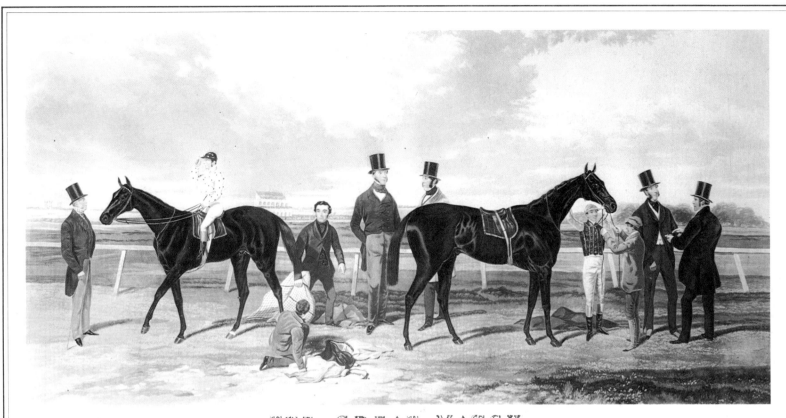

THE GREAT MATCH.

Between the Flying Dutchman Ys 8, 4 8½ lbs the Property of the Earl of Eglinton, & Voltigeur 5 Yrs 8 4 lbs Property of the Earl of Zetland.

RUN AT YORK THE 13TH OF MAY, 1851, DISTANCE 2 MILES — FOR ONE THOUSAND POUNDS.

The First Steeple-Chace on Record.

The last field near Nacton Heath.

PLATE III.

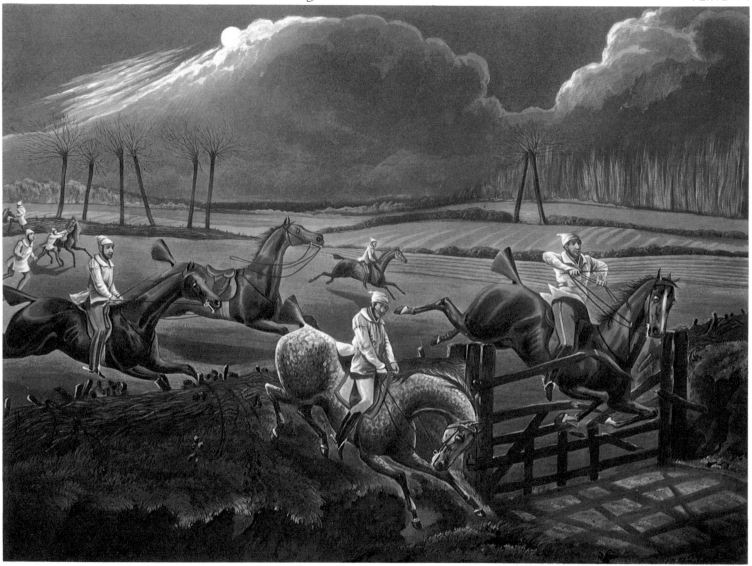

Drawn by H. Alken.

LONDON PUBLISHED MARCH 1ST 1839, BY R. ACKERMANN AT HIS ECLIPSE SPORTING GALLERY, 191 REGENT STREET.

Engraved by J. Harris.

Accomplished Smashers — & a pun upon the Bank.

— — CANNON-BALL, ON HIS "GUNPOWDER" HORSE CHALLENGING THE CHAMPION TO A STRUGGLE FOR THE LEAD, — THEY CHARGED THE LAST FENCE TOGETHER; AND WHILE THE "GREAT GUN" JUMPED SMASH THROUGH THE MIDDLE OF THE GATE, — THE GREY, STILL HAND IN HAND, STEPPED NEATLY OVER THE STRONG HURDLE FENCE AND BANK, BY A JUMP ON AND OFF. — SUDDEN CAME THIRD; — THEN LOUNGER'S HORSE, KICKING HIS HEELS UP AT HIS MASTER, AND CARELESS OF HIS "WOE FUL" CRIES. — SIMPSON WAS MAKING A GOOD LINK OF HIS OWN ACROSS THE FIELD; AND TWO, DISMOUNTED IN THE DISTANCE, WERE EXERCISING ALIKE THEIR PATIENCE, INGENUITY, AND POWERS OF PERSUASION, IN THE SUBJECTION OF THEIR REFRACTORY STEEDS. — Vide "THE SPORTING REVIEW, Nº 1, Janᵞ 1839.

PLATE 20

THE FIRST STEEPLE CHASE ON RECORD (1803)

J. Harris after Henry Alken, *coloured aquatint with etched outline*, 27 × 37 cm. (10⅔ × 14½ in.)

The claim of this set of four prints to represent the 'First Steeple Chase on Record' cannot, of course, be substantiated, if indeed it ever took place, but it might well have been the first and perhaps last steeplechase by moonlight, a dangerous postprandial frolic by some young officers stationed at Ipswich barracks, for a bet on the merits of their horses. They rode with nightshirts over their uniforms, and nightcaps, and were called the phantom Riders of Nacton. The race was supposedly run in December 1803, but the prints were not published till 1839.

Arguably, too, it is the best known of all sporting sets, because of the multiplicity of impressions taken from the plates, still in existence.

Plate III, reproduced here, is an example of the first issue, published by Ackermann, with the shadow of the gate showing no breaks to correspond with the gate above and no shadow of the horse. The second issue was published by Ben Brooks, with the shadows in the gate broken and a splodge for the shadow of the horse. Some of the modern impressions have had the name of Ben Brooks erased and Ackermann's name carefully inked in, to deceive buyers looking for the first issue.

Henry Alken (1785–1851) was the most prolific of the sporting artists, producing paintings, drawings, prints, singly and in sets, and book illustrations, in an almost endless stream. In between all this work he found time to gain practical experience of his subjects, particularly with the hard-riding 'Meltonians', whom he repeatedly portrayed in whimsical situations.

From a print in the collection of Mr and Mrs Paul Mellon

PLATE 21

STEEPLE CHASE, Plate VI, The Finish

Henry Alken, 1827, *coloured etching*, 19 × 27 cm. ($7\frac{1}{2}$ × $10\frac{2}{3}$ in.)

It has been conjectured that this set of six coloured etchings represents the cross-country race between Clinker and Radical, 1826, a distance of about four miles, from Barkby Holt to the Coplow.

Captain Ross had backed himself to ride Mr Francis Holyoake's Clinker, a thoroughbred bay horse, against any horse Lord Kennedy cared to name. His lordship chose a hunter named Radical, belonging to Thomas Assheton Smith, with Captain Douglas as jockey.

Nimrod, in his *Hunting Reminiscences*, says, 'The origin of the match, however, was an opinion given by his countryman, Lord Kennedy, that Captain Douglas, as a rider to hounds, was superior to Captain Ross . . . that Captain Douglas was a superior horseman there can be no doubt . . . [but] a man, to distinguish himself in Leicestershire, must have been experienced in riding over it . . .'

Nimrod continues that all England was ransacked for a horse to beat Clinker before Radical was chosen. Thousands of pounds were staked, including two thousand by Lord Kennedy. In a trial by Dick Christian, the celebrated professional rider and trainer of hunters, Clinker did the course in 11 minutes 15 seconds.

The riders received a good deal of ridicule from spectators, Captain Ross being known as a much better marksman than jockey. 'Two greater tailors never exhibited in a steeplechase,' said Squire Osbaldeston. 'By my troth they both rode like hackney coachmen!' said another.

First the two steeplechasers became entangled through both going for the same gap, Captain Douglas falling over a gate and finally into a ditch, leaving Ross an easy and vainglorious winner. When Nimrod had previously seen Assheton Smith on Radical, he described him as 'always a difficult, but at that time a more than commonly difficult horse to ride.'

Clinker, in the Squire's words, became the terror of the Meltonians, with no one prepared to oppose him, till the Squire backed his Clasher for £1000 (see plate 23).

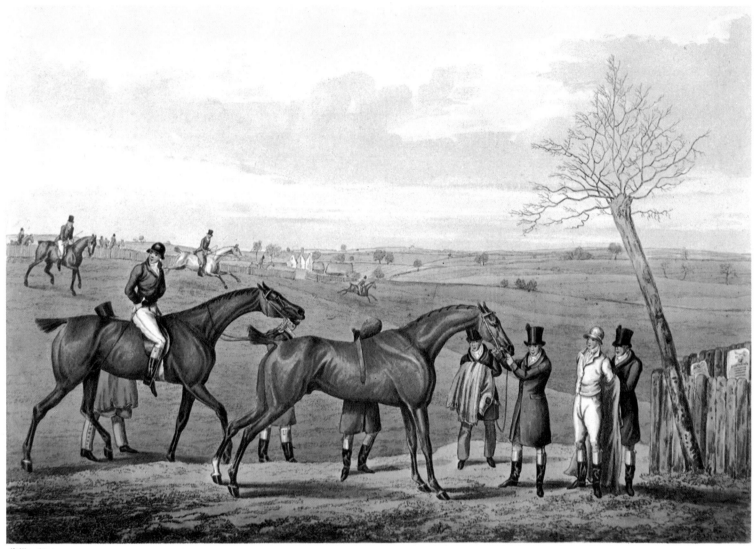

H.Alken. del. et ur.

Plate 6. _ The Winner: _ and to such Wondrous doing brought his horse. _ Hamlet.

Pub.d Jan.y 1 1827 by S & J. Fuller 34 Rathbone Place London

GRAND LEICESTERSHIRE STEEPLE CHASE,

ON THE 12TH OF MARCH, 1829.

Most respectfully Dedicated to Captain Ross, and the Gentlemen in the Quorn Hunt. — By their obliged & humble Servant R. ACKERMANN, JUNr.

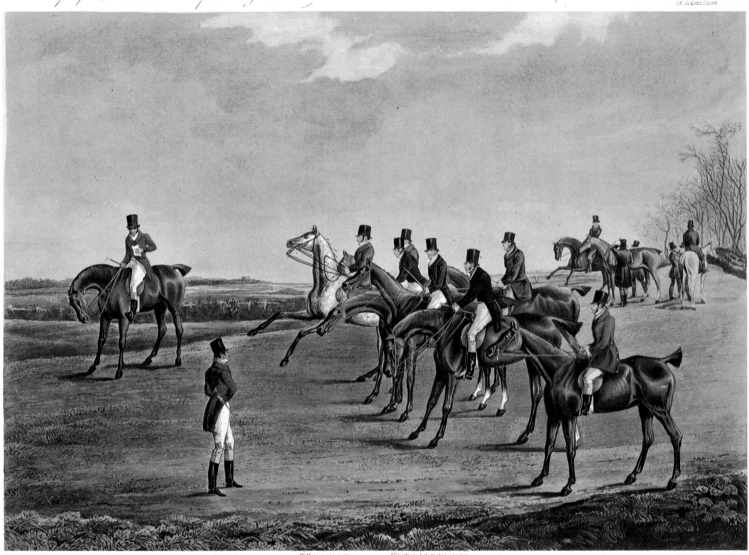

PAINTED BY H. ALKEN. ENGRAVED BY C. BENTLEY.

PLATE I.

The Start.

PLATE 22

GRAND LEICESTERSHIRE STEEPLECHASE, Plate I, The Start

Charles Bentley after Henry Alken, 1829, *coloured aquatint with etched outline*, 26 × 36.5 cm. ($10\frac{1}{4}$ × $14\frac{1}{3}$ in.)

The first of a set of eight plates depicting perhaps the greatest of the hunt steeplechases in Leicestershire, a race of about four miles, from Nowsley Wood to Billesdon Coplow. The starter is Captain Barclay, the champion walker. The umpire is Nimrod, and the names of the 'gentlemen riders', given below the print, occur frequently in his descriptions of fox-hunts during this period.

Captain Ross, although best-known as a marksman with pistol and gun, rode a mare named Polecat, and had Mr Heycock as jockey for a second entry, his famous Clinker. In plate V we see that Captain Ross's chance on the mare was now out, 'his stirrup having been left hanging in a thick fence.' In plate VII, 'Clinker was sixty yards ahead, and within two small fields of the winning post, when, making a trifling mistake at a fence, his bridle slipped over his ears, and thus his chance was out.'

The race was won by Sir Harry Goodricke's Magic. Dick Christian was riding Mr Maxse's King of the Valley, taking a header in plate VI ('' tis nothing when you are used to it'), but still coming in second. According to Nimrod, he would have won 'had he chanced to have met with a practicable part of the Billesdon Brook, where – and reader never forget it – the space he cleared was ten yards and one foot, but he fell! . . . His performance was the climax of everything we may call hunting horsemanship'.

Apparently Dick Christian had but an indifferent opinion of Captain Ross as a horseman: 'The Captain was a poor hand across country without someone to lead him; couldn't make his own running nohow, but go anywhere anyone else went; a bold man, and a good creature he was too. He gave me £100 when Clinker beat Radical' (see plate 21).

Sir Harry Goodricke (M.F.H. Quorn 1831–33) also appeared as an umpire at prizefights and was spoken of by the Squire as having 'one very odd fancy; which was that he always slept naked without even a cap on his head!'

Captain Barclay, the starter, deserves a mention, his most memorable feat being to walk 1000 miles in 1000 hours. He could run a mile in less than five minutes and had phenomenal strength, lifting a man of eighteen stone, by placing him on his right hand on the ground, steadying him with his left and raising him on to a table. He trained John Gully for his fight with Molineux, winning £10,000 in bets.

From a print in the collection of Miss Hildegard Fritz-Denneville.

PLATE 23

EXTRAORDINARY STEEPLE CHASE, for One Thousand Sovereigns – between Mr Osbaldeston's Clasher and Captn. Ross's Clinker

H. Alken and E. Duncan after E. Gill, 1830, *coloured aquatint with etched outline*, 38.5 × 72 cm. ($15\frac{1}{6}$ × $28\frac{1}{3}$ in.)

This race was the result of Captains Becher and Ross extolling the merits of Clinker (see plate 21), and Squire Osbaldeston betting £1000 on his Clasher, a bay horse bought from a farmer, 'an extraordinary fencer, a capital waterjumper and very fast. One day after dinner Becher was vaunting the merits of Clinker, and I said I would run him with Clasher. He laughed, evidently thinking I meant it as a joke; but finding I was in earnest he came to terms and the match was made.' (*Autobiography* of Squire Osbaldeston)

The distance run was five miles, at even weights, from Great Dalby Windmill to near Tilton-on-the-Hill, Leicestershire. Captain Ross had stipulated Dick Christian as his jockey, the Squire to ride his own horse.

Dick Christian had orders to let the Squire make the running. The latter had been badly crippled in the hunting field by another following too close and jumping on him when he fell, and said to Dick Christian at the post, 'Now, Christian, I know what your orders are – I do ask one thing; don't jump on me if I fall.' Christian said, 'I'll give you my word, Squire, I won't.'

While running neck and neck, Dick called out 'Squire, you're beat for a £100', and then rode off-course for a ford he had discovered in Twyford Brook (called by the Squire Sir Harry's brook, i.e. Sir Harry Goodricke) and so, according to the Squire, lost the race, because Clasher cleared it with a yard to spare. Nevertheless it was a close thing, till Clinker fell at the last fence, as shown in the print. The Squire won all his single steeplechases, this being the sixth and last.

Dick Christian, of Melton Mowbray, was a professional horse-trainer, jockey, riding-master, ten years a head-groom, a long time with hounds as whipper-in, and immortalized in hunting and steeplechase prints, and the reminiscences he confided to 'The Druid'.

He seems to have been perhaps the only plebeian allowed on terms of almost intimacy with the sporting aristocrats frequenting Leicestershire.

From a print in the collection of Mr and Mrs Paul Mellon

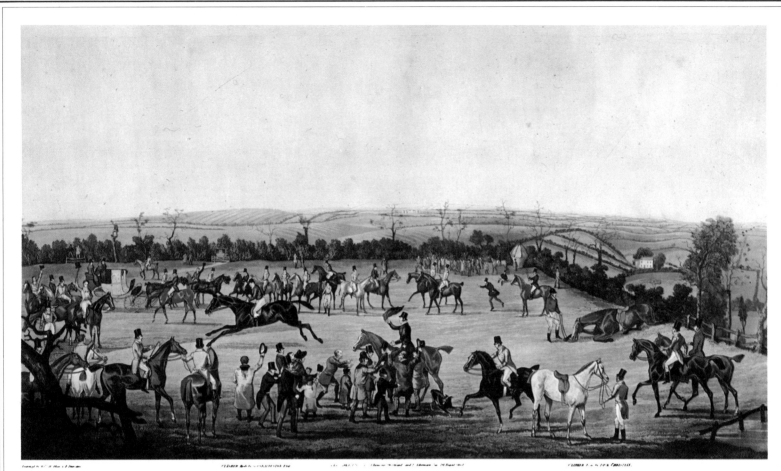

EXTRAORDINARY STEEPLE-CHASE,

For One Thousand Sovereigns, between Mr Osbaldeston's Clasher, and Capt. Ross's Clinker,

From Great Dalby Windmill, to within a Mile of Tilton on the Hill. The 5 Miles was done in 16 Minutes

Dedicated with Permission to Geo. Osbaldeston Esq. and the Gentlemen of the Spilsby Hunt. By their very obliged Obedient Servant R. ACKERMANN.

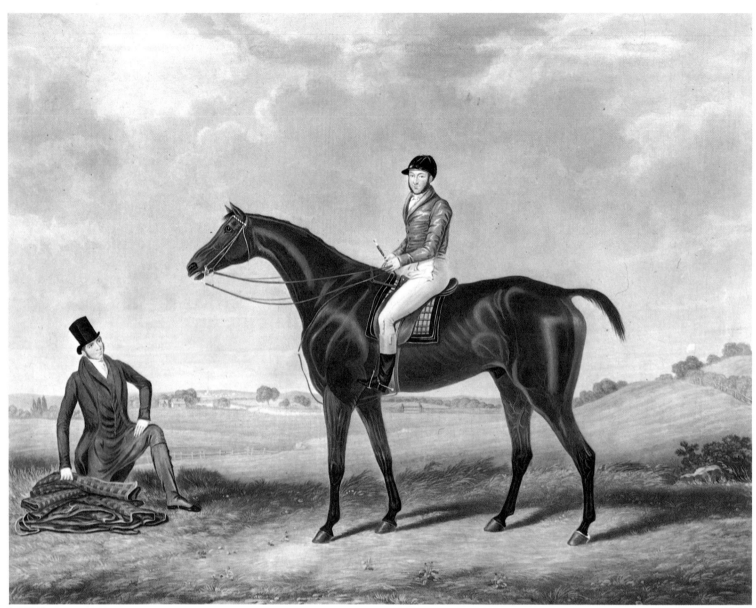

Painted by J.A. Marshall

CAPT. BECHER on VIVIAN.

PLATE 24

CAPTAIN BECHER ON VIVIAN

C. & G. Hunt after J.A. Mitchell, *c.* 1835, *coloured aquatint with etched outline,* 42.5 × 55.5 cm. (16¾ × 21⅞ in.)

Captain Becher was perhaps the most celebrated of the professional riders of the 1820s and 1830s, who regularly competed in the steeplechases supposed to be confined to 'gentlemen riders'. When, in the Grand National of 1839, his mount Conrad precipitated him into a water-jump, it became known ever afterwards as 'Becher's Brook'.

Some of his successes were gained on Vivian in the 1830s, the golden age of steeplechasing, but he rode many other horses, including the famous grey Grimaldi (see plate 28).

He figures in the sporting writings of Nimrod and others of the time, and in Squire Osbaldeston's *Autobiography*, where in the St Albans Steeple Chase of 1832, he came in third to Moonraker and 'a most beautiful grey horse Grimaldi'.

In 1833 he rode against the Squire and Grimaldi, on General Charritie's Napoleon, when Grimaldi, who was not fond of water, fell into a swollen brook, getting out with difficulty, so frightened that the soaked Squire could not mount for a few minutes. The consequence was that Becher, who had cleared the brook, got nearly three fields ahead, but was caught and beaten with only fifty yards to go. This led to the Clasher-Clinker match for £1000 (see plate 23).

Vivian was the horse on which Captain Becher won the Aylesbury Steeple Chase of 1836, followed by Grimaldi. In the present picture he has not yet cultivated the voluminous whiskers, said later by a wit to constitute a severe weight handicap.

From a print in the collection of Mr and Mrs Paul Mellon

PLATE 25

VALE OF AYLESBURY STEEPLE CHASE, Plate II

C. & G. Hunt after F. C. Turner, 1836, *coloured aquatint with etched outline*, 33.5 × 55.5 cm ($13\frac{1}{6} \times 21\frac{7}{8}$ in.)

This race was divided into separate sections, for heavy and light weights, the present set of four prints showing the light weights, with Captain Becher on Vivian, the winner. Cannon Ball, in plate II, is floundering in the Fleet Marston Brook; the famous grey Grimaldi is well placed, in spite of having muffed the first jump, but Vivian retained the lead, Grimaldi coming in second.

Captain Becher's military title belonged to the 'volunteer' Yeomanry, though he also served in the Store-keeper General's department in the Peninsular War, returning on the declaration of peace to become a professional steeplechaser. In this race he just beat Grimaldi, thus upsetting the odds.

From an impression in the possession of Messrs Frank T. Sabin Ltd

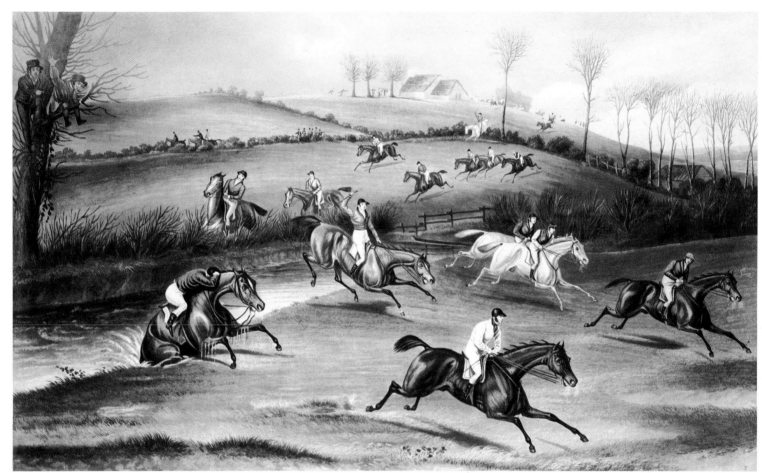

PAINTED BY F C TURNER

PLATE 2.

ENGRAVED BY C & G HUNT

VALE OF AYLESBURY STEEPLE CHASE.

SECOND DAY THURSDAY 11TH FEB.Y 1836, CARRYING 11 ST.N 15 SOV.S EACH WITH 100 SOV.S ADDED, 15 STARTED

THE PONY, LAURESTINA & GRIMALDI, &C&C

CANNON BALL, ROCHILLE, YELLOW DWARF, RED DEER, BUTTERFLY, &C.

DEDICATED TO THE Patrons of Field Sports, BY THEIR OBEDIENT SERVANT J. MOORE, and Published at his Picture Frame Manufactory West St.t Upper St Martins Lane

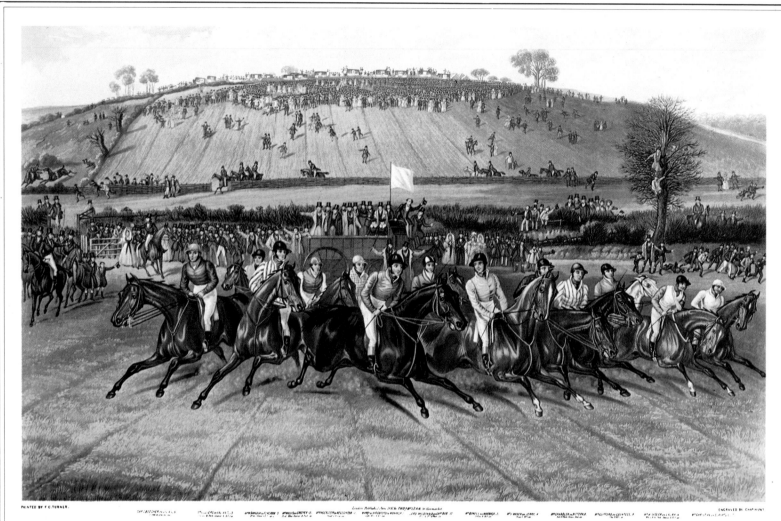

PAINTED BY F.C. TURNER.

London Published June 1837 by THOS McLEAN 26 Haymarket

ENGRAVED BY CHAS HUNT.

Leamington Grand Steeple Chase. 1837.

Dedicated with permission to JOHN CRICHTON ESQ. Umpire of the Chase.

PLATE 26

LEAMINGTON GRAND STEEPLE CHASE, Plate I

Charles Hunt after F.C. Turner, 1837, *coloured aquatint with etched outline*, 37 × 60 cm. (14½ × 23⅔ in.)

Here is a whole string of well-known riders, with Captain Becher on the left and Dick Christian on the right. The Captain rode Vivian and finished second, the winner being Jem Mason on Jerry. In fact, in this set of four plates, the artist seems to have made an effort to produce a likeness of each rider, the names being given below the prints.

Most of these organized steeplechases had rules stipulating gentlemen jockeys, but here again are the professionals, thinly, if at all, disguised.

Jerry was bred in Lincolnshire and bought by the Piccadilly dealer Joseph Anderson, who sold him and bought him back several times. In one of these intervals he followed the Royal Buckhounds with the huntsman Charles Davis (see plate 58), and, after winning the Leamington Steeplechase, became the property of Lord Suffield, Master of the Quorn in 1838.

PLATE 27

ST ALBANS STEEPLE CHASE, Plate I, Preparing to start

R.G. Reeve after James Pollard, 1837, *coloured aquatint with etched outline*, 35 × 47.5 cm. ($13\frac{3}{4}$ × $18\frac{2}{3}$ in.)

The annual St Albans Steeplechases were organized by Tommy Coleman – 'the father of steeplechasing' – a trainer of racehorses, who had bought the old Chequers and rebuilt it as the Turf Hotel, with the rare luxury of baths supplied for the guests. He is here seen emphasizing the rules and pointing out the course.

These steeplechases attracted a lot of custom to the town, the innkeepers filling buckets with beer and dipping the pots for quick service.

By 1837, however, interest was waning. The previous year there had been only five starters; but in 1837 the race was revitalized by a gold cup presented by Prince Esterhazy and there were sixteen runners, including Captain Becher on Grimaldi and Mr Elmore's Lottery, famous two years later as the winner of the first Grand National (plate 29). The present race was won by Grimaldi, who sadly dropped dead after passing the post.

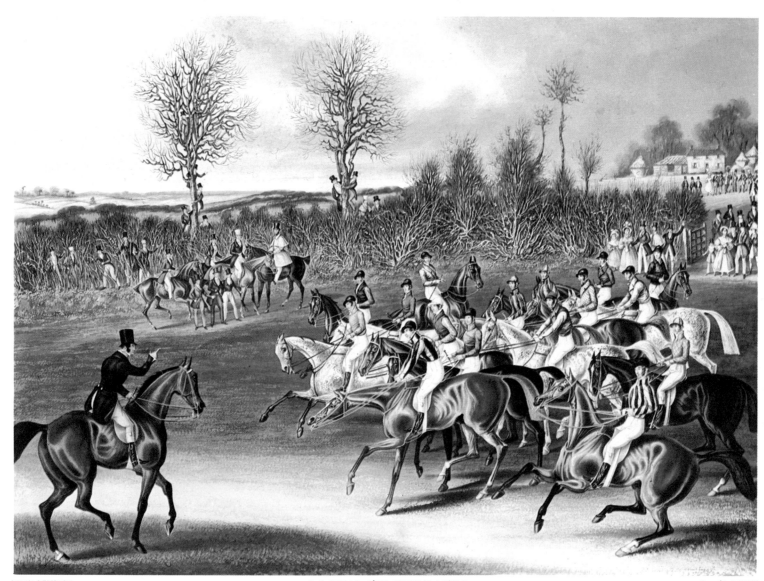

Painted by J. POLLARD. London Published June 1st 1837 by J.W. LAIRD 1 Leadenhall Street Engraved by REEVES.

S⸍ ALBANS STEEPLE CHASE.

The above splendid Set preparing to start, which they did in admirable style CINDERELLA taking the lead.
M⸍ COLEMAN, accompanied by PRINCE ESTERHAZY, the MAYOR, and UMPIRE, pointing on the Course.

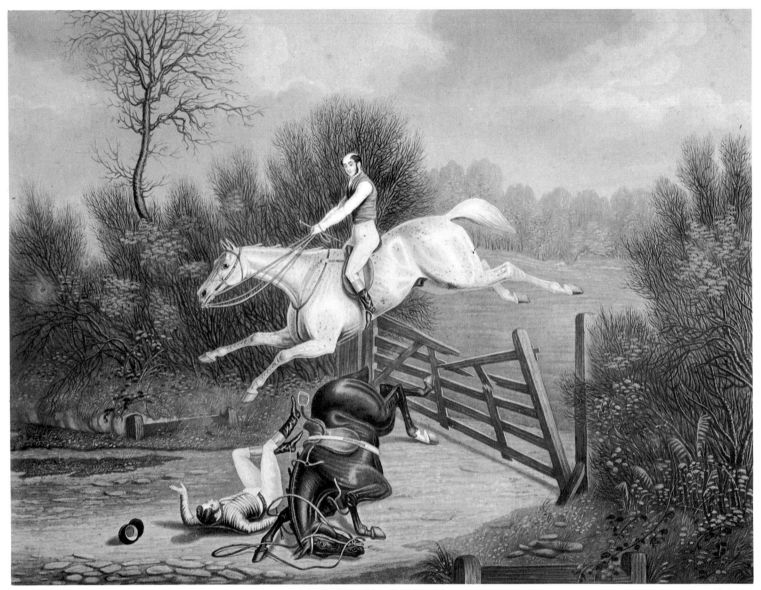

Painted by J. Pollard. London. Published 45th in S.S. Travers & the Sporting and Comic Print Warehouse, 98 Cheapside. Engraved by Cha.s Hunt.

CHANCES OF THE STEEPLE CHASE.

M.r SEFFERT AND GRIMALDI.

AT AYLESBURY

PLATE 28

CHANCES OF THE STEEPLE CHASE, Plate V, Mr Seffert and Grimaldi

Charles Hunt after James Pollard, 1837, *coloured aquatint with etched outline*, 34 × 48 cm. ($13\frac{1}{3}$ × $18\frac{7}{8}$ in.)

This is one of a series of eight plates, showing incidents in various steeplechases, the first six published in 1837 and numbers VII and VIII added in 1839.

It shows the jockey and horse-trainer Dan Seffert on the beautiful grey horse Grimaldi, who, with Squire Osbaldeston up, had beaten Seffert on Moonraker, the victor previously of Grimaldi in the St Albans Steeplechase. The Squire eventually owned him and rode him to victory, but it was under Captain Becher that he died in 1837.

The present scene looks like one of those exaggerations, where a brook at Aylesbury appeared to be 'as wide as the St Lawrence' and Dan Seffert was depicted 'clearing a fence some fifteen feet high and dwelling on the top of it like Mahomet's Coffin between heaven and earth.'

Dan Seffert himself was, like Dick Christian and Captain Becher, one of the professionals who seemed to ride in all the organized steeplechases.

PLATE 29

THE LIVERPOOL GRAND NATIONAL STEEPLE-CHASE, Plate I

J. Harris after F.C. Turner, 1839, *coloured aquatint with etched outline*, 40 × 64.5 cm. ($15\frac{3}{4}$ × $25\frac{1}{3}$ in.)

This is known as the first Grand National, and was run over farmland, 4 miles, twice round a course resembling an old-fashioned point-to-point, but starting and finishing outside the stand, 'no rider to open a gate or ride through a gateway, or more than 100 yards along any road'. Although the rules also stipulated gentlemen riders, it is said that only four or five of them could strictly belong to this category. As usual, among the professionals was the famous Captain Becher, who immortalized himself and the first brook by falling into it, his mount Conrad refusing and sending him flying over its head. This was at the time a natural brook, widened to 8 feet, with a post and rail fence $3\frac{1}{2}$ feet high, a yard from the take-off side. The approach was through a ploughed field.

The names of the starting horses are given below the print, with Lord Sefton, the umpire, one-time Master of the Quorn, on the extreme left. The winner was Lottery, a brown-bay colt, a half-bred or 'cocktail', favourite at 5 to 1 and ridden by Jem Mason.

Lottery's sire Tramp was a grandson of Eclipse. There are conflicting stories about his upbringing. 'The Druid' says he was bred by that Yorkshire worthy Mr Watt and that his temper was so bad he would lie down and roll when he could not otherwise dislodge his jockey. 'Mr Watt was so afraid of further mischief that he wanted to shoot him.' It is said elsewhere that he hated his jockey, Jem Mason, so much that, when twenty years old, he recognized Mason's voice and attacked him.

When mounted, however, he was docile enough and had a 'parlour trick' of leaping over a laid dinner table in the garden. He was so successful it was desired to bar him or weight him very heavily. Properly treated, 'he would have been one of the most brilliant performers on the British Turf.'

From a print in the collection of Mr and Mrs Paul Mellon

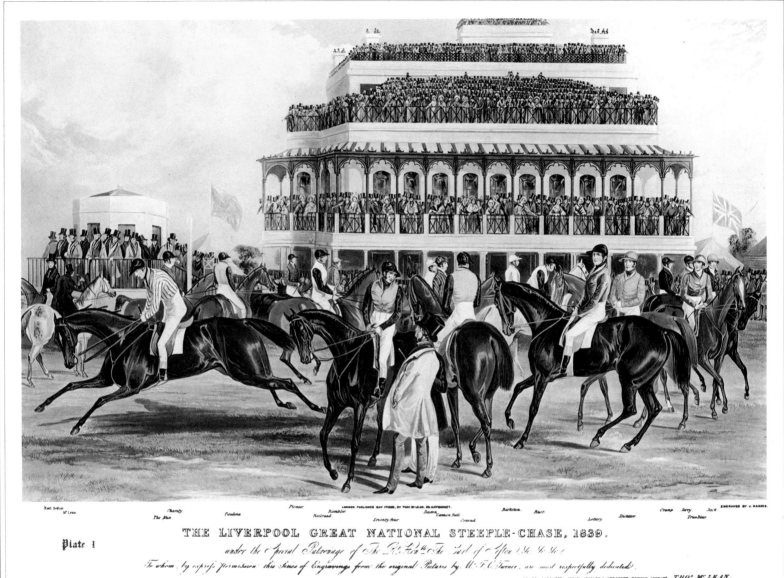

Earl Sefton M^r Lynn Charity Paulina Pioneer Rambler LONDON, PUBLISHED MAY 1st 1839, BY THO^s M^cLEAN, 26, HAYMARKET. Barkston. Rust. Cramp Jerry Jack ENGRAVED BY J. HARRIS.
The Nun Railroad Seventy four Daxon Cannon Ball Conrad Lottery Dictator True Blue

THE LIVERPOOL GREAT NATIONAL STEEPLE-CHASE, 1839.

under the Special Patronage of The R^t Hon^{ble} The Earl of Sefton &c. &c. &c.

To whom, by express permission, this Series of Engravings from the original Pictures by M^r T. C. Turner, are most respectfully dedicated.

BY HIS LORDSHIP'S MUCH OBLIGED & OBEDIENT HUMBLE SERVANT THO^s. M^cLEAN.

Plate 1

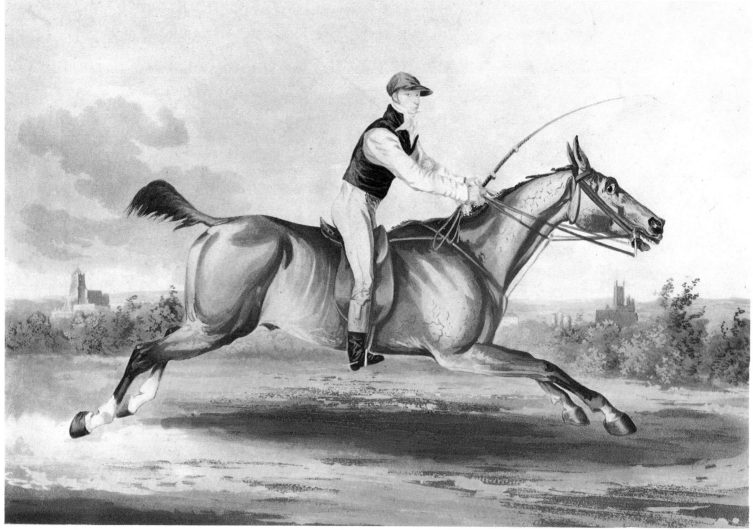

J. Pollard del. Canterbury from the life London Published by J. Hudson 84 Cheapside 4 June 1819 *Eng.d by H. Meyer*

PORTRAIT OF M.r W.m HUTCHINSON *of Canterbury, Mounted on Staremy Tom a famous Hunter the property of Richard Pembroke Esq.r of Littlebourn Court being the Horse on which he started on Thursday 6 May 1819 and performed the arduous undertaking with eleven Horses; without accident or inconvenience in Two Hours 26 Minutes & 51 seconds — distance 55½ Miles. And returned to Canterbury by the Wellington Coach on the same day and dined with both parties (winners & losers) at the Rose Inn when it was* UNANIMOUSLY RESOLVED *to purchase the* FREEDOM *of the* CITY *and present to him in consideration of the* EXTRAORDINARY FEAT *he performed with a faithfulness as honorable to himself as it was satisfactory to every individual concerned in this Match*

"In Britain's race if one surpass,
A Man of Kent was he."

PLATE 30

MR. WM. HUTCHINSON, ON STAREING TOM

H. Meyer after J. Pardon, 1819, *coloured aquatint with etched outline,* 24 × 35 cm. (9½ × 13¾ in.)

This event is described below the print: William Hutchinson, using relays of horses, rode from Canterbury to London, 55½ miles, in under three hours, for a bet of 600 guineas.

Mr Hutchinson used eleven horses, starting on Stareing Tom, returning to Canterbury by stage-coach on the same day, in time for dinner, a great coaching, as well as riding performance, travelling on roads being much harder for the horses than on turf.

Later, in 1831, Squire Osbaldeston won a wager of 1000 guineas that he would ride 200 miles in nine hours. For this race he used racehorses as well as hunters and hacks in relays, on the Round Course at Newmarket.

From a print in the collection of Mr and Mrs Paul Mellon

PLATE 31

BRINGING UP TO THE BAR: 'That seat will do well, Master George'

By and after Henry Alken, 1823, *coloured soft-ground etching*, 18.5×24.5 cm. ($7\frac{1}{4}$×$9\frac{2}{3}$ in.)

In a series of twelve soft-ground etchings, of which this plate is one, Henry Alken showed the means of educating a lad of quality in various kinds of sport. The set is commonly known as 'Scenes in the Life of Master George', but the correct printed title was 'Progressive Sports. A Graphic Description of the Rise and Progress of a Sporting Lad'. He is introduced to various kinds of 'sport', against the brutality of which even Henry Alken himself had already begun to demur.

In this, the last scene but one, Master George is in a riding school, jumping a sacking-covered bar, used for training both horses and riders.

From a print in the collection of Mr and Mrs Paul Mellon

BRINGING UP TO THE BAR.

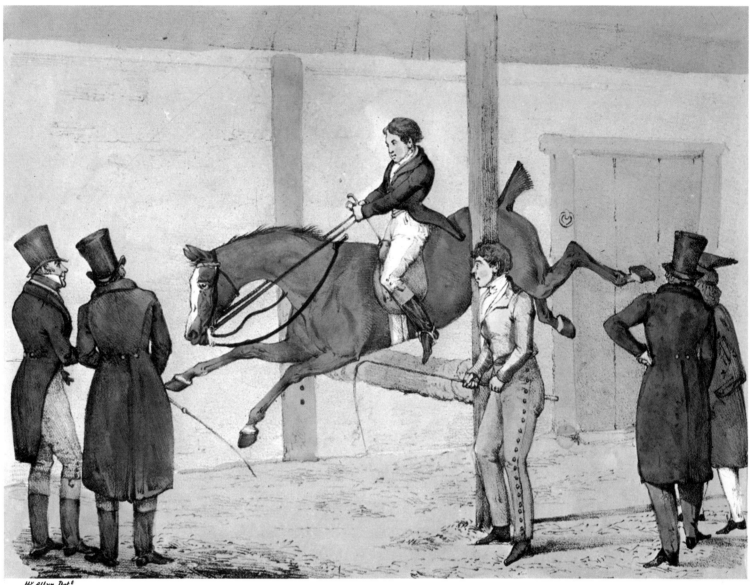

H.y Allan Det.t

That Seat will do well Master George.

London Published by Tho.s M.c Lean, Repository of Wit & Humour 26 Haymarket 1823

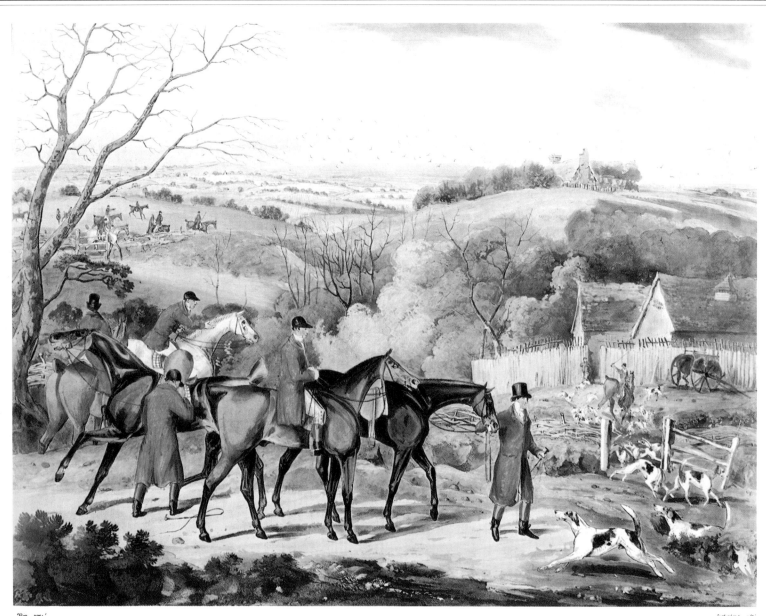

'Three prints' Sutherland sculp

PLATE L UNKENNELLING

PLATE 32

FOX HUNTING: Unkennelling

Thomas Sutherland after Henry Alken, 1817, *coloured aquatint with etched outline*, 39.5 × 52 cm. (15½ × 20½ in.)

Only a few sets of foxhunting prints of the period open with a scene before the Meet. In this case the hounds are greeting the dismounted M.F.H. The kennels themselves look a bit dilapidated, but no hunt could afford to neglect the welfare of a valuable pack. There was often a special kennel huntsman, or the chief huntsman himself supervised them. Charles Davis (see plate 58) found it necessary to lay down an additional floor when his hounds were suffering a rheumatic affliction.

Squire Osbaldeston, who hunted his own three to four packs, washed their feet in warm broth after they came in and saw to it that their oatmeal was 'at least ten months old'.

Nimrod, in *Hunting Tours*, describing his visit to Lord Darlington, says, 'It is not often that a wrinkle is to be given to masters of fox-hounds, but the kennel at Newton House, I think, affords one. There is a passage leading from the feeding to the lodging-room which is made to hold water, about six inches deep on the level. This, on hunting days, is filled with broth from the copper, and hounds pass through it in the evening, after they have been fed. The consequence is, they lick their feet dry; and the healing properties of a dog's tongue to a sore are very well established.'

From a print in the collection of Ian Fenwick-Smith, Esq.

PLATE 33

FOX HUNTING: Going Out

Edward Bell after George Morland, 1800, *mezzotint, printed in colours*, 51 × 65.5 cm. (20 × 25$\frac{3}{4}$ in.)

Plate I of a set of four mezzotints, rarely met with in fine condition and printed in colours, as in this instance.

Morland himself, when young, was a fine horseman, racing as a jockey at Margate, and getting mobbed for winning when he was expected to lose.

Desperately hard-working, but notoriously improvident and a slave to gin, he occasionally took refuge from his creditors at Enderby Hall, the residence of the amateur artist Charles Loraine Smith in Leicestershire, where he joined with his host in painting and no doubt in hunting as well (see plate 46).

Morland's hunters have sometimes been criticized for being on the heavy side, rather like the cart- and farm-horses he more usually painted, but most hunters had to be bred to carry weight and travel over ploughed fields as well as grass.

From a print in the collection of Mr and Mrs Paul Mellon

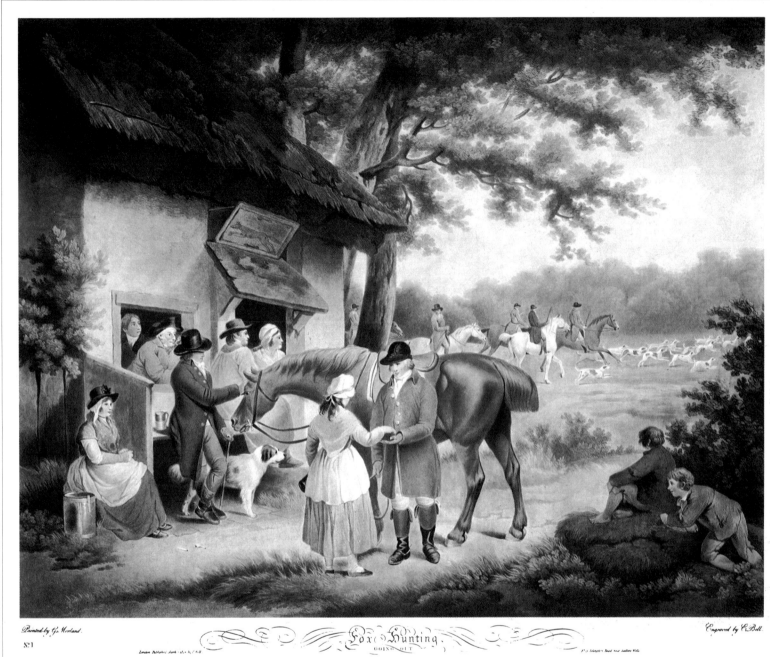

Painted by G. Morland.

Nº 1.

London Published March 1 1800 by C. Bell

Engraved by C. Bell.

Nº 15 Islington Road near Sadlers Wells

Fox Hunting.
GOING OUT

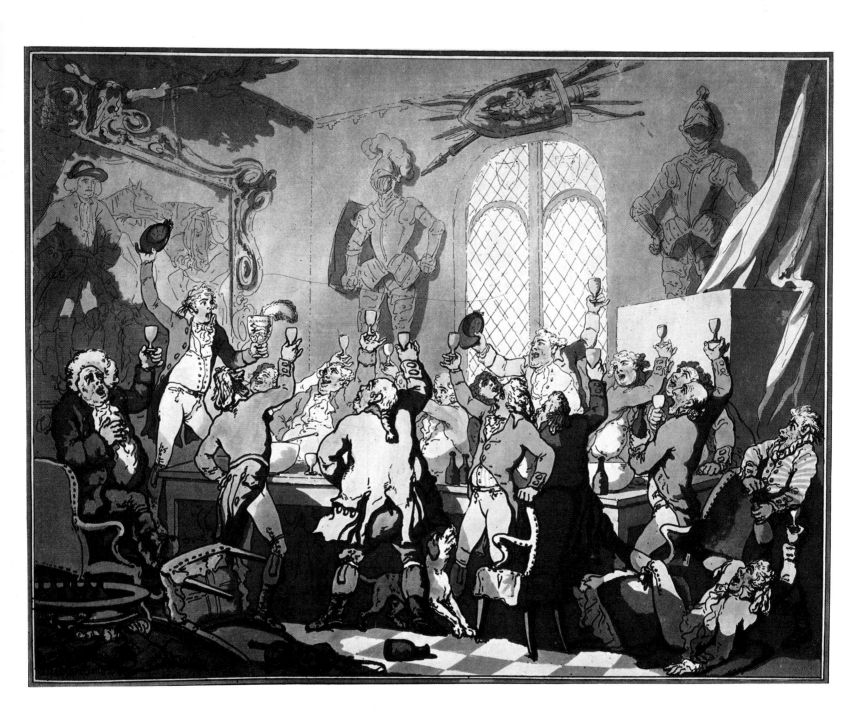

PLATE 34

THE DINNER

Thomas Rowlandson, 1787, *coloured aquatint with etched outline,* 38 × 51 cm. (15 × 20 in.)

This is the last of a series of six hunting scenes by Rowlandson, published at intervals from 1786 to 1788, showing a young squire with his guests, in his ancestral hall, carried away by his enthusiasm for a successful day's sport and standing on his chair, while pledging a toast to the fox. 'The bumpers are lifted on high with reckless hand, and numerous pairs of stentorian lungs are echoing the challenge with boundless goodwill' (Joseph Grego, *Rowlandson the Caricaturist,* 1880). Even the butler seems to be joining in, and a huntsman on the right has cleverly fallen on his back, still holding his glass aloft.

The complete set consists of Going Out in the Morning, The Chase, The Death of the Fox, The Refreshment, The Return and The Dinner. The first plate has been said to include the Prince of Wales, later George IV. A Refreshment as well as a Dinner is unusual in a hunting set, probably because the hard riders had no time to spare. When they did, it was said they took their fences much better than before.

From a print in the collection of Mr and Mrs Paul Mellon

PLATE 35

THE BILSDEN COPLOW DAY

F. Jukes after Charles Loraine Smith, 1802, *coloured aquatint with etched outline*, 49×65.5 cm. (19$\frac{1}{4}$× 27$\frac{3}{4}$ in.)

A view of Mr Meynell's Hounds carrying a head with their second fox! at the end of a chase from Bilsden Coplow, Leicestershire, past Tilton Woods, Skeffington Earths, crossing the river Soar below Whetstone to Enderby making a distance of twenty-eight miles, which was ran in two hours and fifteen minutes, on Monday, the 24th day of Feby 1800.

This print commemorates a notable run of the Quorn Hunt, one of the last under the Mastership of the famous Hugo Meynell, from the Billesdon Coplow cover to Enderby Hall. Charles Loraine Smith, owner of Enderby, was one of the few to cross the river Soar and be in at the finish; he is seen leading his horse on the right.

The event was also recorded in a poem, which went into six editions, by another follower, the Rev. Robert Lowth, son of the Bishop of London.

These foxes were the 'straight-necked' gallant fellows, allowing the riders to take their fences, veering neither to right nor left, not those 'damned ringing varmints' who ran in a circle and finished where they started. The latter deserved short shrift, the former were deified, if annihilated; their brushes waved aloft and toasted at the subsequent dinner, their masks enshrined on the walls, the artist even expressing his intention of raising a monument in the grounds of Enderby to this particular one.

The accepted modern spelling is Billesdon Coplow.

From a print in the collection of Mr and Mrs Paul Mellon

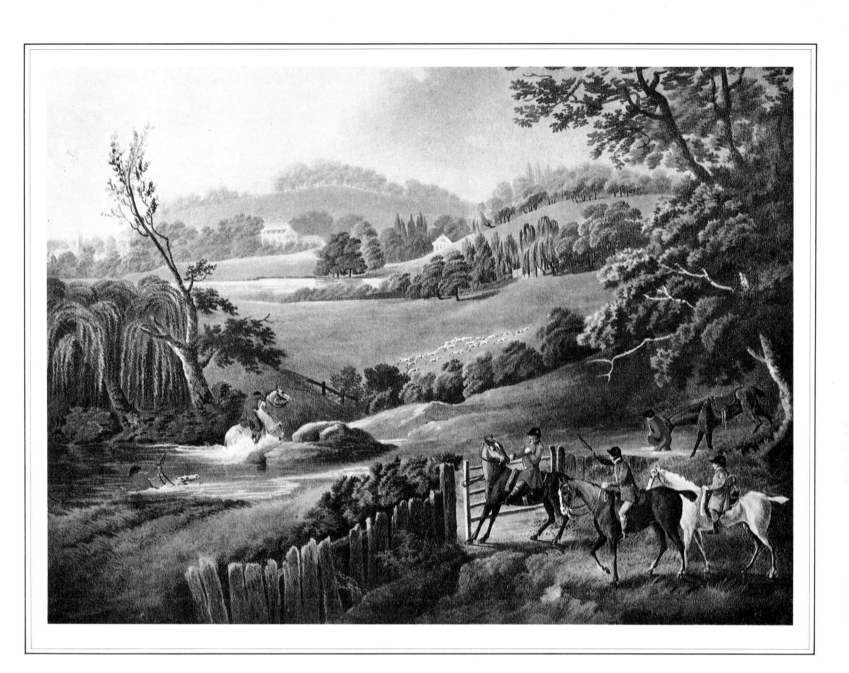

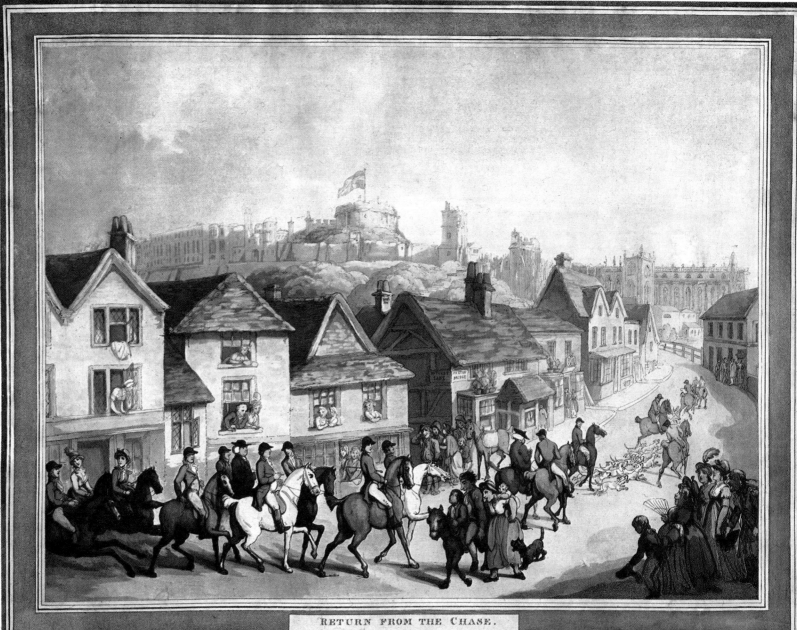

RETURN FROM THE CHASE.
SCENE at EATON.

PLATE 36

THE RETURN FROM THE CHASE, Scene at Eaton

Thomas Rowlandson, 1801, *coloured aquatint with etched outline*, 37.5 × 50 cm. ($14\frac{3}{4}$ × $19\frac{2}{3}$ in.)

The fourth plate of a very rare set of four, showing stag-hunting and fox-hunting scenes.

In spite of the tendency to caricature, one admires the apparent ease of the artist's work, the masterly simplification and the effortless foreshortening. The horses all show a variety of different actions, much less stilted than usual in prints of the period.

The blue hunting uniform suggests that the hounds are the Royal Buckhounds, but the figure the pedestrians are saluting is much too slim for George III, who rode at nineteen stone (266 lbs.): it could be the Master at this time, Lord Hinchingbroke, later Earl of Sandwich.

Two parsons appear in the procession, reminding us that Rowlandson loved a good-natured dig at the cloth, whose members commonly hunted in those days. The famous 'Bilsden Coplow Day' (plate 35) was recorded in verse by the Rev. Robert Lowth, a participant, and when the Rev. William Pochin, following the Cottesmore, was unseated, he was left where he fell 'because he wouldn't be wanted till Sunday.' One, the Rev. John Empson, was known as 'The Flying Parson' for his riding. Another, the Rev. Jack Russell, hunted his own pack, and persuaded his parishioners to put away their guns and leave the foxes to him.

The presence of ladies is of interest, always until recently riding sidesaddle, and more fully discussed in plate 62. Although they continually rode to hounds, they hardly ever appeared in hunting prints between the time of Rowlandson and the late 1840s.

From a print in the collection of Mr and Mrs Paul Mellon

PLATE 37

FRANCIS DUCKENFIELD ASTLEY ESQ.^R AND HIS HARRIERS

R. Woodman after Ben Marshall, 1809, *stipple and line-engraving, printed in colours*, 19 × 24 cm. ($7\frac{1}{2}$ × $9\frac{1}{2}$ in.)

Francis Duckenfield Astley was High Sheriff of Cheshire, where he was Master of one of the finest packs of Harriers, with a reputation for horsemanship and bold riding. Here he is represented on The Old General, a bay hunter of great speed and power as a fencer. In the last year of his Mastership, Astley hunted the pack as deer-hounds.

The print was first published in 1809 by Ben Marshall himself, the name spelled Dukinfield. When reissued in 1810 by W. D. Jones of Cambridge, the name was altered to Duckenfield. Later reprints are without the publication line.

It forms a companion to The Earl of Darlington and His Fox Hounds (plate 38).

From a print in the collection of Mr and Mrs Paul Mellon

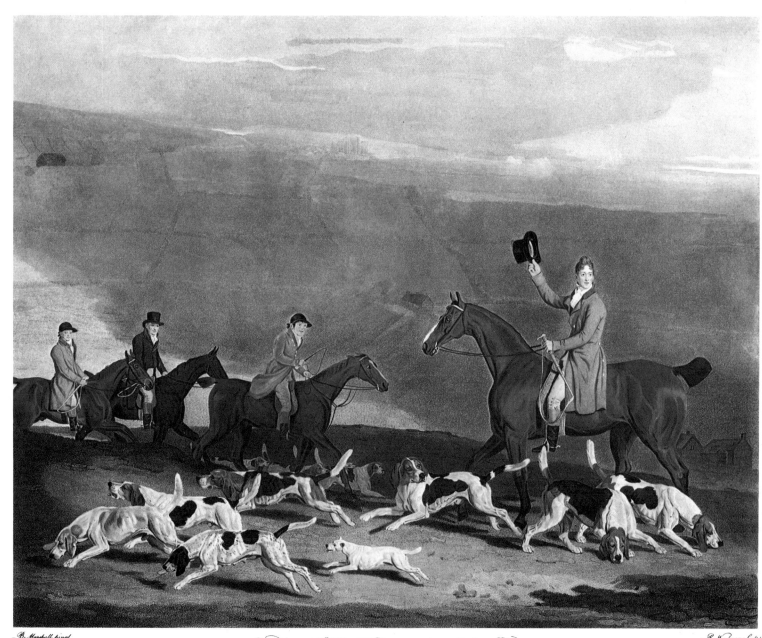

B. Marshall pinxt

R. Woodman Sculpt

Francis Duckenfield Astley Esq: and his Harriers

Published March 1 1810 by W. B. Joiez, Cambridge

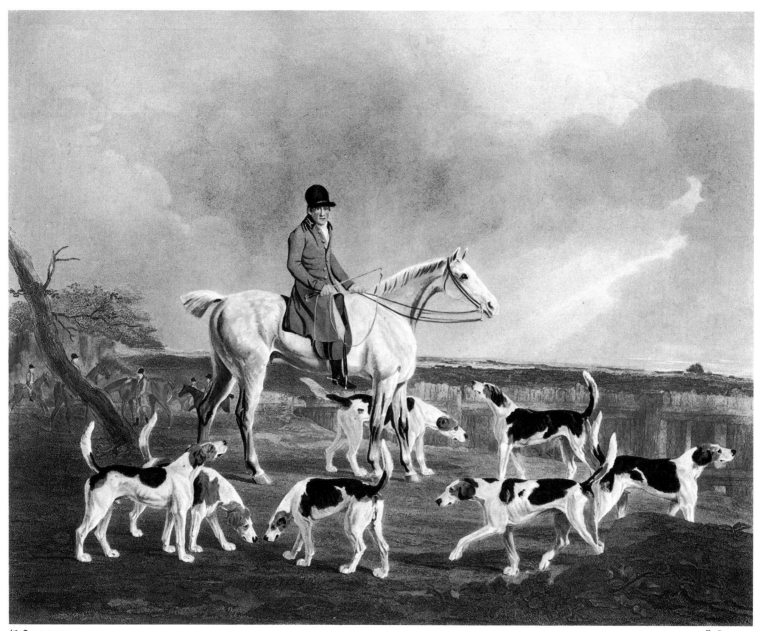

The Earl of Darlington and His Fox Hounds

Publish'd March 12 1817 by W.B. Jones Cambridge.

PLATE 38

THE EARL OF DARLINGTON AND HIS FOX HOUNDS

J. Dean after Ben Marshall, 1810, *stipple and line-engraving, printed in colours*, 48 × 60 cm. ($18\frac{7}{8} \times 23\frac{2}{3}$ in.)

The third Earl of Darlington (afterwards first Duke of Cleveland, 1766–1842) is seen on Ralpho, with some hounds of the Raby Pack. He is wearing the cap of the professional huntsman instead of the ubiquitous top-hat of the period, an embroidered gold fox on his black velvet collar. His one-time neighbour Squire Osbaldeston, another M.F.H. who hunted his own pack, also wore a cap.

This certainly must have been easier to keep on than a tall hat, though the latter was regarded as some kind of crash-helmet, especially when passing at full speed through 'bull-finches', thorn or thick hedges, and the loss of it so serious that about 1820 the hat-guard was invented: a cord fastened one end to the brim of the hat and the other to a button of the coat. It is said that the Earl later reverted to a top-hat, but the reason given was that it was warmer.

Nimrod, in his *Yorkshire Tour* (1826), gives a long account of a visit to Raby Castle, and this picture of Lord Darlington is mentioned, hanging in the dining room. 'In the well-known print of the Earl of Darlington and his fox-hounds, his lordship appears in a cap, which himself and his men for many years rode in, but at present they all wear hats. . . .

'Lord Darlington's hounds met on Monday the 13th at York Gate, on the London & Glasgow road, three miles from Sir Bellingham's house . . . Lord Darlington drove up in his carriage with Lady Arabella Vane, his youngest daughter, for whose riding a most splendid horse was in waiting. Lady Arabella was attired in her scarlet habit, with his Lordship in a straight-cut scarlet coat, with an embroidered fox on the collar, a hat, and a leather girdle across his shoulder. His two whippers-in were also in hats, and had the embroidered fox on the collar.'

The Druid, in *Scott and Sebright*, speaks of the Earl of Darlington as long the Nimrod of the North, 'with his chin sticking out, and his cap on one ear (from the poem "Darlington's peer, With his chin sticking out, and his cap on one ear"). He was all for riding, and four couple of hounds in front, and the rest coming as they could was the general order of things. The stud, which was headed by the grey Ralpho, whose skin still covers an armchair at Raby, was first-rate, and worthy of their master.'

This print was first published in 1805 by Ben Marshall himself, reissued in 1810, by W.D. Jones of Cambridge, and reprinted with the publication line erased. It forms a companion to Francis Duckenfield Astley (plate 37).

From a print in the collection of Mr and Mrs Paul Mellon

PLATE 39

J.F. HERRING'S SENR. FOX HUNTING. The Meet

J. Harris and W. Summers, 1857, *coloured aquatint with etched outline*, 35.5 × 51.5 cm. (14 × 20¼ in.)

One of the chief points of interest in this picture is the lady. Although it is evident from contemporary descriptions that quite a few rode to hounds, it is difficult to find a hunting print in which any ladies appear between the early years of the nineteenth century and the late 1840s. The subject is discussed more fully opposite plate 62.

The artist himself was a remarkable man, being almost self-taught, apart from some lessons from Abraham Cooper. He earned his living first of all as a stage-coach driver and painted all but one of the St Leger winners from 1815 to 1843, and the Derby winners from 1827 to 1849, besides many other pictures of racing, hunting and farmyard scenes.

First published in 1857, this set was republished by F. Herbault without date, and reprinted by L. Brall & Sons, also without date.

From a print in the collection of Graf Alexander von der Palen

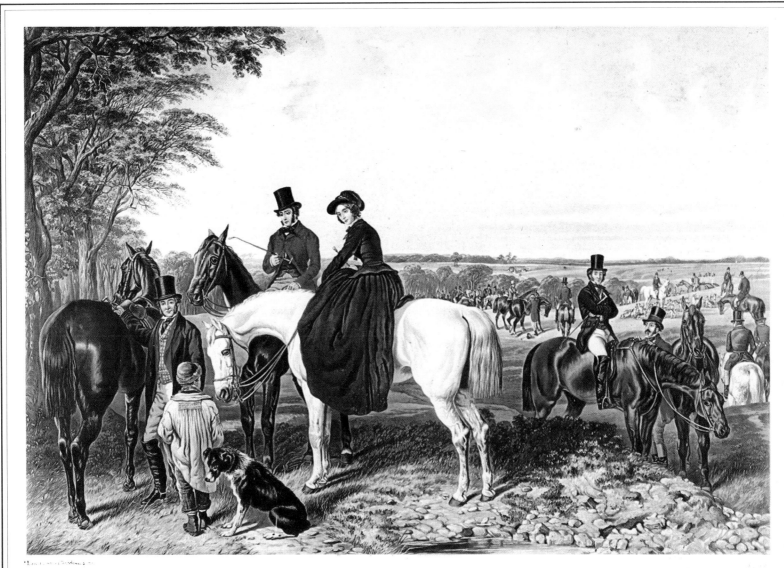

J.F. HERRING'S SENᴿ FOX HUNTING.
The Meet

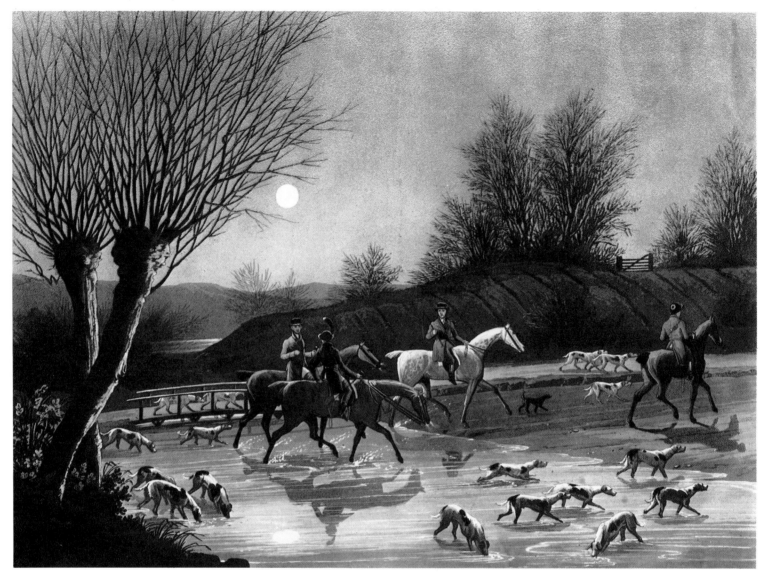

RETURNING HOME BY MOONLIGHT.

London, Published July 1, 1817.

No. 4.

Prout

PLATE 40

RETURNING HOME BY MOONLIGHT

R. Havell & Son after James Pollard, 1817, *coloured aquatint with etched outline, 33.5 × 46.5 cm. (13⅙ × 18½ in.)*

This attractive moonlight scene is the last of a set of four, the first plate bearing the title 'A Celebrated Fox Hunt'. They are very rare and much sought for by collectors, reminding us also that these hardy men hunted all day for six days a week, often finishing more than 20 miles from home, and not in these ideal weather conditions. The more enthusiastic masters were not above making a new find late in the day, and here there are only four riders left from a field that might have numbered hundreds at the start.

Many, if not most, were abstemious men, one of them breakfasting on a pound of veal condensed into a teacup, and nothing more till night-time. If they drank wine, it was of a matured quality practically unobtainable today. Squire Osbaldeston sipped his pint of port at the end of a strenuous day's hunting or riding, and surely there can have been few fitter men than this all-round sportsman and athlete.

When Beau Brummell, Lord Alvanley, handsome Jack Musters and their friends forsook the drawing- and gaming-rooms for the country, they soon became fit enough to dine sumptuously and still be at the Meet next morning.

Harriette Wilson records that in Leicestershire she was invited to dine every day at the Old Club, originally Lord Forester's house. 'The house was very comfortable and their dinners most excellent . . . The members led what I considered a very stupid sort of life. They were off at six in the morning . . . and came back to dinner at six . . . The evening hunt dress is red, lined with white, and the buttons and whole style of it are very becoming. I could not help remarking that the gentlemen never looked half so handsome anywhere in the world as when, glowing with health, they took their seats at dinner, in the dress and costume of the Melton Hunt' (*Memoirs of Harriette Wilson*, 1825).

Because of their popularity a smaller set of these plates (20.5 × 30 cm.: 8 × 11¾ in.) was also published.

The moonlight scene may well have been inspired by an earlier 'Night', after Dean Wolstenholme, one of the four times of day, published in 1811.

From a print in the collection of Mr and Mrs Paul Mellon

PLATE 41

THE TOAST

Cooper and Sutherland after Henry Alken, 1818, *coloured aquatint with etched outline, 23 × 31.5 cm. (9$\frac{2}{3}$ × 12$\frac{3}{8}$ in.)*

This is the last plate of a set of seven fox-hunting scenes, in which the members of a hunt are at dinner, probably at an inn, and the customary toast is being given to a gallant fox, who has provided some good sport.

An interesting light is thrown on the decoration of a country house or inn and some of the customs of the time, though it is not to be supposed that a spurred boot on the mahogany would be approved. A little puzzling, too, is the behaviour of the guest in the bottom left corner towards the servant who has been helping him remove his boots.

The late Major Guy Paget wrote, 'Old pictures show hunting men sitting round the table, some in their boots, some in slippers. They often began dinner at 3 or 4 o'clock and drank port or claret from the beginning till they went, or were carried, to bed.'

Surtees, in his *Analysis of the Hunting Field*, says, 'Hunt dinners are nasty things, but upon the whole, perhaps they are advisable . . . A hunt dinner at a country inn . . . say a quarter to six . . . buckets of soup, roasts and boils, sirloins, saddles, rounds, geese, sucking pig, a haunch of venison, game, tarts, celery & c.' He goes on, however, to dampen our ardour: 'But our humane disposition shrinks from describing the horrors of the evening – the hot wine and cold soup – the fatless venison and the gravy-congealed mutton.'

From a print in the collection of Mr and Mrs Paul Mellon

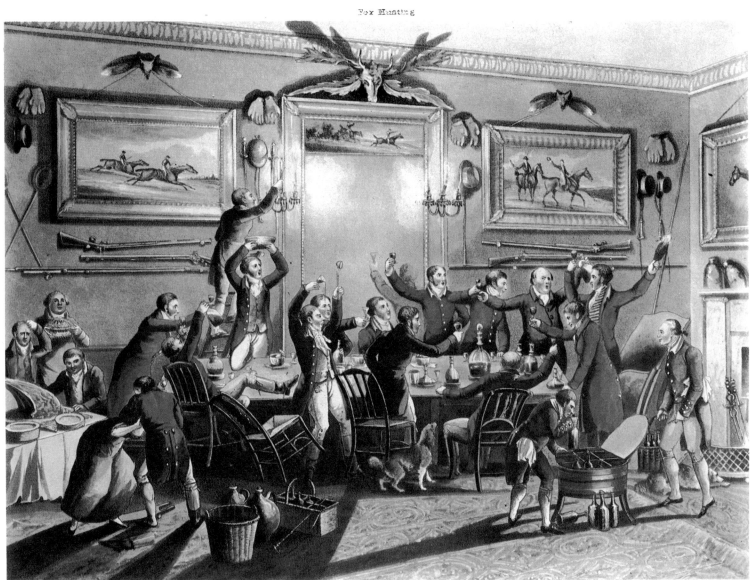

H. Alken. del.

Cooper & Sutherland. sculp.

The Toast

London Pub.d Aug.t March 1.st 1821 by S.t J. Fuller 34 Rathbone Place

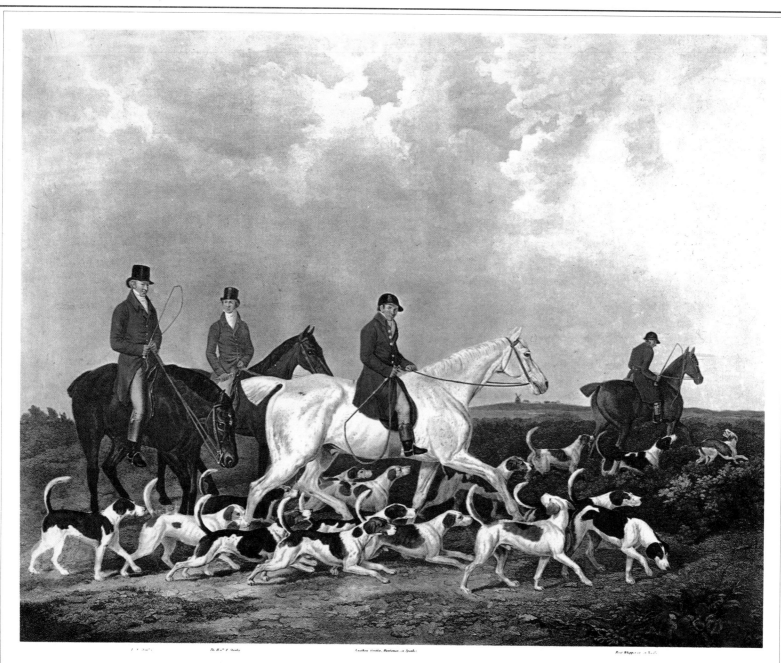

THE EARL OF DERBY'S STAG HOUNDS.

PLATE 42

THE EARL OF DERBY'S STAG HOUNDS

R. Woodman after J. Barenger, 1823, *coloured engraving*, 48.5 × 60 cm. $(18\frac{7}{8} \times 23\frac{2}{3}$ in.$)$

The figures shown are the twelfth Earl's son and grandson, Lord Stanley, and the Hon. E. Stanley, Jonathan Griffin, the huntsman, on the grey Spanker, and the First Whipper-in, Jem Bullen, on Noodle.

The twelfth Earl himself is not present, although, then over seventy, he still attended the first stages of the hunts.

The deer were brought to the Meets in vans, and performed their duties so often that they developed individual routes and were known by affectionate names, such as Ben the Sailor, Ploughboy and Alexander.

The Earl's first wife eloped with the Duke of Dorset; his second wife was the famous actress Elizabeth Farren.

PLATE 43

EASTER MONDAY. Turning out the Stag at Buckits Hill, Epping Forest

By and after James Pollard, 1820, *coloured aquatint with etched outline*, 31.5 × 62.5 cm. ($12\frac{3}{8}$ × $24\frac{2}{3}$ in.)

The Epping Hunt is said to date back to 1226, when Henry III granted the citizens of London the right to hunt in the nearby country. The scene is the annual place of the Meet near the Bald-faced Stag, Buckhurst Hill; the inn actually showing in the distance is The Roebuck, on the way to Loughton, Essex, not more than a mile from Queen Elizabeth's hunting lodge at Chingford.

The print is a very good representation of the surrounding scenery, so must be taken to give a fairly accurate idea of the Meet itself. According to a contemporary account the horsemen, pedestrians, gigs, cabs, drags and coaches were all abroad by 9 a.m., and by 12 there were not less than 3000 merry lieges then and there assembled. 'It was a beautiful set-out. Fair dames, "in purple and in pall", reposed in vehicles of all sorts, sizes and conditions, whilst seven or eight hundred mounted members of the hunt wound in and out "in restless ecstasy", chatting and laughing with the fair,' sometimes rising in their stirrups to look out for the long-coming cart of the stag, 'whilst with off-heel assiduously aside' they 'provoked the caper which they seemed to hide'.

The stag, in the meantime, was being exhibited in turn at various local hostelries, where there were 'buttocks of boiled beef and fat hams, and beer and brandy in abundance,' so that it might be half-past two before the stag was turned out, to 'a shout that seemed to shake heaven's concave'.

In 1882 the affair had become so disorderly that it was banned by the police as a public nuisance.

A few years earlier, and for a short time, the eccentric Colonel Thornton ran the Epping Hunt 'and his buffoonery found fine scope here. Dressed in a sort of military uniform, and accompanied by three splendid ladies of wonderful attire, he would arrive at the Meet in a carriage. The deer provided for the day's sport was gaily bedecked with ribbons, and wore round its head a frontlet bearing a motto both loyal and patriotic.' (Siltzer, *The Story of British Sporting Prints*)

From a print in the collection of Mr and Mrs Paul Mellon

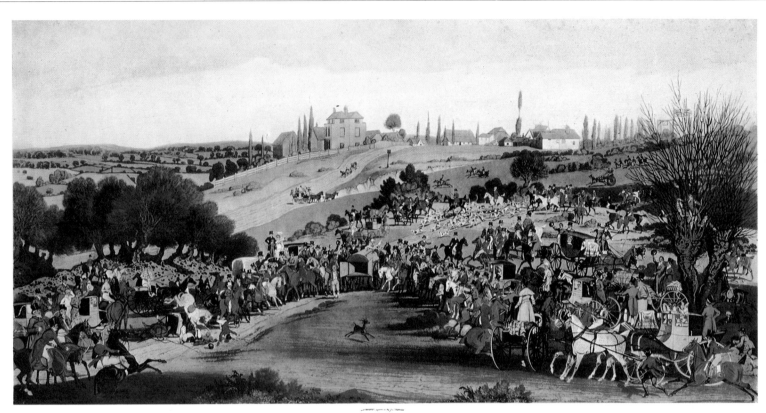

EASTER MONDAY

TURNING OUT THE STAG AT BUCKIT'S HILL EPPING FOREST

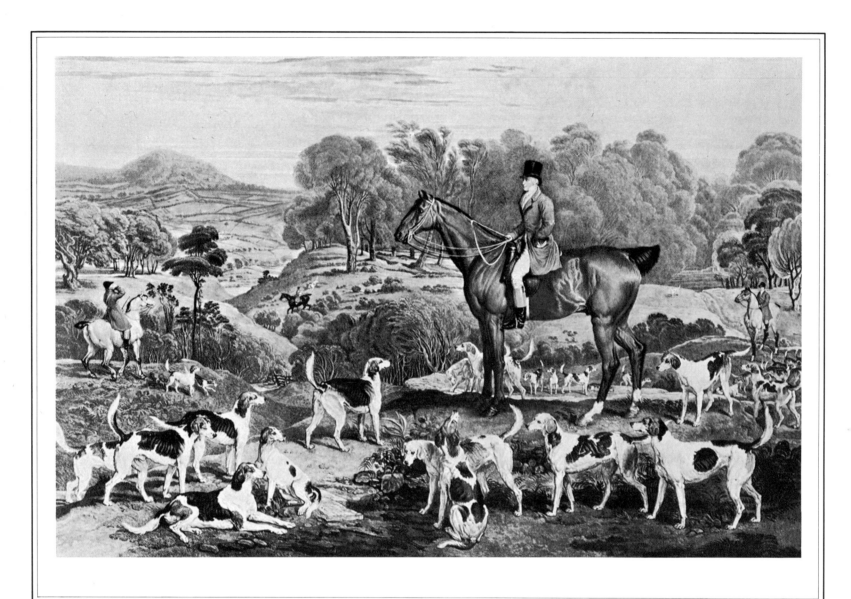

PLATE 44

RALPH JOHN LAMBTON. His Horse Undertaker and Hounds
(Calling Hounds out of Cover)

Charles Turner after James Ward, 1821, *mezzotint printed in colours*, 50 × 74.2 cm. ($19\frac{2}{3}$ × $29\frac{1}{4}$ in.)

It would not be too much to say that this is one of the most imposing sporting prints, in both its dimensions and composition. It is rare in any form, but extremely scarce when printed in colours.

The Lambton Hounds hunted at one time a large territory from Morpeth to Darlington, but resigned the Northumberland country when the Northumberland Hounds were formed in 1815.

Ralph John Lambton hunted the pack from 1809 to 1829. The original painting for this print, measuring 5 × 7 feet, was presented to him by the members of the Lambton Hunt in 1822, at a dinner in the Assembly Rooms in Newcastle.

James Ward claimed to have started this plate himself.

PLATE 45

SIR MARK MASTERMAN SYKES, Bart., with his Fox Hounds breaking cover

William Ward after H.B. Chalon, 1821, *mezzotint, printed in colours*, 55.5 × 73 cm. (21⅞ × 28¾ in.)

Sir Mark Masterman Sykes (1771–1823) was the elder brother of the more famous Sir Tatton Sykes, who inherited from Sir Mark the title and the Sledmere estate in Yorkshire.

Sir Mark bought the Middleton hounds from Lord Feversham in 1804, and hunted them for two seasons, largely at his own expense. Later Mr Watt and Mr Digby Legard joined him, but Sir Tatton took them over in 1811 and held them with only a two-season break for forty-two years, with old Will Carter as huntsman and his son Tom as chief whip.

The scarlet club coats had light blue collars with a silver fox; the buttons had 'Sykes, Goneaway!' on them.

Sir Mark is better remembered as a collector, his pictures selling for nearly £6,000, his books £10,000 and his prints £17,000, after his death in 1823. Tradition in the family says the money was devoted to the horses and hounds.

It has been estimated that the library would today have been worth perhaps two million pounds, one of his most remarkable books being a 'Gutenberg Bible', valued alone at the better part of a million.

He had a 'magnificent collection' of prints, numbering about 100,000 items. These were sold in five portions, occupying forty-two days, realizing £17,000, and worth a possible million pounds today. A famous early Italian niello *Pax*, by Maso Finiguerra, now in the British Museum, realized £315, the highest price for a print until 1860.

From a print in the collection of Miss Hildegard Fritz-Denneville

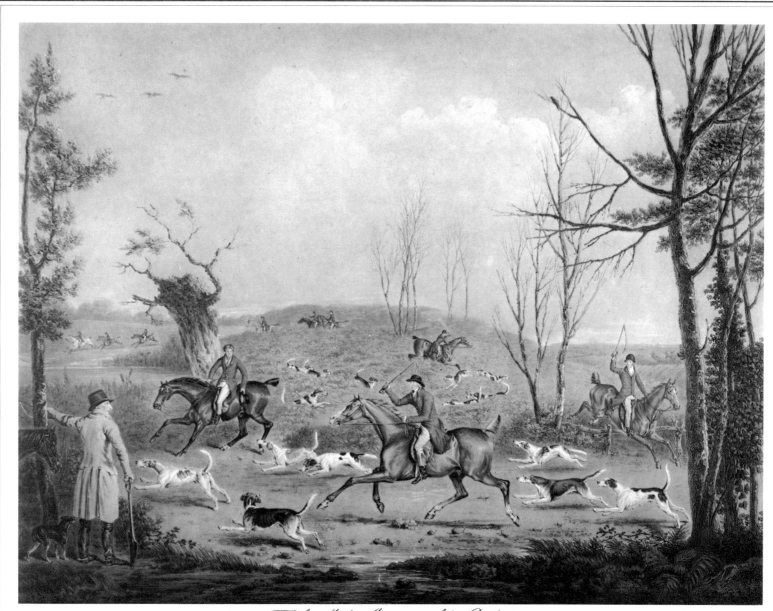

To Sir Mark Masterman Sykes Bar.[t]

This Plate of his FOX HOUNDS BREAKING COVER, is with great respect dedicated

by his obliged humble Servant John Wolstenholme

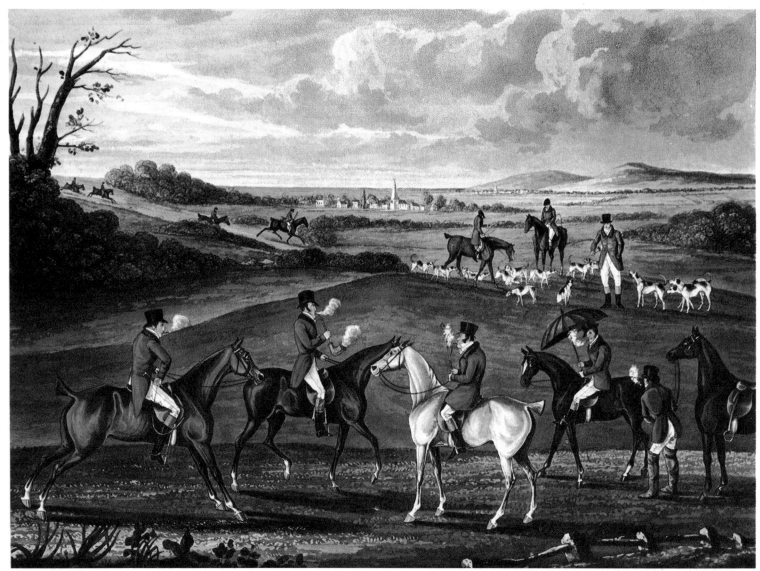

C. LORAINE SMITH, ESQ.ª DEL.ᵗ London, Published Feb:ʸ 1826 Watson, 7. Vere Street. PLATE. 1.

The Rendezvous of the SMOKING HUNT *at Braunstone,*

on Friday the 8.ᵗʰ of February, 1822.

dedicated to Sir Bellingham Graham, Bar.ᵗ

PLATE 46

THE RENDEZVOUS OF THE SMOKING HUNT AT BRAUNSTONE

After Charles Loraine Smith, 1826, *coloured aquatint with etched outline*, 24 × 33 cm. (9½ × 13 in.)

Plate I of a set of eight caricaturing the smoking habit. Most are smoking cheroots, but one has a large German pipe. The significance of these plates is obscure, except that smoking might impair the scent. One of the plates, 'Bagging the Fox', introduces Dick Knight, huntsman of the neighbouring Pytchley, in front of Sir Bellingham Graham, and Mr Cradock, Master and Secretary of the Quorn in 1822, when Squire Osbaldeston was recovering from a broken leg. The plates are also dedicated to Sir Bellingham and the meeting is at Branston, proof enough that the Quorn is shown.

 The artist, known as 'The Squire of Enderby', was at one time Deputy Master of the Quorn. We read in the records of the time that 'Mr Loraine Smith had a magnificent horse, called Hyacinth, got by Holly-hock. He asked a thousand for him.' And 'I saw Mr Loraine Smith in London in the Spring, and he told me he had built a triumphal arch on the spot which had produced so gallant a fox, and a run well deserving of a record beyond the day.'

From a print in the collection of Mr and Mrs Paul Mellon

PLATE 47

THE TOAST

G. Hunt after Henry Alken, 1824, *coloured aquatint with etched outline*, 26 × 40 cm. ($10\frac{1}{4}$ × $15\frac{3}{4}$ in.)

The sportsmen gathered 'after the cheering labours of the day', at the hospitable mansion of the Master – or so it would appear, rather than an inn – toasting, with a resounding View Halloo, the gallant fox, who has led them straight, not like those rascals with curvature of the spine, causing them to run in circles.

Missing, fortunately, from this table is the large punch bowl, sometimes a conspicuous object on these occasions, in which the true enthusiasts immersed the fox's head, stirring it with the brush: 'the whole party were then re-baptised with the dripping brush, and the highly-improved liquor was quaffed by all, with the true *goût* of enthusiastic votaries of the chase.'

As in other 'toast' and 'dinner' prints, the decoration of a room of the period shows to advantage, and glass collectors have been interested in the inverted glasses in the cut-glass coolers.

Nimrod (*Hunting Reminiscences*): 'The Shropshire gentlemen meet twice in the season at Shrewsbury, for a week each time . . . The gentlemen dine together in the great room at the Lion Inn, and each hunt gives a splendid ball and supper to the ladies. Perhaps no other county in England can boast of such gay doings as these. . . .

'The Berkley Hunt Club consists of about 30 members, who dine together at Cheltenham twice or three times during the season. Their field uniform is a scarlet coat with black velvet collar, on which is em-broidered a silver fox with a gold brush, much after the fashion of the Raby Hunt collar. The dress uniform is handsome and unique. It consists of a black coat, lined throughout with scarlet silk; buff breeches, and buff satin waistcoat – the tout ensemble of which has a very showy effect in a ball-room . . .'

This print was published singly and is not one of a set.

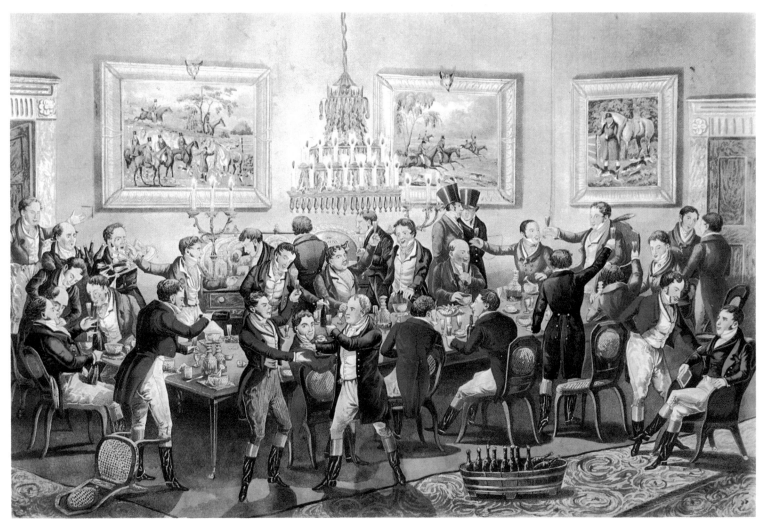

Drawn & Etched by H. ALKEN. London Published by THO.S M.C LEAN, 26 Haymarket, 1824. Aquatinted by G. HUNT

THE TOAST.

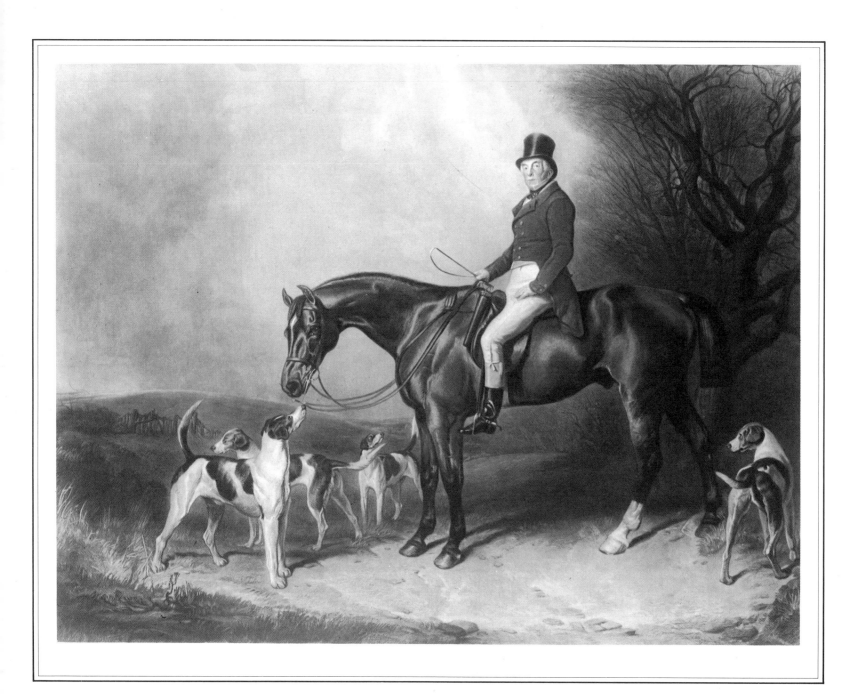

PLATE 48

THOMAS ASSHETON SMITH

D.G. Thompson after William Sextie, 1853, *coloured engraving*, 53 × 70.5 cm. (20⅝ × 27¾ in.)

Thomas Assheton Smith was one of the most famous M.F.H.s, and Nimrod describes a run with the Quorn under his Mastership, when 'He never turned his horse's head ten yards to the right or to the left for an open gate, or for a gap, but rode by the side of his pack, cheering them to their fox, in a manner and at a pace that I shall never forget.'

When a friend remarked that he did not like the Market Harborough country, because the fences were so large, Mr Smith replied, 'Oh, there is no place you cannot get over, with a fall.' In fact, he claimed that he must have fallen in every field in Leicestershire, and once fell over five gates in the course of a single run, yet miraculously escaped serious injury.

Dick Christian, the horse-trainer and steeplechaser, told 'The Druid': 'Nothing ever turned Mr Smith. If we had come near the Coplow, I'd have shown you that big ravine he jumped – 12 feet perpendicular, and 21 feet across . . . No man that ever came into Leicestershire could beat Mr Smith . . . He'd get away with three or four couple of hounds . . . The whips could never get the others out of cover fast enough for him.'

He rode loosely, largely by balance, looking back to his hounds while taking the jumps. A chestnut horse called Fire King, which came from Ireland with the name of The Devil, was considered almost unmanageable, until tamed by this fine horseman, and had been sold for only £25 because of his temper. His owner, Mr Denham, beat all Derbyshire on him and then astonished Leicestershire, including Mr Smith who bought him for two hundred guineas, and, after impatiently sending him back to the stables several times, was quite sure he had never had such a horse before.

PLATE 49

HUNTING QUALIFICATIONS, Plate I, The Appointment

By and after Henry Alken, 1829, *coloured etching*, 16.5 × 25.5 cm. (6½ × 10 in.)

Nearly all sets of sporting prints were first published with a title and some explanatory letterpress, in paper wrappers. In the case of *Hunting Qualifications* the six plates were accompanied, in the first edition, by a title, plus seven leaves of letterpress, in brown paper wrappers, the title being repeated on the upper wrapper.

The Appointment means The Meet, and the six plates have been described as one of Alken's most charming sets.

> With easy seat behold them ride –
> These are the Truly qualified –
> Models of Sporting men;
> Graceful and elegant, yet neat;
> Egad, the very sight's a treat
> I long to have again!

In the first edition the plates have Ackermann's publication line with the date 1829. They were reissued with the publication lines altered to *London: Published at 31, Ely Place, E.C.,* and later reprinted with the publication lines removed.

Because sporting prints were nearly always framed and hung on walls, few sets have survived complete with wrappers and letterpress.

From a print in the collection of Mr and Mrs Paul Mellon

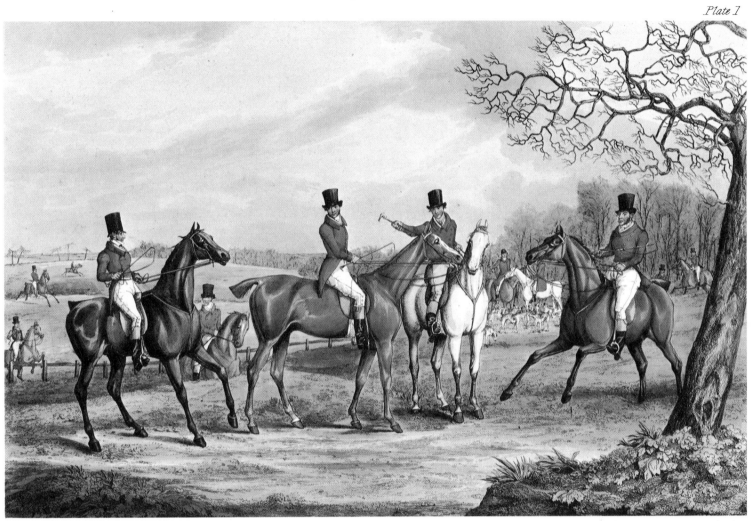

Drawn & Engraved by H. Alken.

THE APPOINTMENT.

London Published Aug.t 1st 1829 by R. Ackermann. Jun.r 191 Regent Street.

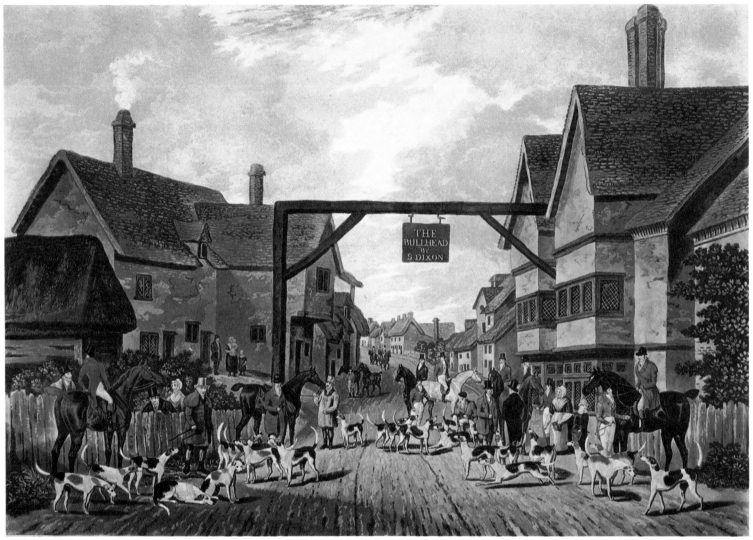

THE
BULLHEAD
BY
S DIXON

(Whitwell near Welwyn.)

VILLAGE SCENERY - HOUNDS MEETING.

PLATE 50

HERTFORDSHIRE. VILLAGE SCENERY – HOUNDS MEETING (Whitewell near Welwyn)

Dean Wolstenholme junior after Dean Wolstenholme, 1833, *coloured aquatint with etched outline*, 24.5 × 36 cm. $(9\frac{2}{3} \times 14\frac{1}{6}$ in.)

The Hertfordshire Village Scenery fox-hunting set is possibly the most attractive of all sporting prints, much sought after and rare.

The other plates in the set of four are Hounds Going to Cover (View near Offley), Full Cry (View leading to Pauls Waldens Park) and Death (View near St Albans), the hunt starting at the Bullhead Inn and conveniently finishing at another Bull Inn.

The Hertfordshire set was first published in 1833 by Wolstenholme himself, and reissued by Ackermann very shortly after, because the Ackermann issue has been seen with a Whatman watermark dated 1833.

From a print in the collection of Mr and Mrs Paul Mellon

PLATE 51

COUNT SANDOR'S EXPLOITS IN LEICESTERSHIRE, Plate I

Edward Duncan after John Ferneley, 1833, *coloured aquatint with etched outline*, 26.5 × 35 cm. (10$\frac{1}{2}$ × 13$\frac{3}{4}$ in.)

The full set of these plates numbers ten and shows the exploits in Leicestershire of a Hungarian nobleman, when he was the guest of that hard-riding Meltonian, Lord Alvanley (see plate 60).

He falls while putting on his gloves, his horse shying at a drain. This interesting view shows Melton Mowbray, the Metropolis of hunting, in the heyday of the 'Meltonians', who stayed only for the season and were rather a pain to M.F.H.s like Squire Osbaldeston, hoarse from shouting 'Hold hard!' The more sedate old-timers considered that the new generation of bruising young riders was spoiling the sport and putting the hounds in danger by their impetuosity. Hugo Meynell, 'the father of fox-hunting', describing a run, said: 'First came the fox, then Lord Forester, followed by my hounds.'

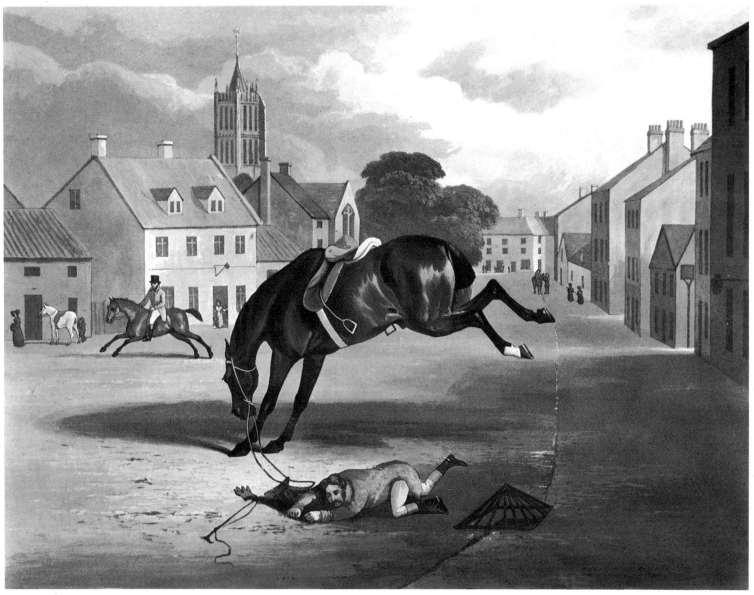

Count Sandor's Exploits, in Leicestershire.

To whom these Prints are with permission most respectfully Dedicated by His Excellency's most obliged and humble Servant R. ACKERMANN, JUN.ᴿ
191 Regent Street

J. FERNELEY. PINX.ᵀ
Melton Mowbray

London. Pub.ᵈ 1.ˢᵗ Aug.ᵗ 1833, by R. Ackermann, Jun.ʳ at his ECLIPSE Sporting Gallery, 191 Regent Street.

F. DUNCAN. SCULP.ᵀ

PLATE 1.

A floorer. + Pick up the pieces!

Cruiser starts at a drain and floors the Count in the streets of Melton

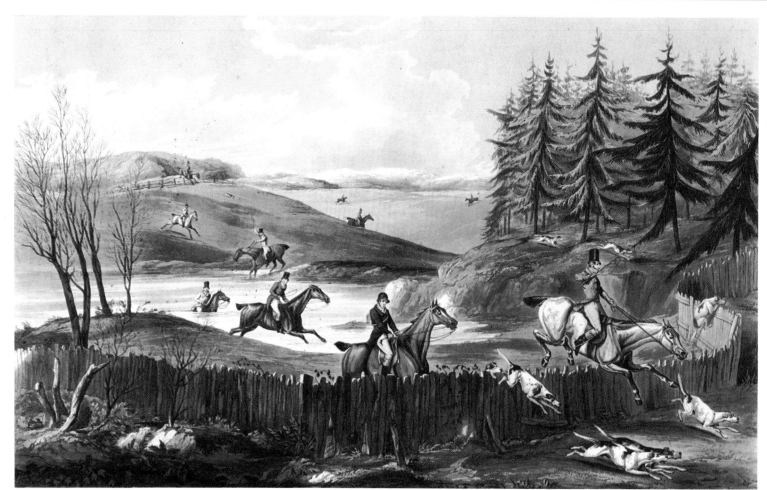

From the original Drawings by W. P. HODGES, ESQ. T. M. LEAN, Direxit Engraved by H. ALKEN

THE CHASE.

Dedicated with Special Permission to his Grace the Duke of Beaufort, K.G.

London, Published Jan.y 1st 1833, by THO.S M.c LEAN, 26, Haymarket.

PLATE 52

THE BEAUFORT HUNT: The Chase

Henry Alken after Walter Parry Hodges, 1833, *coloured aquatint with etched outline, 32 × 52 cm. ($12\frac{1}{2}$ × $20\frac{1}{2}$ in.)*

Published as a set of eight in 1833, with a ninth issued a year later, the *Beaufort Hunt* was eulogized at the time as 'the handsomest set of hunting pictures' and 'the best ever published'. They were the collaboration of a Dorset amateur, Walter Parry Hodges (1760–1845), with a gift for composition, and a professional, Henry Alken. The latter corrected the bad drawing, but retained entirely the composition.

This was in the time of the Marquis of Worcester, seventh Duke of Beaufort, who is said to be the dismounted huntsman in plate I, greeted by his hounds *Coming out of Kennel*, two years before he inherited.

The hounds were kept at Badminton, so the hunt is often referred to by that name. The Marquis of Worcester succeeded to the Dukedom of Beaufort in 1835, and by 1844 was hunting his own country. His huntsman was Will Long, the most famous of all Badminton huntsmen, who had succeeded Philip Payne in 1826.

The set was published in pink paper wrappers, with a dedication to the Duke, and the frontispiece of a fox's mask, but no more than two or three sets have been preserved in this form. The Mellon Foundation has a complete set, formerly in the collections of C.F.G.R. Schwerdt and H.R.H. the Duke of Gloucester.

PLATE 53

THE BEAUFORT HUNT: The Return Home

Henry Alken after Walter Parry Hodges, 1833, *coloured aquatint with etched outline,* 32 × 52 cm. (12$\frac{1}{2}$ × 20$\frac{1}{2}$ in.)

Another plate in the same set as plate 52.

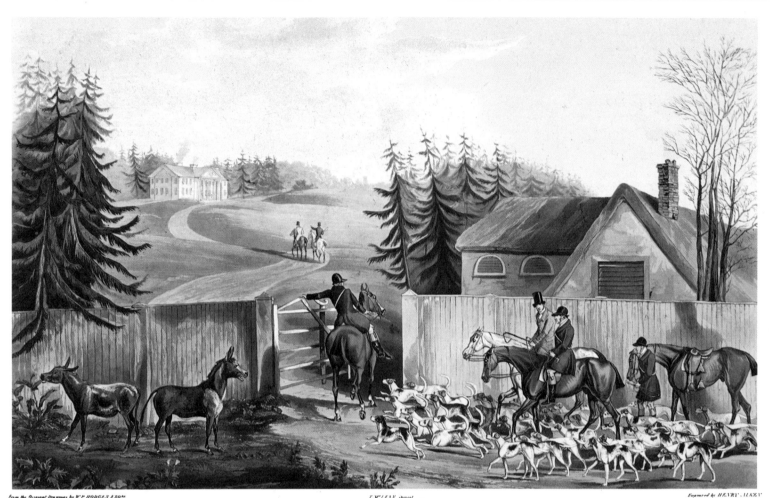

From the Original Drawings by W^m P. HODGES ESQ^{re}. T. M^cLEAN Direxit Engraved by HENRY ALKEN

THE RETURN HOME.

Dedicated by Special Permission to his Grace the Duke of Beaufort K.G.

London Published by THOS M^cLEAN 26 Haymarket, Feb^y 1833.

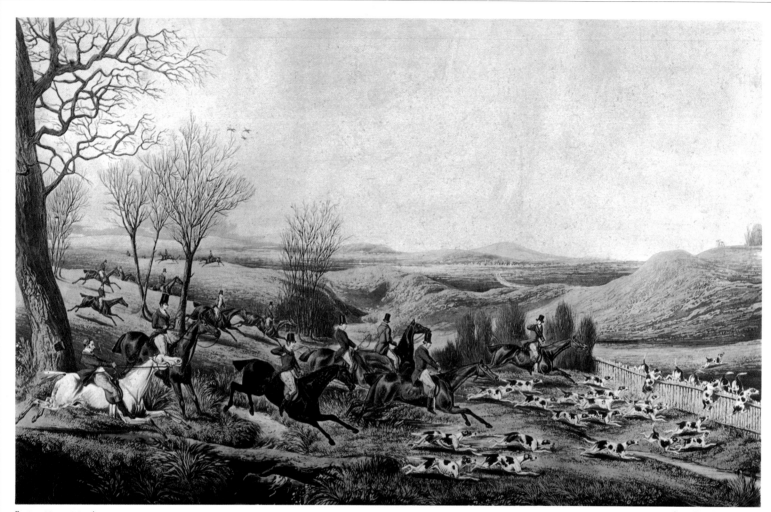

THE CHASE OF THE ROEBUCK.

Dedicated by permission to E. M. Lloydell, Esqr. many Years Master of a Pack of Roebuck Hounds.

By his Sincere and obliged Friend W. P. HODGES.

PLATE 54

THE CHASE OF THE ROEBUCK

Henry Alken with R.G. Reeve after W.P. Hodges, 1834, *coloured aquatint with etched outline*, 32.5 ×
51.5 cm. ($12\frac{3}{4}$ × $20\frac{1}{4}$ in.)

Walter Parry Hodges was the Dorset amateur who designed the famous *Beaufort Hunt* (see plates 52
and 53).

In this plate we see his gift for composition, any faults in his drawing having been duly corrected by
Alken when etching the outlines on the copper plate, R.G. Reeve adding the aquatint tone and shading.

It is interesting to note that the artist had introduced some followers of the Beaufort, in their green uniform.

PLATE 55

THE FOX CHASE, 'A Southerly Wind & A Cloudy Sky', Plate II.

Charles Hunt after F.C. Turner, 1835, *coloured aquatint with etched outline*, 36.5 × 47.5 cm. ($14\frac{1}{3}$ × $18\frac{3}{4}$ in.)

One of a set of four prints illustrating the poem 'A Southerly Wind and a Cloudy Sky/Proclaim it a Hunting Morning', by William Somerville. Dr Johnson said he 'wrote very well for a gentleman', but experts have thrown doubts on the propitiousness of these weather conditions.

The huntsman is 'capping them on to the scent', a practice considered unseemly by the late Lord Ribblesdale, who did not like a picture in which the huntsman had his hat off; but the silent waving-on has been advocated in order not to cause any other fox in the cover to bolt and thus distract the hounds from their first quarry, though this seems unjustifiable with all the racket of horsemen and hounds giving tongue.

Behind, on the left, a whipper-in is attempting to catch the horse of a rider, who has neglected or been unable to carry out the fundamental instruction to hold on to his reins when falling.

Matters could be better left to the huntsman's horse, which, with the spectator, can obviously see the fox. Foxhounds, however, hunt by scent; only greyhounds, stag- and wolfhounds hunt by sight.

PLATE II

"A SOUTHERLY WIND & A CLOUDY SKY."

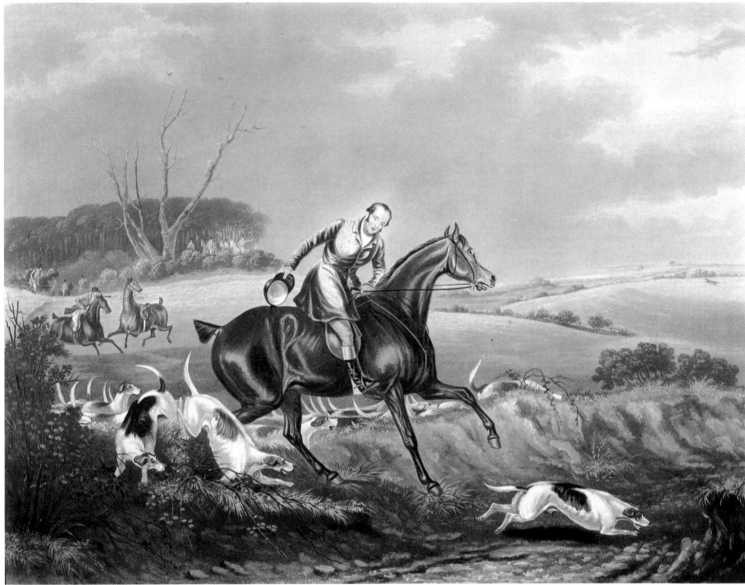

Painted by F.C.Turner

London Published 1835, by ACKERMANN & C°. 96. Strand.

Engraved by Chas Hunt

THE FOX CHASE.

How completely the Cover and Furze they draw,
Who talks of Berry or Meynell.
Young Surrr he flourishes now through the show;
And Saucebox roars out in his kennel.
Away we fly as quick as thought,
The new sown ground soon makes them fault;

Cast round the sheeps train, cast round, cast round,
Try back the deep lane, try back, try back.
Hark I hear some hounds challenge in yonder spring sedge,
Comfort Bitch hits it off in that old third hedge.
Hark forward, hark forward, have at him my boys,
Hark forward, hark forward, Zounds don't make a noise.

Most respectfully Dedicated to the Gentlemen in the Quorn Hunt. By their Obliged, & humble Servant, Rudolph Ackermann.

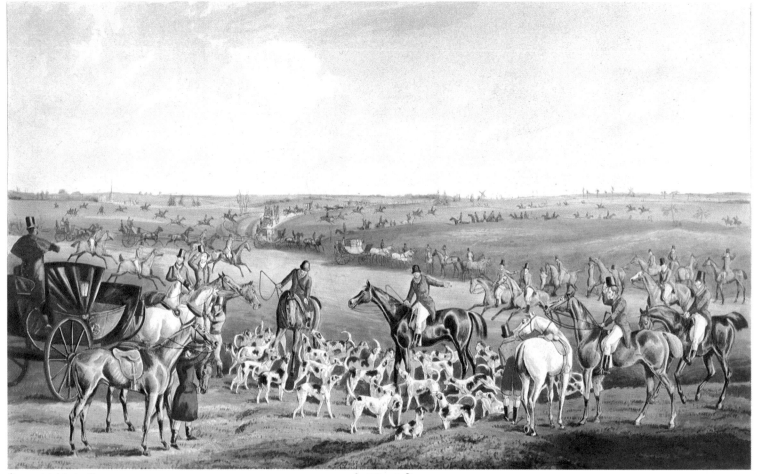

Jack Stevens Mr Osbaldeston

The Meet.

Let us suppose ourselves at Ashby Pasture in the Quorn country with Mr Osbaldeston's hounds. Let us indulge ourselves with a fine morning, in the first week of February, and at least two hundred well mounted men by the covers side. Time being called, say a quarter past eleven, nearly our great-grandfathers dinner hour, the hounds approach the gorse. Vide Quarterly Review N VIII Page 218.

London Published 1 st Feb 1835 by RUDOLPH ACKERMANN at his ECLIPSE Sporting Gallery 191 Regent Street.

PLATE 56

THE QUORN HUNT, Plate I: The Meet

F.C. Lewis after Henry Alken, 1835, *coloured aquatint with etched outline*, 32 × 52 cm. ($12\frac{1}{2}$ × $20\frac{1}{2}$ in.)

The Quorn Hunt set consists of eight plates, drawn and etched by Henry Alken, the aquatint shadowing put on by F.C. Lewis, illustrating an article by Nimrod (C.J. Apperley) in *The Quarterly Review*. It is one of the best and most famous sporting sets.

The Meet is at Ashby Pasture, Leicestershire, under the Mastership of George Osbaldeston, 'The Squire', with Jack Stevens, his huntsman, although the Squire hunted his own pack and always wore a cap like the professionals, instead of a tall hat (see plate 38).

Strictly speaking, he was no longer the Master in 1835, having gone to the Pytchley, but Nimrod was dreaming of one of those long straight runs, sometimes 20 miles or more, like the 'Bilsden Coplow Day' (plate 35), when the fox became 'gallant Reynard', toasted after dinner, instantly translated at the end of a run, like the Trojan warriors, from a mortal to a god.

'Let us suppose', says Nimrod, 'a fine morning in February, two hundred well-mounted men by the cover's side . . . approach the gorse.' A gorse (or whin) cover did not provide so much protection to the fox as a wood.

PLATE 57

THE QUORN HUNT, Plate V: Snob is Beat

F.C. Lewis after Henry Alken, 1835, *coloured aquatint with etched outline*, 32 × 52 cm. ($12\frac{1}{2}$ × $20\frac{1}{2}$ in.)

Here we have several of the best-known riders of the day: Mr Holyoake, Captain Ross, Mr White – and Snob. While the others still fly over obstacles on the fresh horses brought by grooms, poor Snob's only horse is blown, so that he is reduced to opening a gate!

'Who is poor Snob?' is often asked, and there is no doubt he is one of the poorer class, encouraged, it must be said, by the wealthy dilettanti to join in, so long as they did not speak out of turn. The local farmers all rode to hounds, and sometimes sold their horses at handsome prices. There was even 'a sporting sweep', and a follower of the Beaufort, who 'could not vote' for a fellow-huntsman, 'because I always 'unts with the Duke.' Or a 'horse-dealer's cad', who collided with the Squire and knocked him flat on his back. Yet again, there was the Hunting Tailor, always on foot, who is shown in one of Henry Alken's prints, running beside the galloping Lord Segrave towards a fence, shouting, 'I say, my Lord, it is only you and I can take this. There's a devil of a yawner on the other side!'

Surtees would, no doubt, have equated Snob with his Peter Pigskin, a postilion to the Duke of Blazington, who left him £20 a year, whereupon he married the head housemaid and took the Fox and Hounds, selling out to the railway at three times its worth and retiring to spend his days hunting. 'One day riding down Regent Street, his horse fell and he was carried insensible into Ackermann's, where the publisher gave him a set of The Quarterly Review Hunt, by Alken after Apperley [i.e., The Quorn] on his recovery.'

Captain Ross is riding his famous horse Clinker, against which the Squire matched his Clasher for a thousand sovereigns (see plate 23).

THE QUORN HUNT.
PLATE V.

Most respectfully Dedicated to the Gentlemen in the Quorn Hunt, by their obliged, & humble Servant, Rudolph Ackermann.

191 Regent Street

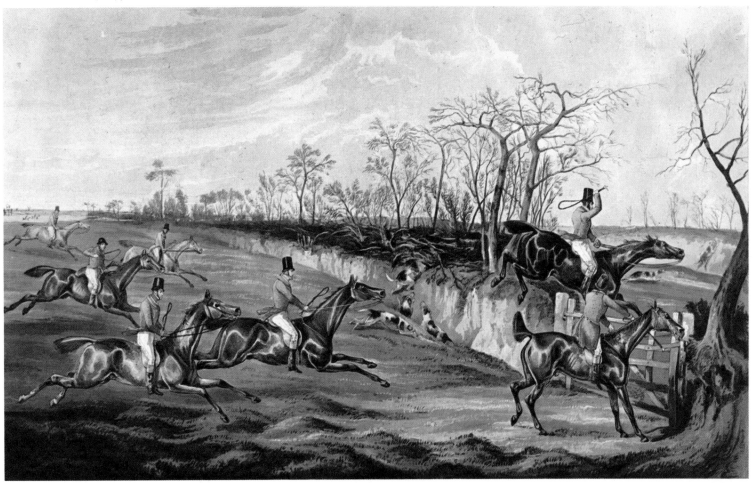

Etched by H. Alken.

Mr Osbaldeston. Mr Holyoake. Capt.n Ross Mr White. Snob.

"Snob" is beat!

'Snob' all this time has gone quite in the first flight, and is here in the best of company. Wishing however to cut Wood Wood, and to have a clue story to tell when he gets home, he pushes to his speed on ground in which all Leicestershire men are careful, and the death warrant of the little bay horse is signed. It is true he gets first to the gate, and has no idea of opening it, as it contains two new and strong bars that will neither bend nor break; has a great idea of a fall, but no idea of refusing; presses his hat firmly on his head, and gets his whip hand at liberty to give the good little nag a refresher, but as at once he perceives it will not do. When attempting to collect him for the effort he finds his mouth dead and his neck still; fancies he hears something like a wheezing in his throat, & discovering quite unexpectedly, that the gate would open places the hook of his whip under the hatch, just as John White goes over it close to the hinge-post, and Capt.n Ross, upon Climber, follows him. Vide Quarterly Review, N.º XCIII page 238.

London, Published Feb.y 1835, by RUDOLPH ACKERMANN, at his ECLIPSE Sporting Gallery, 191 Regent Street.

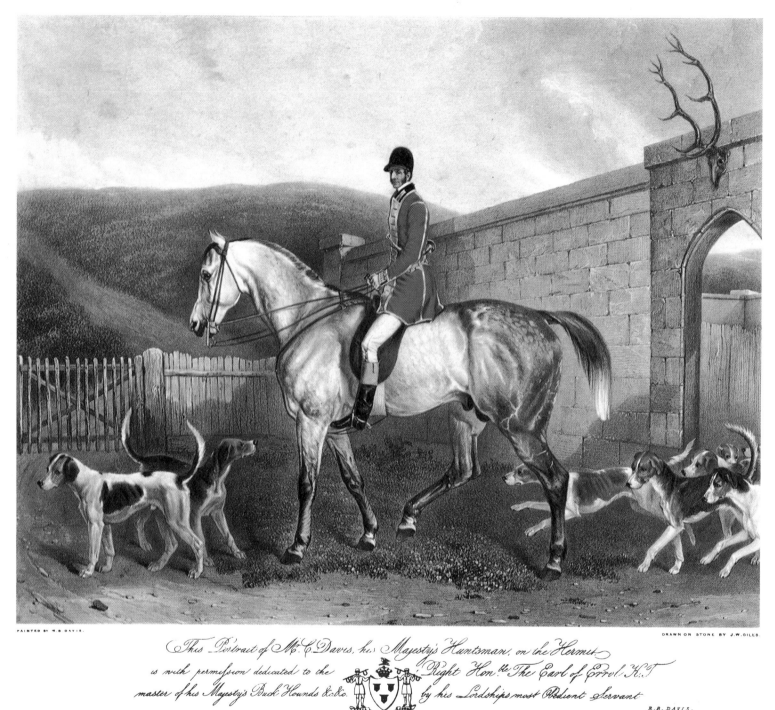

PAINTED BY R.B DAVIS.

DRAWN ON STONE BY J.W.GILES.

This Portrait of Mr. C. Davis, his Majesty's Huntsman, on the Hermit,
is with permission dedicated to the Right Honble The Earl of Errol, K.T.
master of his Majesty's Buck Hounds &c &c. by his Lordships most Obedient Servant

Printed by J. Graf

R.B.DAVIS.

PLATE 58

CHARLES DAVIS, His Majesty's Huntsman, on Hermit

J.W. Giles after R.B. Davis, 1836, *coloured lithograph*, 33 × 42 cm. (13 × 16½ in.)

Charles Davis was appointed huntsman to the Royal Buckhounds in 1822, a post his father Richard Davis had held before him. One of his eight brothers and sisters, Richard Barrett Davis, became a well-known sporting artist, and painted this picture, with others of professional huntsmen, published as a series of sixteen, entitled *The Hunter's Annual*, from 1836 to 1841.

Earlier, Charles had been a pistol boy, one of two boys who always accompanied King George III with loaded pistols when he hunted. He grew to be 6 ft. 1 in. tall, but weighed only a little over 125 lbs: grave, frugal, an ascetic, gentlemanly in appearance, manner and conversation, whose hounds appeared to love him. 'Let them alone', was his advice to the whips if the hounds lost the scent, and when they caught up with the stag he had to be near enough to rescue it.

In 1832 they chased a stag named 'Richmond Trump' for 20 miles in one hour, when Davis rolled with it into a ditch and lay there with his arm round the beast's neck until help arrived.

A bad fall in his seventy-sixth year compelled him to resign.

From a print in the collection of Mr and Mrs Paul Mellon

PLATE 59

THE MELTON BREAKFAST

C.G. Lewis after Sir Francis Grant, 1839, *coloured mezzotint*, 46.5 × 72 cm. (18½ × 28⅓ in.)

The scene is a room possibly in the New Club, formerly Lord Alvanley's house in Melton Mowbray, with, from left to right: Massey Stanley, the Earl of Wilton, the Count Matuchevitch, Lord Gardner, W.L. Gilmour, T. Stevens, Sir Frederick Johnstone, Lord Rokeby, Lord Forester, Lord Kinnaird, Rowland Errington, Mr Errington's servant.

Visitors to Melton for the hunting season – those who were not guests at the big houses – stayed at the clubs and inns; some maintained their own houses in the town. Here are a few of these 'Meltonians', often reviled by Squire Osbaldeston for their reckless riding near hounds and gently ridiculed by Henry Alken as 'The Few', 'The Right Sort', 'The Real Meltonians'.

The Squire said, 'One of their maxims was rather spoil a run than not get a start; and the consequence was that they spoiled many. The greatest mischief is done when hounds first go away, because they are under great excitement and don't settle to their work instantly, and then the Meltonian system of "getting a start" frequently proved fatal to their settling at all.'

Alken, in his set of six prints, *How to Qualify for a Meltonian*, said, 'never ride at less than 16 miles an hour'. They discarded the frock coat, but, when going to cover, wore overalls to protect their breeches and polished boots. 'I shall not be surprised in the course of another season to see them (if they are not extinct) dressed in silk caps and jackets.'

The artist who painted this picture, Sir Francis Grant, later President of the Royal Academy, was himself a follower of hounds in his younger days, and Dick Christian said he took 'a monstrous lot of beating across country yet, for all his weight'. He had his first lessons from the Melton artist John Ferneley, and chose to be buried there rather than in St Paul's.

From a print in the collection of Mr and Mrs Paul Mellon

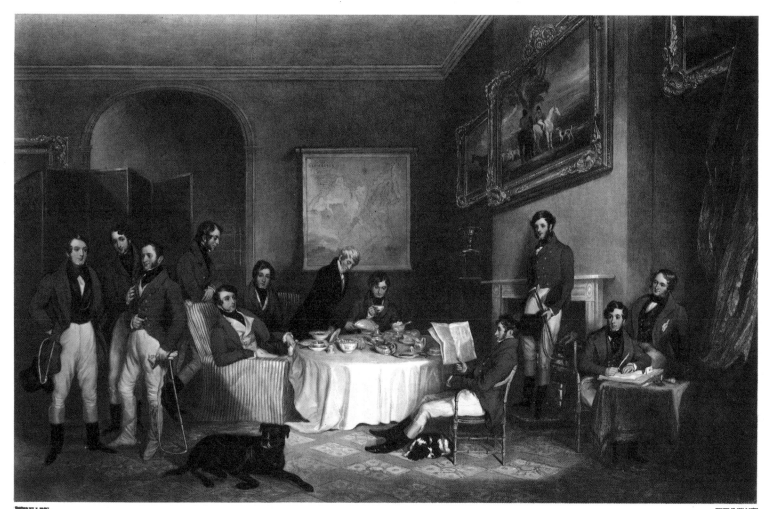

THE MELTON BREAKFAST.

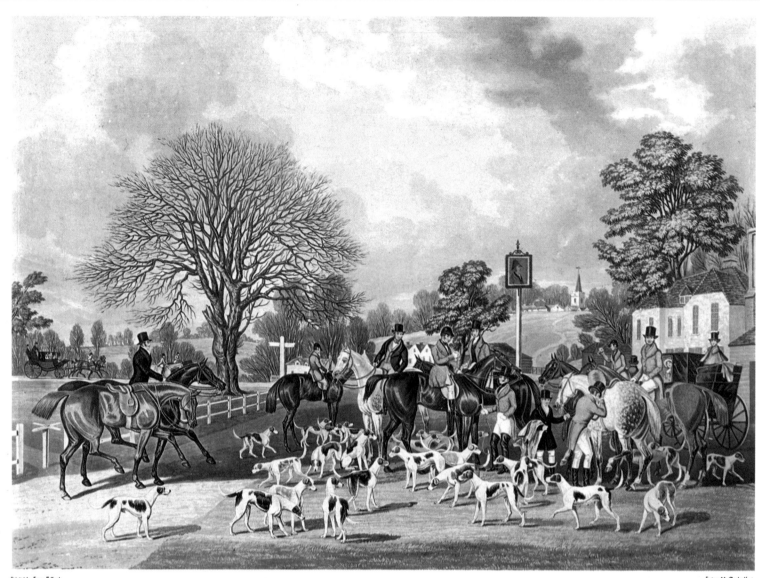

Painted by James Pollard.

Engraved by Charles Hunt.

Now the time has arrived
Lets hasten away

FOX HUNTERS MEETING.

To find a Game Fox
And have a Good day.

PLATE 60

FOX HUNTERS MEETING

Charles Hunt after James Pollard, 1840, *coloured aquatint with etched outline*, 40.5 × 55.2 cm. (16 × 21¾ in.)

Plate I of a set of four Fox Hunting scenes, painted by Pollard in 1839, the engravings published in 1840.

The picturesque old inn has the appropriate sign of the Duke of Wellington, who was a warm patron of hunting, supporting the Vine Hunt, even keeping a pack of hounds in Spain during the Peninsular War, under Tom Crane, who at least once found himself within firing distance of the enemy. Nevertheless, an authority on the subject said the Duke was not a very good horseman, and could not prevent his mount turning its back on King George IV at his coronation. Copenhagen, the charger he used at Waterloo, was a racehorse with several victories to its name, which afterwards spent a pleasant retirement in the grounds of Strathfieldsaye.

In the year these pictures were painted, Delmé-Radcliffe laid down the rule that the place of meeting should not be too near the cover to be drawn. No one should ride by it 'before the hounds are thrown off, as a very old fox is easily disturbed'.

The central dismounted figure, who appears to be treating the huntsman to a stirrup-cup, is wearing an unusual kind of top-boot of a military pattern, reaching over the knees and probably affording some protection when jumping through a 'bullfinch' hedge.

Nimrod, in his *Hunting Tours*, speaks of the prominent Meltonian, Lord Alvanley, wearing such boots when hunting with the Quorn: 'Lord Alvanley's return to Melton Mowbray has been hailed as a happy omen of perpetuating the renown of Leicestershire as a hunting country... His appearance and costume in the field also amused me much. He wears what may be compared to the regulation jack-boot of the Royal Horse Guards Blue, the top of which reaches considerably higher than the knee, and doubtless protects him from the thorns and blows he would otherwise receive in cramming through the rough Leicestershire fences of which he is anything but shy.' He is to be seen wearing unusual boots in Alken's *Quorn Hunt*.

When in London, Lord Alvanley became the lisping Regency dandy, who succeeded Beau Brummell as the arbiter of fashion, and fought a duel on Wimbledon Common with a Member of the House of Commons for calling him a 'bloated buffoon'.

PLATE 61

THE YOUNG ENGLISH FOX HUNTER, Plate III

Charles Hunt after F.C. Turner, 1841, *coloured aquatint with etched outline*, 40 × 60.5 cm. $(15\frac{3}{4} \times 23\frac{3}{4}$ in.$)$

Sir Bellingham Graham, later famous in the hunting field, as a young man was described by the Earl of Darlington as 'riding conspicuously and well'. To keep up with the hounds and be in at the kill often required a great deal of skilful and fearless riding (and more than one horse) even from the most experienced huntsmen, with a lot of luck thrown in. The quarry did not necessarily run in a straight line, so that the stragglers would sometimes be in at the death, with most of the hard-riders still a long way behind.

Some, too infirm or old to jump, would follow by road, using foresight and experience to gauge the direction the fox would take. Nimrod speaks of the veteran John Corbet, 'Never having been what is called a straight forward rider . . . the extraordinary manner in which he and some others would contrive to keep . . . in wake of the hounds without ever taking a fence . . .' One man, at least, is known to have followed by road in a gig.

The ceremony of 'treeing the fox' was becoming obsolete at this time.

From a print in the possession of Dieter Dent, Esq.

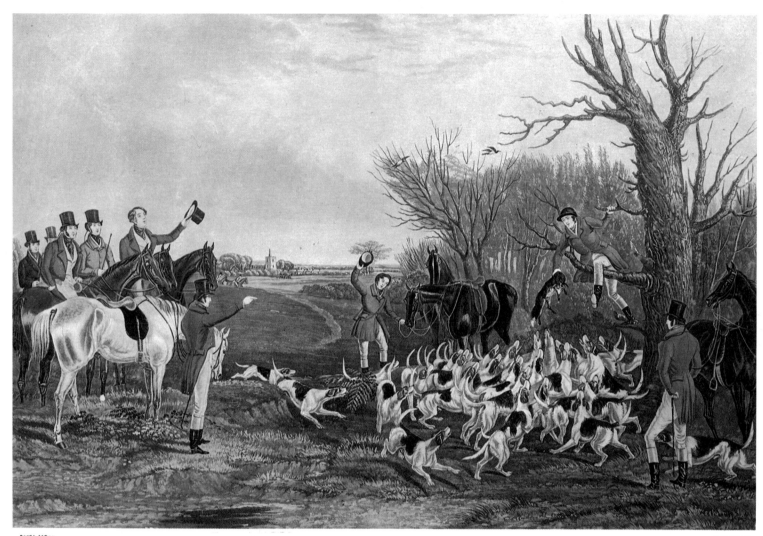

Painted by J C Turner

Engraved by L Stock

THE YOUNG ENGLISH FOX HUNTER.

O'er hedge and ditch, o'er hill and dale,
He thinks his steed can never fail:
Yet, far in view he tries

Swift at his heels the well tried pack
Invade at last sly Reynard's back,
Whil'st horns resound, he dies.

PLATE 3.

THE DEATH.

LONDON 1841 PUB.D BY W. LAIRD, LEADENHALL ST

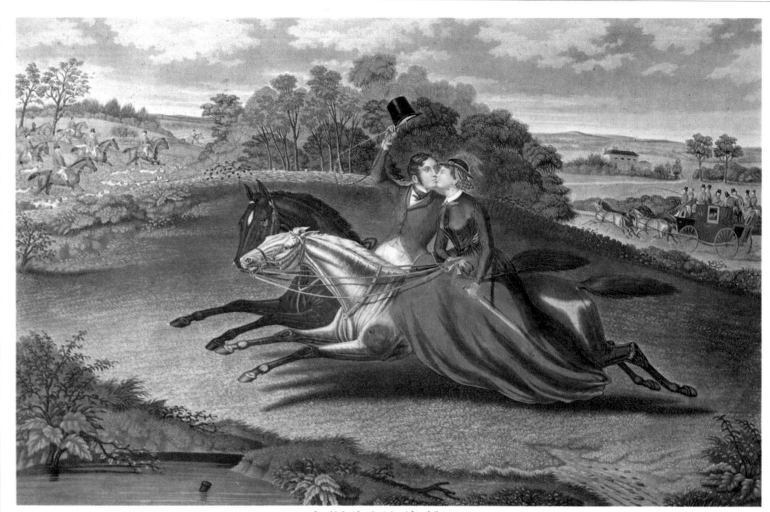

Engraved by Hunt & Sons from the Original Picture by Hunt, Sen.

THE BELLE OF THE HUNT.

Published Feb 1ˢᵗ 1856 by G. Shier 38 Halton S. Covent Garden

PLATE 62

THE BELLE OF THE HUNT

Hunt & Sons, 1866, *coloured aquatint with etched outline*, 51 × 80 cm. (20 × 31½ in.)

This print is more an example of acrobatic equestrianism than a serious hunting incident, the two partici-
pants showing a sublime indifference to the hunt, indeed going in the opposite direction. It is, however,
interesting because it shows ladies riding to hounds, who for fifty years, in sporting prints, had only been
seen in carriages.

From the time of Rowlandson, or the earliest days of the nineteenth century, no ladies are shown in prints
attending hunt meetings on horseback, until just before Herring's fox-hunting scenes of the 1850s, although
Nimrod, writing in 1825, says, 'There was to me, and indeed it must have been to everyone, a very agreeable
sight on this day in the field. This was Mrs Shakerley (the lady of Mr Shakerley, jun., of Somerfield Hall,
Cheshire), upon her beautiful, I might almost say superb, horse the Golden Ball. Mrs Shakerley is a French
lady of high birth, and certainly the most graceful horse-woman I ever saw upon a horse: the lady Eveline
herself, on her white palfrey, could not have excelled her. Her hand, as well as her seat, is quite perfect,
and I understand she has gone very well once or twice in Leicestershire.'

On another occasion he says, 'ladies were often of the party, though they never quitted the carriages.'
And again, 'met at Kettleby, where at least 300 horses were assembled, with a pretty sprinkling of ladies.'
There is a print after F.C. Turner of the late Mrs Georgiana Theobald in 1846, flying over a gate which
a gentleman is trying to open for her, saying 'By your leave, gentlemen'.

In spite of the respectability that had been given to huntresses by the Countess of Salisbury and later by
the Empress of Austria on a visit to England, it appears that one or two 'frail ladies' had flaunted their
equestrian charms, so that few but married women of unassailable reputations dared appear at cover, except
in carriages.

By virtue of date this print might even represent the delectable Lucy Walters (Skittles), who not only
curveted in the Park, but started to ride with the Quorn, till warned off by Lord Stamford at the insistence
of his wife. 'I don't know', complained Skittles, 'what right Lady Stamford has to object to me. She's not
even head of our profession; Lady Cardigan is.' Lady Stamford herself, at the time of her marriage, had
been a member of a highly respectable profession, a circus equestrienne. Lady Cardigan, the Earl's second
wife, survived him fifty years and published her 'outspoken' *Recollections* in 1909.

PLATE 63

PARTRIDGE SHOOTING

C. Catton after George Morland, 1789, *stipple engraving, printed in colours*, 30.5 × 37 cm. (12 × 14½ in.)

George Morland (1763–1804) spent most of his brief life working furiously to free himself from debts incurred through improvidence.

 This example of Partridge Shooting is one of a series of shooting subjects after Morland and J.C. Ibbetson, and shows the sportsman priming the pan of his flintlock from a powder flask. The dogs with him are pointers, whose chief duty was to find the game on the ground by scent and then 'stand' or 'come to a point', but they could, as in this instance, also be trained to act as retrievers.

From a print in the collection of Mr and Mrs Paul Mellon

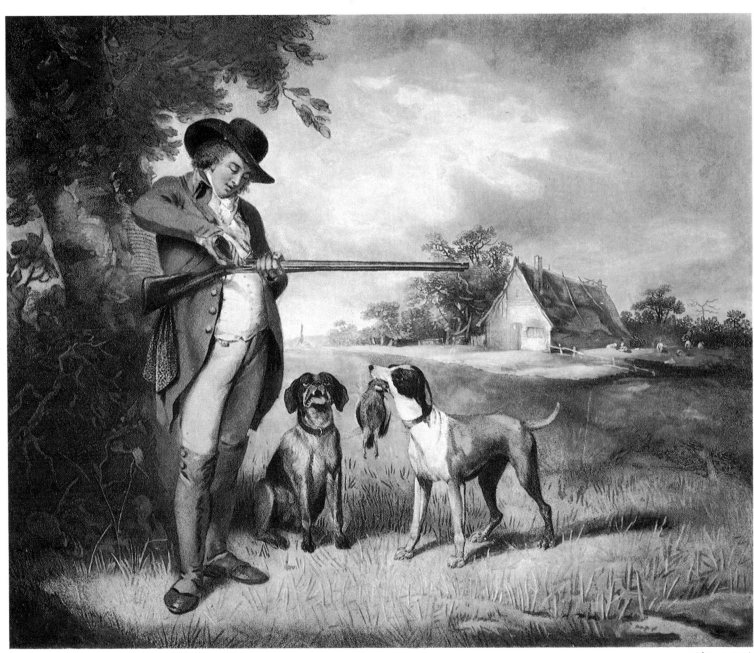

G. Morland pinx. E. Catton jun. fecit

PARTRIDGE SHOOTING

London. Pub. Feb. w. 1789 by T. Smith N.º 35 New Bond Street.

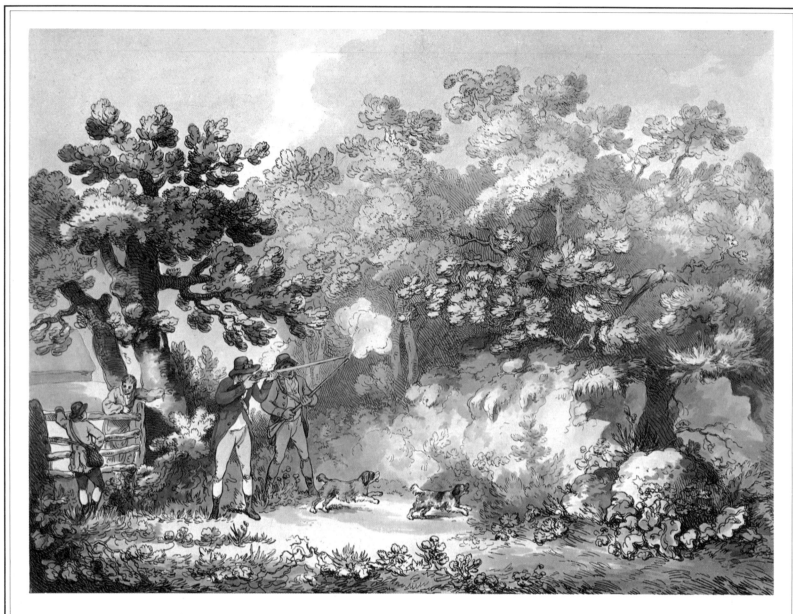

PHEASANT SHOOTING.

PLATE 64

PHEASANT SHOOTING

Thomas Rowlandson after George Morland, 1790, *coloured etching*, 37 × 49.5 cm. ($14\frac{1}{2}$ × $19\frac{1}{2}$ in.)

This illustration is taken from a very rare proof before an aquatint grain was added to the plates by Samuel Alken, father of the noted Henry Alken; it is one of a set of four, a collaboration by two brilliant, if sometimes disreputable geniuses, Morland and Rowlandson. A puff of smoke comes from the pan as well as the barrel, although there is said to have been an almost perceptible pause between the pulling of the trigger and the explosion of the charge, in these old muzzle-loading flintlocks.

The bird flies serenely on, but such celebrated shots as Colonel Thornton, Captain Ross and Squire Osbaldeston rarely missed. The Squire in his *Autobiography* claimed to have bagged 100 pheasants with 100 shots in one day, when shooting with Sir Richard Sutton; and, in Scotland, 97 grouse with 97 shots, twice killing two birds with one barrel – virtually 95 hits out of 97. In Yorkshire he claimed 40 partridges with 40 shots, never missing one. These exploits were done with a flint and steel of 18 bore. When pigeon-shooting the Squire used a gun with $1\frac{1}{2}$ inch bore!

Both Captain Ross and the Squire were expert pistol shots as well, the latter scoring ten hits out of ten on the ace of diamonds at twenty paces. Captain Ross hit a black wafer stuck on a playing card 155 times out of 300 at 14 yards, missing the card only twice.

From a print in the possession of Peter de Vink, Esq.

PLATE 65

THE RETURN FROM SHOOTING

Francis Bartolozzi and Samuel Alken after Francis Wheatley, the figures being engraved in stipple by Bartolozzi and the landscape in aquatint by Samuel Alken, 1792, *printed in colours*, 47 × 62 cm. ($18\frac{1}{2}$ × $24\frac{1}{2}$ in.)

The second Duke of Newcastle is shown with Colonel Litchfield; Mansell the keeper is coupling two spaniels, Day the under-keeper is putting game into a sack, and the Duke's valet Rowlands is on the extreme right. Clumber House is in the background, and the spaniels are of the Clumber breed, the forbears of which were given to the Duke on a visit to France in 1775 by the Duc de Noailles.

This print was reissued without the dedication to the Duke of Newcastle, the Garter Star being removed, so that it became a general sporting print, with a companion plate *The Return from Hunting*, after William Hamilton.

From a print in the collection of Mr and Mrs Paul Mellon

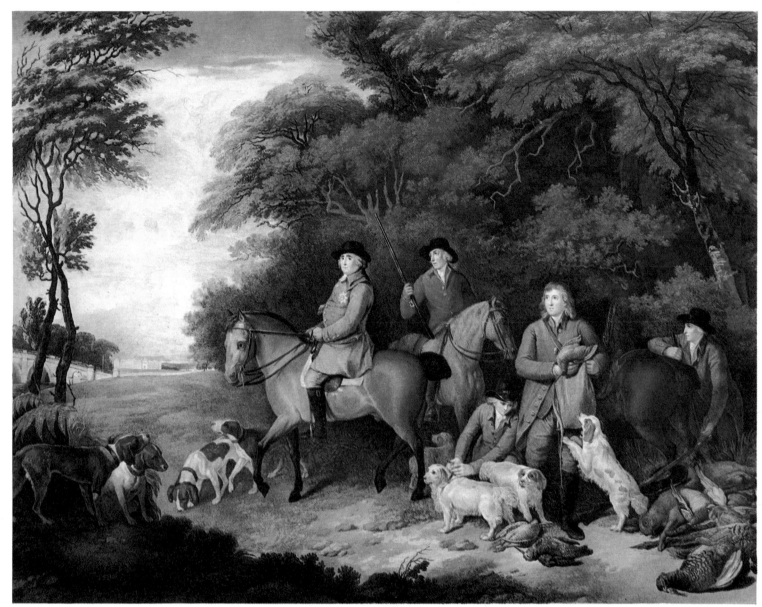

TO HIS GRACE THE DUKE OF NEWCASTLE THIS PRINT OF THE RETURN FROM SHOOTING.

Is by Permission dedicated by his Grace's *most obliged & most humble Servant*

Francis Wheatly.

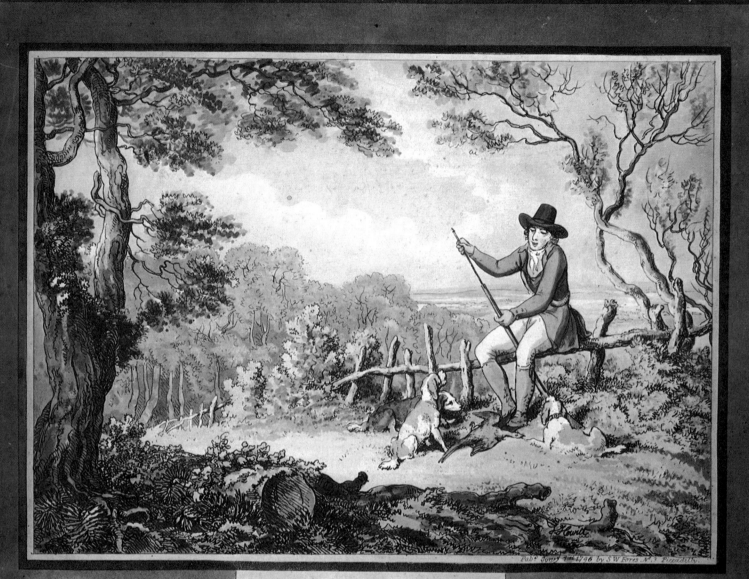

Pub.d Jan.y 1.st 1796 by S W Fores N.o 3 Piccadilly

PHEASANT SHOOTING.

PLATE 66

PHEASANT SHOOTING

By and after Samuel Howitt, 1796, *coloured aquatint with etched outline*, 18.5 × 26 cm. ($7\frac{1}{4}$ × $10\frac{1}{4}$ in.)

Samuel Howitt (*c.* 1765–1822) was brother-in-law to the famous Thomas Rowlandson, whose influence can distinctly be seen in this print. Howitt had exquisite taste and produced the designs for some of the best sporting prints, including the famous set of twenty, published by Edward Orme, and known as 'Orme's British Field Sports'. With Rowlandson and George Morland, Howitt was responsible for some of the earliest of the coloured sporting prints.

In this plate the sportsman is using his ramrod in the laborious process of reloading: first the powder, then a wad is rammed down, next the shot, then another wad pushed down by the ramrod: afterward the priming. The dogs are spaniels, employed to flush the game into the air and retrieve it when brought down.

From a print in the possession of Dieter Dent, Esq.

PLATE 67

MYTTON WILD DUCK SHOOTING

Edward Duncan after Henry Alken, 1835, *coloured aquatint with etched outline, 8 vo.*

This is an illustration to *The Life of John Mytton*, written by his friend, the sporting writer Nimrod (C.J. Apperley). It shows Mytton on the ice, clad only in his nightshirt, shooting duck. Mytton was said to be half mad without drink and quite mad with it.

For the portrait of John Mytton, see plate 7.

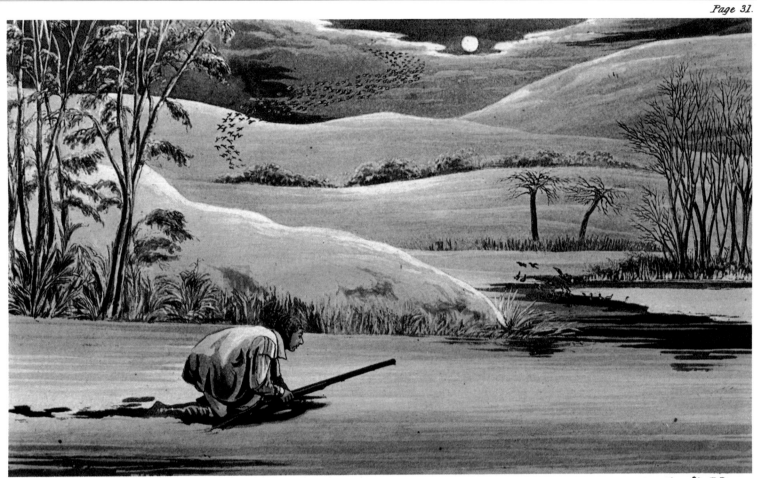

Drawn & Etched by H. Alken.

Aqua.ᵗ by E. Duncan.

Mytton wild duck shooting.

Pubᵈ Novʳ 1, 1850, by R. Ackermann at his Eclipse Sporting Gallery _ 191 Regent Street.

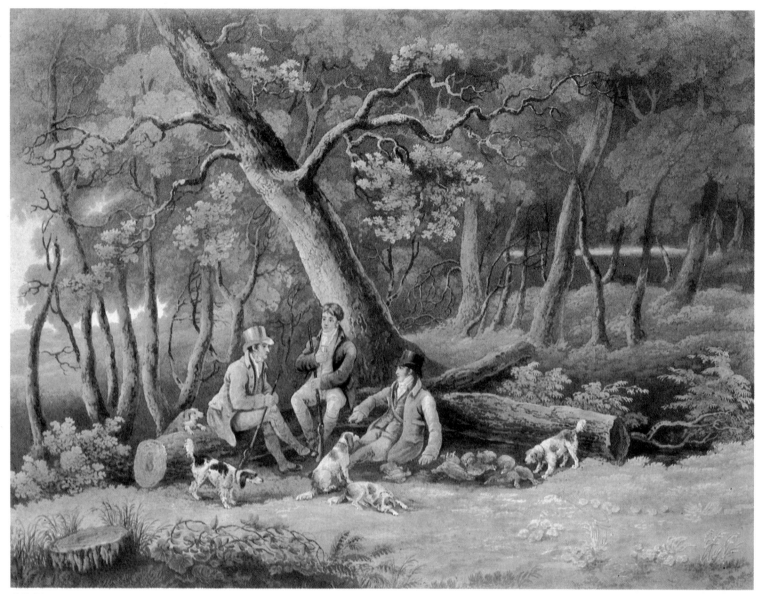

H Alkin Delt. R Reeve sculp.

N.º 2 The Repast

Published May 1ᵗ 1813 by S & J FULLER at the Temple of Fancy, Rathbone Place London.

PLATE 68

SHOOTING: The Repast

R.G. Reeve after Henry Alken, 1813, *coloured aquatint with etched outline*, 34.5 × 45.5 cm. (13¾ × 18 in.)

The Repast is one of a set of four shooting subjects, published in 1813, the earliest of all Alken's sets, apart from four similar fox-hunting scenes, issued in the same year.

The two sportsmen, with a gamekeeper, are taking their noonday refreshment, accompanied by their spaniels. Considering that they were probably up at dawn, the bag looks lamentably small.

From a print in the possession of Peter de Vink, Esq.

PLATE 69

SHOOTING. Plate I, Going Out

Thomas Sutherland after Dean Wolstenholme, 1823, *coloured aquatint with etched outline*, 25.5 × 32 cm. (10 × 12½ in.)

Two sportmen passing or leaving a thatched house in the early morning, probably for partridge, as they are taking pointers with them.

They are still in the days of the flintlock; though the percussion cap had been invented some years before, it did not come into general use for some time, the army adopting it in 1839.

From a print in the collection of Mr and Mrs Paul Mellon

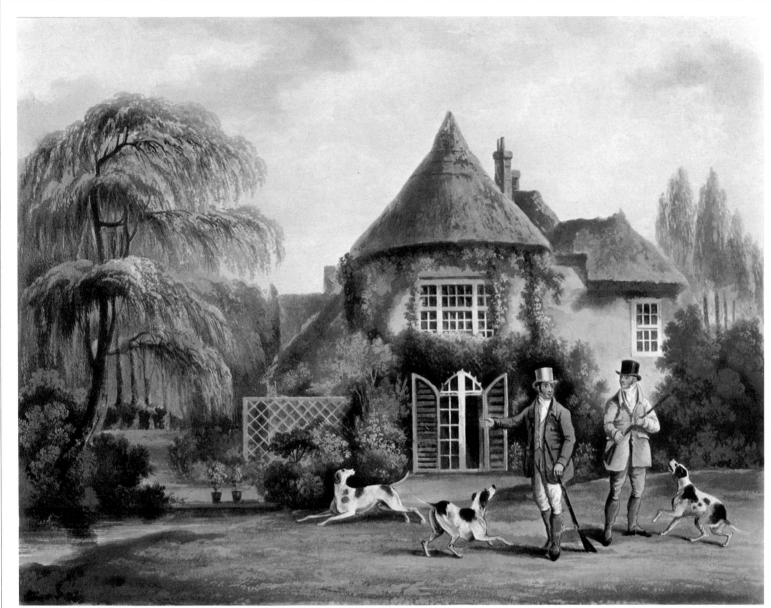

Painted by D. Wolstenholme. London, Published at R. ACKERMANN's, 101 Strand, May 1 1825. Engraved by T. Sutherland.

SHOOTING. PLATE I.

Going out.

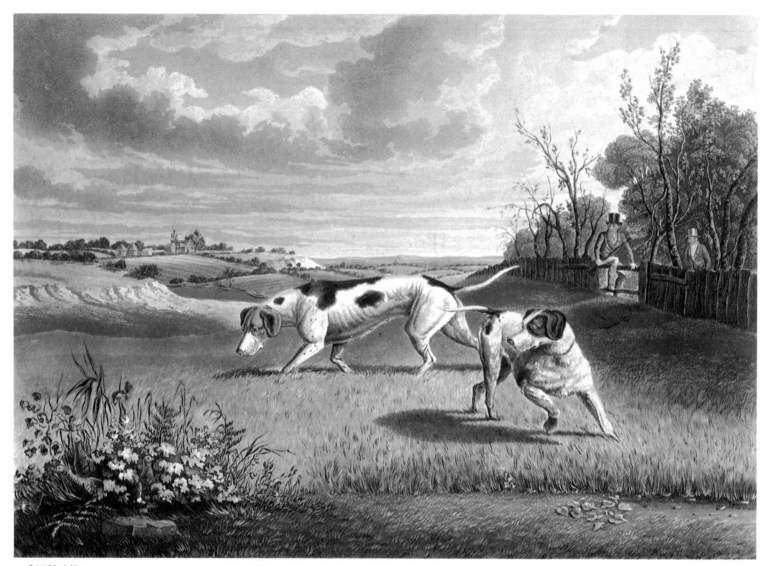

Painted by S. Alken.

London, Published by J. Moore, at his Looking Glass & Picture Frame Manufactory, N.º 1, West St. Upper St. Martins Lane.

Eng.ᵈ by G. Hunt.

PARTRIDGE SHOOTING.

PLATE 70

PARTRIDGE SHOOTING

George Hunt after Samuel Alken, *coloured aquatint with etched outline*, 27 × 38 cm. (10⅔ × 15 in.)

One of a pair after the younger Samuel Alken, brother of Henry. Two pointers are 'standing' at a covey of partridges on the left, careful not to flush the game, while a sportsman and a gamekeeper cautiously emerge from a wood on the right.

The pointers are evidently a variety crossed with foxhound, similar to the celebrated 'Dash' belonging to the eccentric Colonel Thornton, which was bred from a rather small pointer bitch and a foxhound, and in his appearance indicated his relationship to the latter in a very preponderating manner.

We are told that he was sold for £160 worth of champagne and burgundy, a hogshead of claret, an elegant gun and a pointer.

From a print in the collection of Mr and Mrs Paul Mellon

PLATE 71

PARTRIDGE SHOOTING

Charles Bentley after Henry Alken, 1835, *coloured aquatint with etched outline*, 21.5 × 27.5 cm. (8$\frac{1}{2}$ × 10$\frac{7}{8}$ in.)

Plate IV of a set of four, all of partridge shooting. The group here consists of a sportsman, a gamekeeper and three dogs, two of which are pointers, the third a setter, employed in this case as a retriever.

From a print in the possession of Walter Urich, Esq.

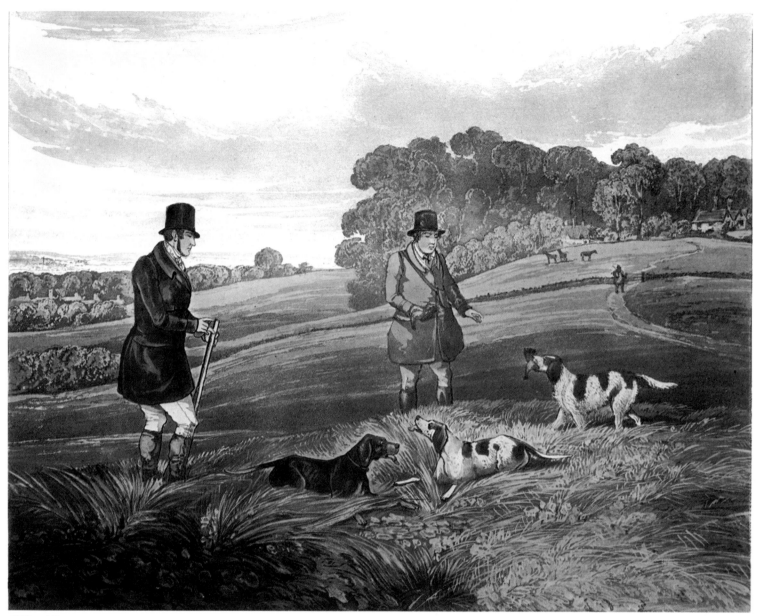

PARTRIDGE SHOOTING.

Plate. 4.

London Pub.d April 6 1836 by S & J. FULLER, at their Sporting Gallery 34. Rathbone Place.

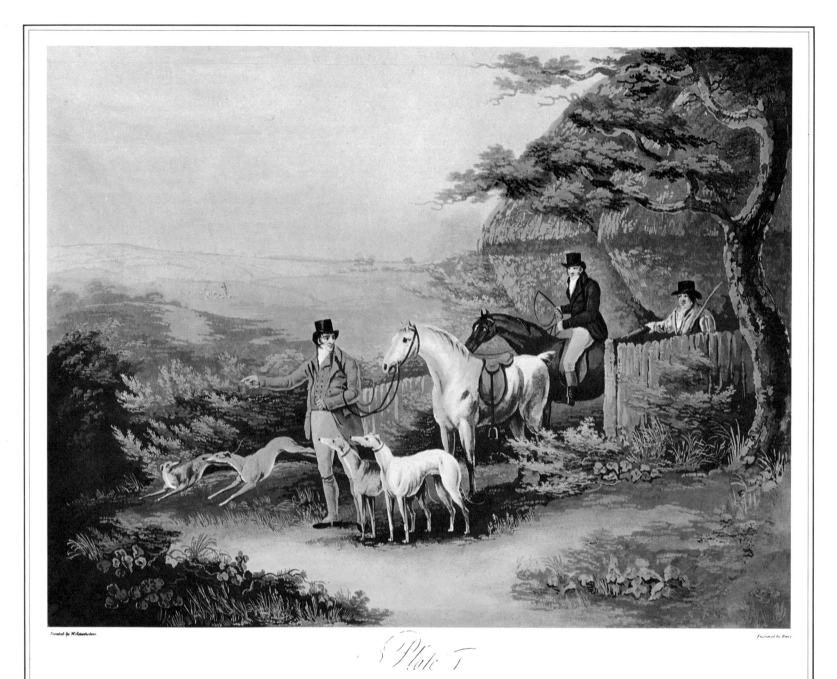

Plate I

PLATE 72

COURSING, Plate I

R.G. Reeve after Dean Wolstenholme, 1807, *aquatint*, 42 × 55.5 cm. (16½ × 21⅞ in.)

Coursing with greyhounds is known to have been practised by the Greeks and Romans, and public meetings to have taken place in England in Jacobean times. This, however, looks like an occasional outing by two local farmers 'for the pot' almost as much as for the sport.

Greyhounds hunt by sight, and the man in the smock may be the beater, to put up the hares.

For a proper competition there would need to be an umpire on horseback and a neutral man to hold each pair of hounds in leash until they had both seen the quarry.

From a print in the collection of Mr and Mrs Paul Mellon

PLATE 73

FLY FISHING

George Hunt after James Pollard, *coloured aquatint with etched outline,* 34.5 × 44.5 cm. (13½ × 17½ in.)

Pollard painted a series of views on the river Lea, with anglers, the prints of which are very rare when taken from the unworn plates. Some of them show the old fishing inns, and this has been identified as Tottenham Mills, which was also drawn by Thomas Creswick, as 'View on the Lea, Fishing-House, near Tottenham', for Walton's *Compleat Angler,* edited by John Major and published by John C. Nimmo, 1889.

According to *Angling* (1886 ?), the charge to anglers at Tottenham Mills was half a guinea for bottom fishing and a guinea for trolling.

From a print in the collection of Mr and Mrs Paul Mellon

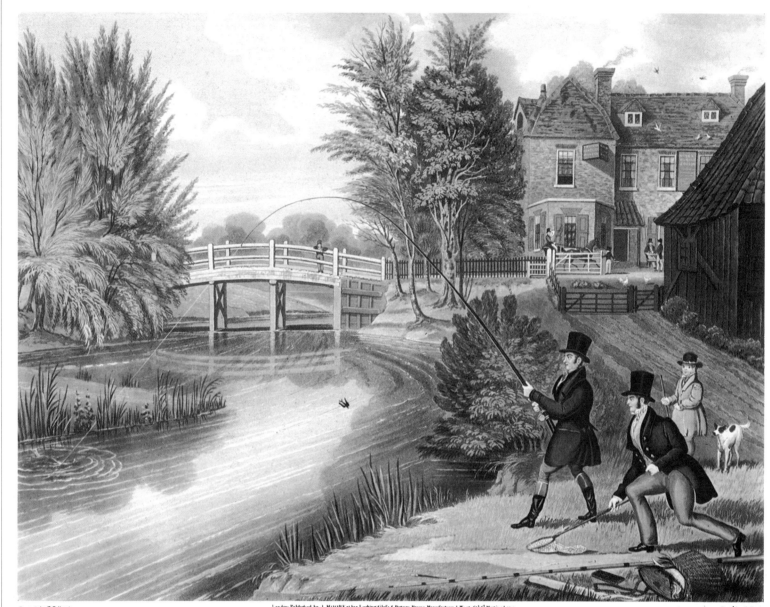

Painted by J.Pollard. London Published by J. MOORE at his Looking Glass & Picture Frame Manufactory 1.West St. St. Martins Lane. Eng.d by G.Hunt.

FLY FISHING.

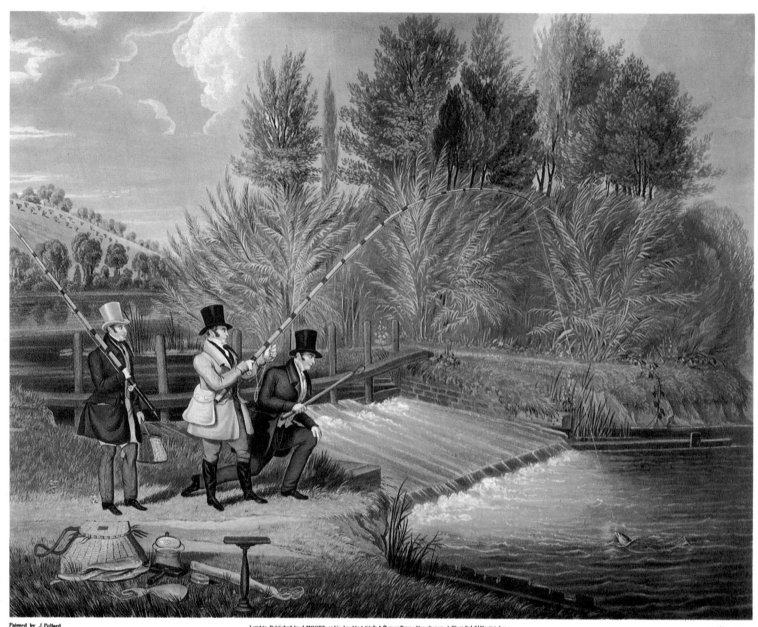

Painted by J.Pollard. London, Published by J.MOORE, at his Looking-Glass & Picture Frame Manufactory, 1 West St. St. Martin's Lane. Eng.d by G.Hunt.

TROLLING FOR PIKE.

PLATE 74

TROLLING FOR PIKE

George Hunt after James Pollard, *coloured aquatint with etched outline*, 34.5 × 44.5 cm. (13½ × 17½ in.)

Trolling for Pike is a companion plate to Fly Fishing (plate 73) and another of Pollard's views on the Lea, or on the New River, which runs parallel to the Lea in the Tottenham district.

 Both these prints are very desirable, and very valuable, when in good state.

From a print in the collection of Mr and Mrs Paul Mellon

PLATE 75

FISHING IN A PUNT

John Clark after Henry Alken, 1820, *coloured aquatint with etched outline, 23.5 × 24 cm. (9¼ × 9½ in.)*

In 1820 Henry Alken produced one of his most important works, *The National Sports of Great Britain*, a series of fifty plates, aquatinted by John Clark. Three plates are devoted to fishing, six to foxhunting and eight to shooting. Many of the sports were then already being condemned.

Although all the plates bear the 1820 imprint, it is most unusual to find the title with this date, most bearing the date 1821.

From a print in the possession of Dr Ian Murray-Lyon

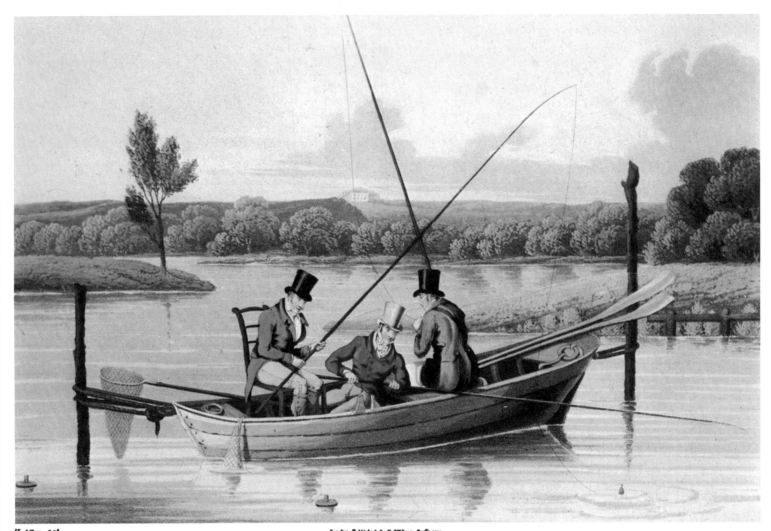

H. Alken delt. London, Published by T. McLean Nov.1, 1820. I. Clark sculp.t

FISHING in a PUNT.

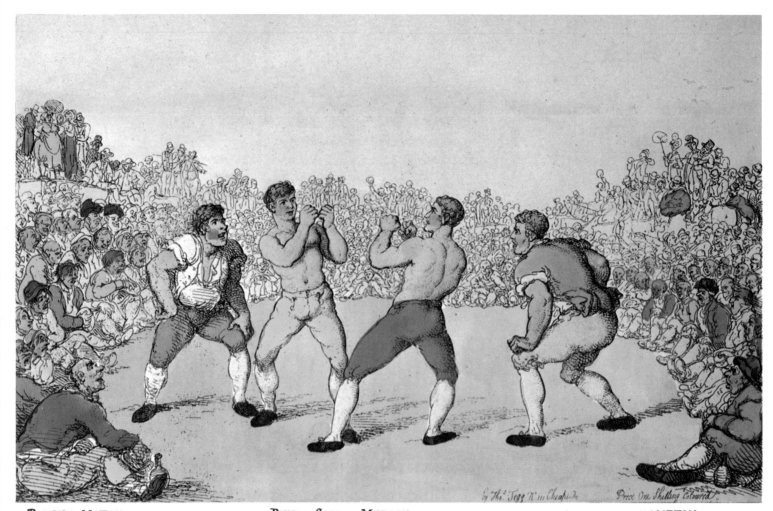

BOXING MATCH FOR 200 GUINEAS BETWIXT DUTCH SAM AND MEDLEY FOUGHT 31 MAY 1810, ON MOULSEY HURST NEAR HAMPTON

The Concourse of people exceeded any thing we have ever witnessed. The Spectators were computed at ten thousand. At one O'Clock the Champions entered the ring, and Sam had for his second Harry Lee, whilst Joe Ward officiated for Medley. after a severe and bloody contest of 40 Rounds Victory was decided in favour of Sam.

PLATE 76

BOXING MATCH for 200 Guineas, betwixt Dutch Sam and Medley fought 31 May 1810, on Moulsey Hurst near Hampton

Thomas Rowlandson, *coloured etching*, 21 × 33 cm. (8¼ × 13 in.)

> The Concourse of people exceeded any thing we have have ever witnessed. The Spectators were computed at ten thousand. At one O'Clock the Champions entered the ring, and Sam had for his second Harry Lee, whilst Joe Ward officiated for Medley; after a severe and bloody contest of 49 Rounds Victory was decided in favour of Sam.

The ring here is formed by the spectators themselves – not unusual in early days – a singularly orderly crowd, considering some accounts of fights of the period, when the backers kicked the man they wanted to lose.

Dutch Sam, a lightweight, succeeded Mendoza as so-called 'Champion of Jewry'. He was credited with inventing the uppercut, an effective blow in the clinches. He 'trained on gin' and died an alcoholic.

Ben Medley was one of several prizefighters engaged as bodyguards by George IV at his Coronation.

PLATE 77

THE INTERIOR OF THE FIVES COURT, with Randall and Turner Sparring

Charles Turner after T. Blake, 1818, *coloured aquatint with etched outline*, 46.5 × 66 cm. (18½ × 26 in.)

The Fives Court, in Little St Martin's Street, was a tennis and fives court hired for prizefighters' benefits, when exhibition sparring matches, with the 'mittens' or 'mufflers', were provided by well-known boxers, on a temporary stage.

The contestants here are Jack Randall 'The Nonpareil' and Ned Turner 'The Out-and-Outer', lightweights who fought an epic battle of thirty-four rounds on Crawley Downs in 1818, Randall winning to become the King of the Lightweights.

The print is dedicated to 'the Noblemen, Gentlemen, Patrons and Lovers of the Art of Self Defence' – in short 'The Fancy' – the first two categories viewing the proceedings from the windows on the right.

Among the spectators below are Gentleman Jackson and John Gully, the latter to become a respected Member of Parliament, both Champions of England and both painted by Ben Marshall.

Artists and sculptors sometimes attended to note the physique of the prizefighters, and it is recorded that Sir Thomas Lawrence occasionally employed Jackson as a model for the bodies of his less well endowed sitters.

The Fives Court was pulled down in 1826 for the development of Trafalgar Square.

From a print in the collection of Mr and Mrs Paul Mellon

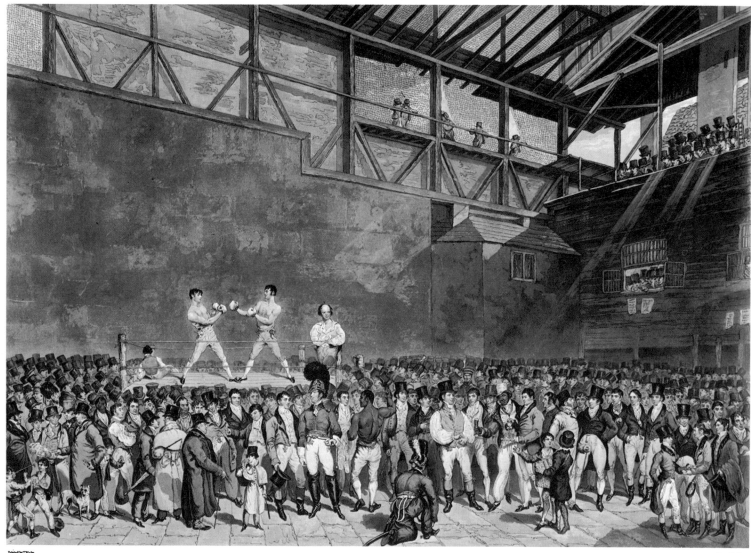

Painted by T.Blake

Engraved by C.Turner

Printed by Mc.Queen &

THE INTERIOR OF THE FIVES COURT.

With RANDALL *and* TURNER *Sparring.*

To the Noblemen, Gentlemen, Patrons & Lovers of the Art of Self Defence,

this print is Inscribed by their obliged & humble Servant, T. Blake.

London Published Sept.r 1 1819 by C. Blake, 3, Warren Street Fitzroy Square.

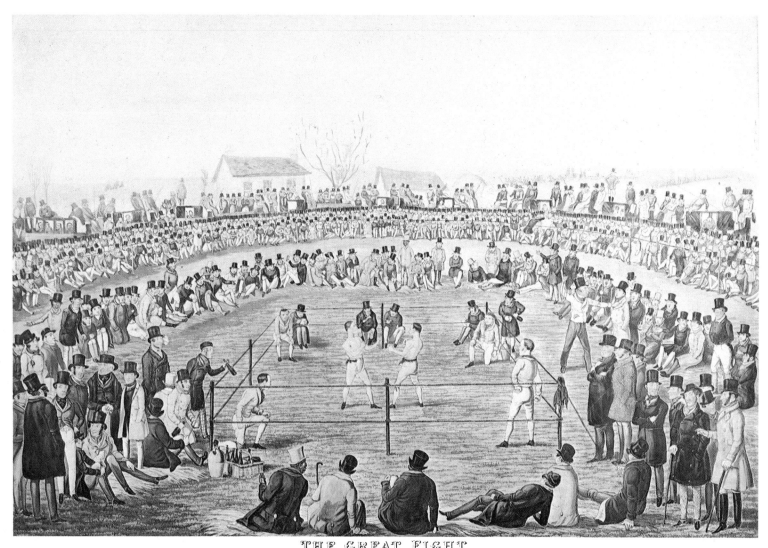

THE GREAT FIGHT
BETWEEN BROOME AND HANNAN FOR £1000,

Which took place Jan.ʸ 26ᵗʰ 1841 in the presence of Thousands of Spectators at the Park Farm, near Bicester, being on the borders of Buckinghamshire.

THE BATTLE LASTED 1 HOUR AND 19 MINUTES. 47 ROUNDS. WHEN BROOME WAS DECLARED THE VICTOR.

HANNAN stands 5ft 5in fighting wt 9st 4lbs, Born Sep.ʸ 20 1817. BROOME stands 5ft 6½ fighting at 9st 11lbs. Born March 4 1818.

This Print is dedicated to the Patrons of the P.R. as an Antidote to the Knife by their Obged Servant John Moore corner of U.S.A.P. Upper St. Martin's Lane.

PLATE 78

BROOME versus HANNAN

Charles Hunt after William Heath, 1841, *coloured aquatint with etched outline*, 46 × 66 cm. (18 × 26 in.)

This contest seems to have been of relatively minor importance in the history of boxing, although Harry Broome became Champion of England in 1851. Squire Osbaldeston in his *Autobiography* gives Harry Broome's weight as '12 st. at least', not the 9 stone 10 lbs given on the print.

We are provided with a very good idea of the formation of a prize ring under the New Rules of 1838, but before the 'Queensberry' Rules of 1866.

The ring is 24 feet square, with two ropes, the higher 4 feet from the ground; and there is an outer ring, patrolled by professional pugilists 'beating out the ring' with fists, sticks or horsewhips, to prevent the occasional breakthrough of the crowd, if the man they had backed were losing.

Only one 'beater' is visible in this print, but it is recorded that there were four at the Scroggins v. Turner fight in 1817, not surprisingly overwhelmed when the 30,000 crowd took charge.

This reproduction was made from an example kindly lent by Messrs Thomas Ross & Son, copperplate printers, who own the original plate.

PLATE 79

MR H. ANGELO'S FENCING ACADEMY

Thomas Rowlandson and C. Rosenberg, 1791, *coloured aquatint with etched outline*, 33 × 50.5 cm. (13 × $19\frac{7}{8}$ in.)

Although this print is dated 1791, it has been supposed to represent the room occupied by the famous fencing academy in the Opera House, Haymarket, destroyed by fire in 1789. Henry Angelo, in his *Reminiscences*, describes how his first thought was to rescue the portrait of Monsieur St George (another famous fencer), by Mather Brown, which hung over the chimney-piece, but while he was putting this in safety, the mob rushed in and plundered everything, including a collection of drawings by his lifelong friend Rowlandson.

The portrait of the creole St George is hanging on the right in this print, Angelo standing beneath it with spare foils. The contestant on the left may be Sergeant Leger, who, though only in the ranks, was welcome in any fencing-room for his swordsmanship, elegant figure and manners.

The smaller figure making the lunge could be the Chevalier d'Eon, one of the best swordsmen of his time, who first joined the French Secret Service as a woman, then served with distinction as a soldier. Having quarrelled with the French diplomatic authorities, owing to secret orders he had received from Louis XV, he was given a pension in 1785, provided he thenceforth wore female clothes. He died in 1810, and a post-mortem 'established his predominantly masculine characteristics'.

From a print in the collection of Mr and Mrs Paul Mellon

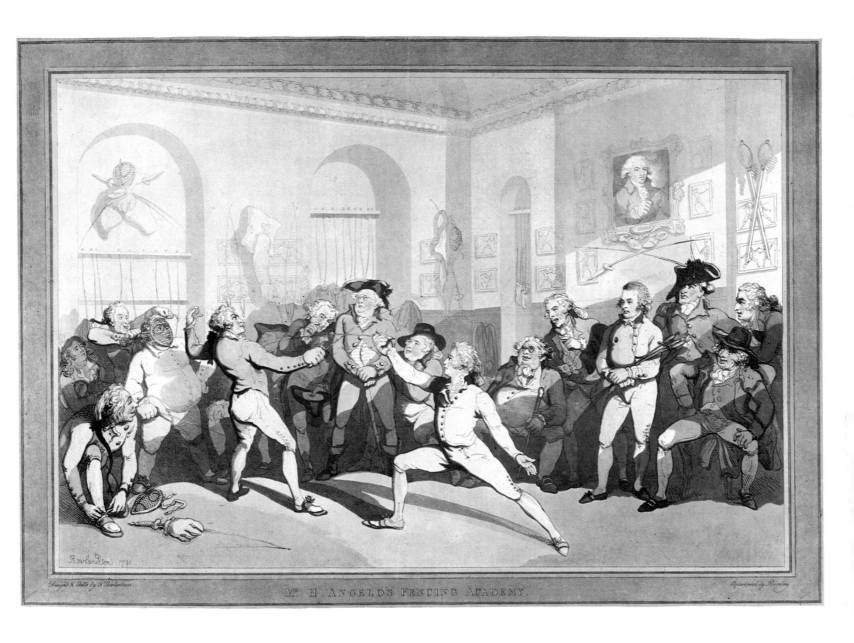

Mr. H. ANGELO'S FENCING ACADEMY.

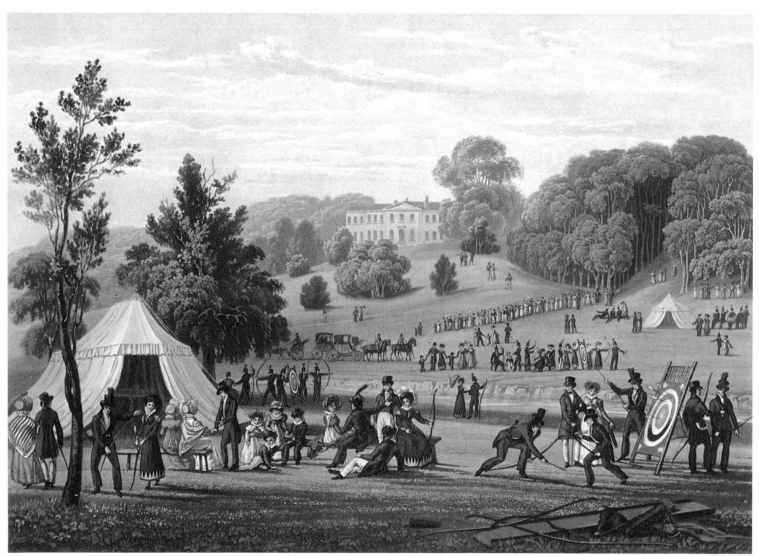

J. Townshend del.ᵗ

Engraved by Bennett.

This Plate representing the Meeting of the Royal British Bowmen, in the Grounds of Erthig, Denbighshire, the Seat of Simon Yorke Esq. on Sept.ʳ 13.ᵗʰ 1822, is respectfully dedicated to that Society by ONE of its MEMBERS

Obtained from the original Drawing by W.H. Timms

Published as the Act directs 1823

PLATE 80

THE MEETING OF THE ROYAL BRITISH BOWMEN, in the Grounds of Erthig, Denbighshire, Sept.r 13.th 1822

W.J. Bennett after J. Townshend, 1823, *aquatint*, 21 × 30 cm. ($8\frac{1}{4}$ × $11\frac{3}{4}$ in.)

The Royal British Bowmen was an archery club dating back to the end of the eighteenth century, finally dissolved in 1880. It will be noticed that both men and women are in uniform.

From a print in the collection of Mr and Mrs Paul Mellon

PLATE 81

THE CRICKET MATCH, TONBRIDGE SCHOOL

W.L. Walton, *coloured lithograph*, 53 × 87.5 cm. ($20\frac{7}{8}$ × $34\frac{1}{2}$ in.)

Tonbridge School was founded by Sir Andrew Judd, Lord Mayor of London in the time of Edward VI, and was rebuilt in 1865, remodelled in 1880, and extended subsequently.

In addition to the cricket match, the beautiful old building is shown before it was rebuilt.

From a print in the possession of Sir Malby Crofton, Bart.

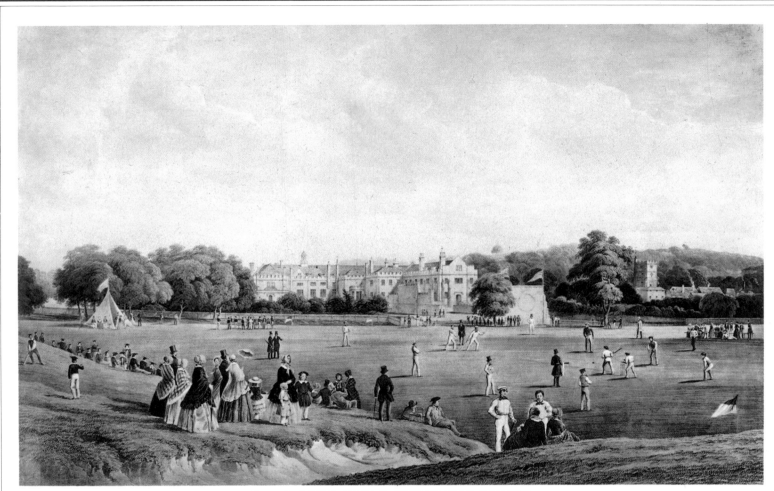

THE CRICKET MATCH, TONBRIDGE SCHOOL

Published by C Tattershall Dodd, Tonbridge Wells.

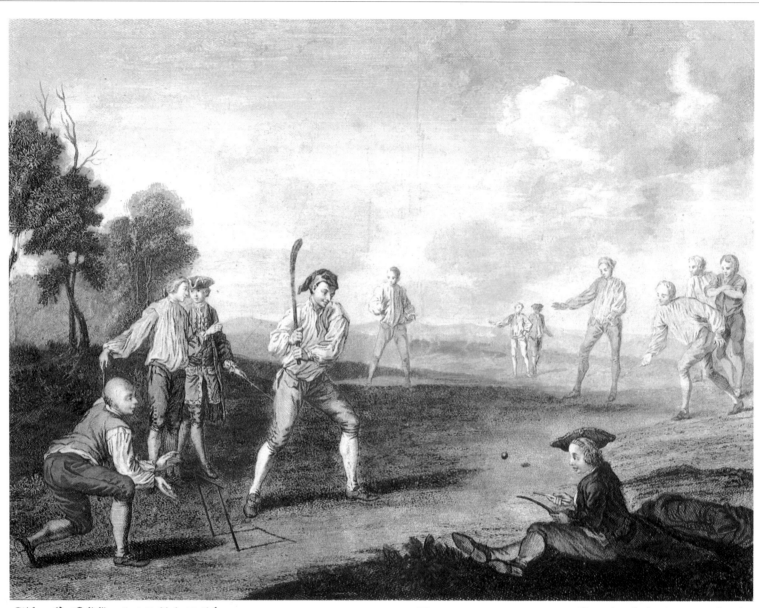

F. Hayman Pinx. Publish'd according to Act of Parliam.t April 4.th 1743.

Benoist Sculp. after the Painting. in Vaux-hall Garden.

To exercise their Limbs, and try their Art,
Forth to the verdant Fields the Swains depart:
The buxom Air and chearfull Sport unite,
To make Hulse useless by their rough Delight.

CRICKET.

Britons, whom Nature has for War design'd,
In the soft Charms of Ease no Joy can find:
Averse to wast in Rest th'inviting Day,
Toil forms their Game, & Labour is their Play.

Printed & sold by Jno Bowles in St Pauls Church yard & Pt Bowles at y Black Horse Cornhill.

PLATE 82

CRICKET

Benoist after Francis Hayman, 1743, *coloured line engraving,* 26 × 35 cm. ($10\frac{1}{4}$ × $13\frac{3}{4}$ in.)

 This print was engraved from one of the pictures painted by Francis Hayman to decorate Vauxhall Gardens.

 It shows the game of cricket as it was played at the time, with a curved bat like a hockey stick, the bowler delivering the ball underarm, not the overarm action that was at first termed 'throwing'. The wicket consists of two stumps each twelve inches high, set, in this case, about twelve inches apart, with a third laid on the top. A 'tallyman' on the right is notching up the runs.

From a print in the collection of Miss Hildegard Fritz-Denneville

PLATE 83

BILLIARDS

Henry William Bunbury, *coloured etching*, 23 × 33.5 cm. (9 × 13⅙ in.)

The chief point of interest about this caricature is the use of the leather-tipped cue, which must have just been invented, replacing the 'spoon', a row of which stands in a rack against the wall.

Henry William Bunbury was a brother of Sir Charles Bunbury, the well-known sportsman, who won the first Derby in 1780 with Diomed and was again successful in 1801 and 1813.

Henry was an amateur and one of Thomas Rowlandson's *entourage*; in fact it is obvious that Rowlandson must have etched this plate. Later on, Bunbury must have earned money from his very numerous published satirical prints, and again when he was commissioned to supply the twenty illustrations to Macklin's *Shakespeare*.

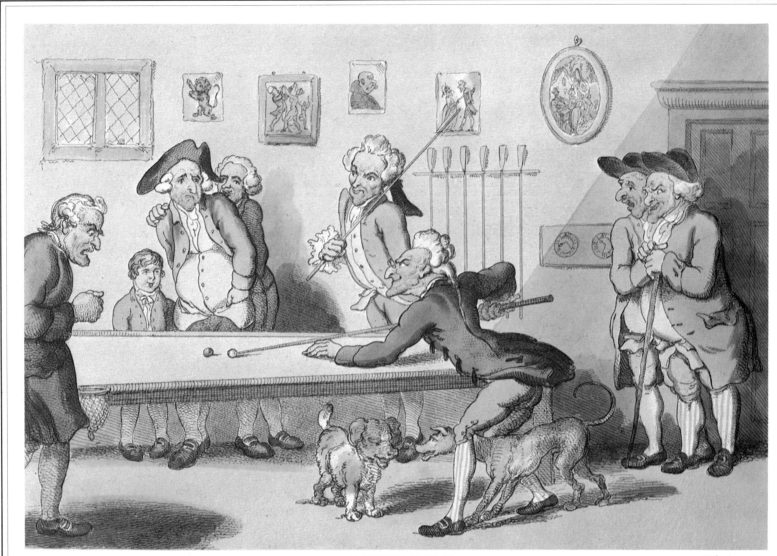

BILLIARDS.

H Bunbury. Delin

Plate 1.

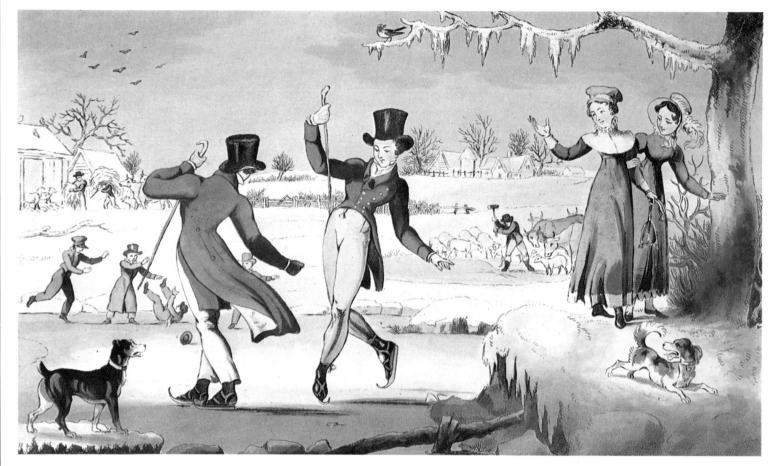

JANUARY.

Printed, Published & Sold by W. Belch, Staverton Row, Newington Butts, London.

PLATE 84

JANUARY

Published by W. Belch, *coloured aquatint with etched outline,* 16.5 × 28.5 cm. (6½ × 11¼ in.)

One of a set of the Months, from the same series as *July* (plate 85).

 Several of the months are represented by appropriate sporting subjects, but the name of the artist is unknown. They have an idyllic and naive simplicity, not far removed from the 'penny plain, tuppence coloured' style.

From a print in the collection of Miss Hildegard Fritz-Denneville

PLATE 85

JULY

Published by W. Belch, *coloured aquatint with etched outline*, 16.5 × 28.5 cm. (6$\frac{1}{2}$ × 11$\frac{1}{4}$ in.)

From the same series of the Months as the skating scene *January* (plate 84). Artist unknown, but done with commendable simplicity.

From a print in the collection of Miss Hildegard Fritz-Denneville

PLATE 85

Plate 7.

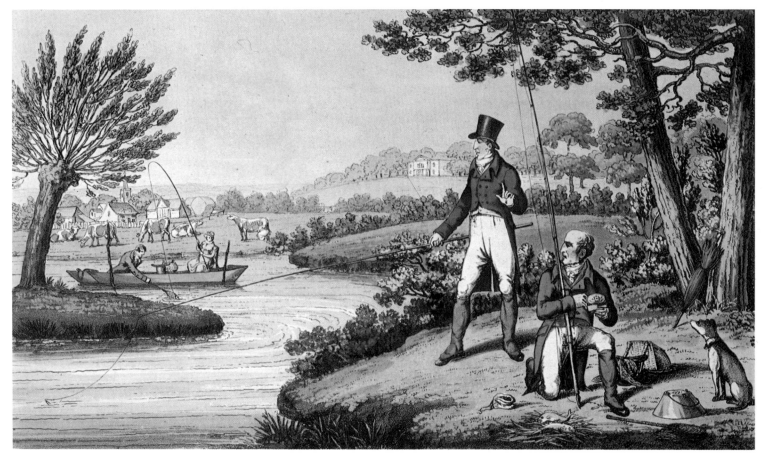

JULY.

Printed, Published, & Sold by W. Belch, Staverton Row, Newington Butts, London.

THE PASSAGE OF A CAB.

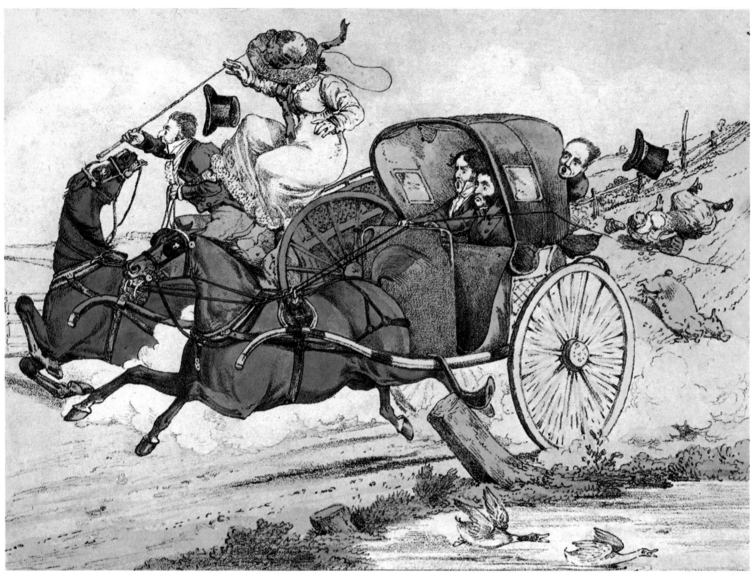

H. Alken. Del.

I say Captain I have an IDEA we have run foul of several things in our passage

London Published by Thos. McLean. 26 Haymarket. 1827.

PLATE 86

IDEAS

By and after Henry Alken, 1825–30, *coloured soft-ground etching*, 17 × 23 cm. (6⅔ × 9 in.)

From time to time Alken produced lengthy sets of prints, mostly of a comic nature. The 'Ideas' comprise forty-two plates in all, published in seven sets of six, each set in paper wrappers, with the word 'Idea' incorporated in the captions. The title of the complete work is *Ideas, Accidental and Incidental to Hunting, and Other Sports, caught in Leicestershire*. The title of the section from which this plate comes is 'A Few Ideas, being Hints to all Would-be Whips'.

The cabriolet coming to grief resembles a 'Tilbury', invented by the West End livery-stable keeper of that name, who horsed many hunting gentlemen, including Count Sandor when he was guest of Lord Alvanley at Melton (see plate 51).

Satirical prints of the period were given to laughing at the adventures of 'cits' when they visited the country, but to the real Corinthian (or amateur sportsman) the ability to handle any vehicle, even including four-in-hands, was an essential part of his education.

Captain H.E. Malet, in *Annals of the Road*, says that 'the management of a horse, whether in or out of harness, is of prime consequence, and to none more so than to the upper classes; that skilful driving is an enviable accomplishment, even for a Prince; and that is only to be attained in any high degree by a course of actual practice upon the public road.'

PLATE 87

MAIL COACH

M. Dubourg after J.L. Agasse, 1824, *coloured aquatint*, 30 × 37.5 cm. ($11\frac{3}{4}$ × $14\frac{3}{4}$ in.)

Mail coaches started running in 1784 – superseding the horsemen ('postboys') – the guard always sitting alone at the back, heavily armed with blunderbuss, pistols, etc.

At first they travelled largely by night, 'hustling along the roads at a pace considerably over ten miles an hour, highly dangerous to other users, alarmed by the heart-shaking thunder of their approach.' But, at the period of this print, they began to be beaten for speed by the fast day coaches, which stopped only twenty minutes for lunch and changed horses in the incredible time of from fifty seconds to three minutes.

Unlike these stage-coaches, which could have up to twelve outside passengers, the mails were allowed only four inside and at first only one beside the driver, though a few years later the outside passengers were increased to three, one with the coachman and two others, their backs to the guard for security.

Another version of this print was published in 1820, with a lady sitting beside the driver: the only explanation for issuing this new plate, with a man replacing the lady, seems to be that it was considered not quite *comme il faut*. Against this argument is the print of *The Road-Side*, after the same artist (plate 92), in which a woman is holding the reins, and there is also a print after James Pollard of a *Royal Mail Coach*, dated 1824, with a lady beside the coachman.

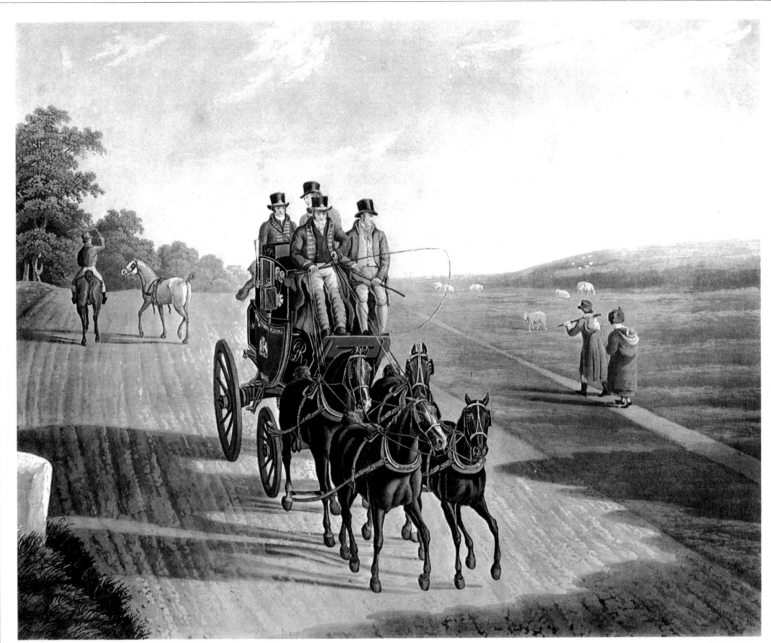

Painted by S.L.r. Engraved by N. Salway

MAIL COACH.

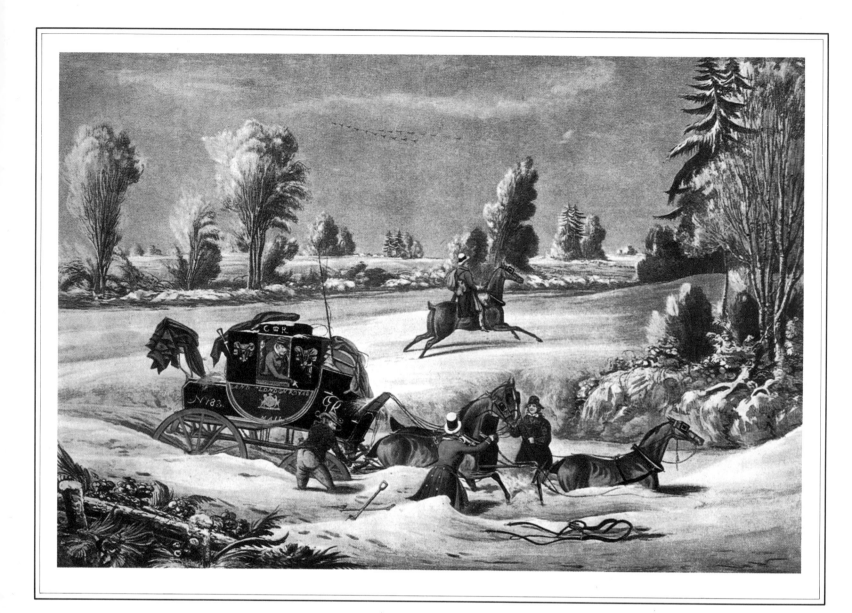

PLATE 88

THE MAIL COACH IN A DRIFT OF SNOW

R.G. Reeve after James Pollard, 1825, *coloured aquatint with etched outline*, 28 × 41 cm. (11 × 16⅛ in.)

One of a set of four plates published as *Incidents in Mail Coach Travel*, showing some of the less pleasant aspects of coaching, the other plates in the set being *Mail Coach in a Storm of Snow, Mail Coach in a Flood* and *Mail Coach in a Storm on Newmarket Heath*.

Here the London-York-Edinburgh mail is fast in a drift, over the axles; one of the privileged inside passengers appears to be giving some 'backseat' advice to the coachman, while two outside passengers are freeing the horses. Beyond, the guard has mounted the offside leader and is galloping away with the mail, a reminder that this was his chief responsibility – the mail went forward whatever happened.

PLATE 89

THE ELEPHANT AND CASTLE ON THE BRIGHTON ROAD

T. Fielding after James Pollard, 1826, *coloured aquatint with etched outline*, 54 × 77.5 cm. (21¼ × 30½ in.)

This famous and attractive print was published in 1826 when George IV was still on the throne: 'Prinny', who had passed this inn so many times on his way to 'Brightelmstone' (Brighton in the eighteenth century). It was then customary to do the journey in a day, even 5¼ hours, but some passengers still stayed the night at Cuckfield or Reigate.

We are looking across the road from the West, with the Brighton road to the right, where some thirty public coaches passed every day bound for this seaside town alone.

Some of these were owned and driven by amateurs. Sir Vincent Cotton drove the Age, the Marquis of Worcester the Beaufort and the Hon. Fred Jerningham the Brighton Day Mail. 'No fees were solicited on these coaches, yet all of them pocketed their "tips" with as much readiness and relish as would the poorest "knight of the whip"' (Captain H.E. Malet, *Annals of the Road*).

Sir John Lade and other Jehus tried to look like coachmen, even, said Captain Gronow, spitting like the professionals, but later on, after the formation of the coaching clubs, they were advised to drive like coachmen but look like gentlemen.

Quite a slice of contemporary life is shown. Besides the coaches – on one of which appears the artist's name – there is a fly van for carrying luggage and a large carrier's waggon, doing its journeys from one end of England to the other at no more than a walking pace. In these vehicles, on a bed of straw, travelled the poor, such as Emma, the future Lady Hamilton, and Hogarth's less fortunate Moll Hackabout from York, to be met by motherly mesdames like Mrs Needham, who was sent to the stocks in St James's Street, when all she wanted to do was earn enough money to retire and make her peace with God.

To the right is a postchaise, with servants at the back, privately owned, but employing horses and postboys from the posting inns.

From a print in the collection of Mr and Mrs Paul Mellon

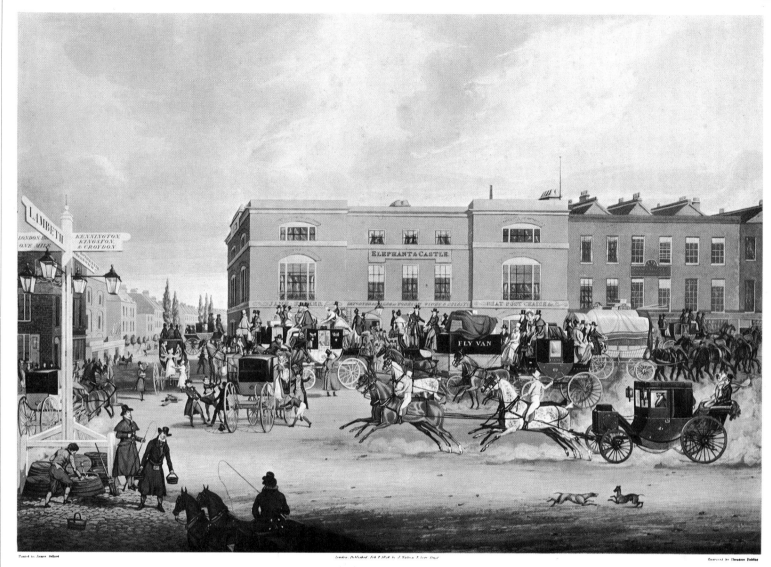

THE ELEPHANT AND CASTLE on the BRIGHTON ROAD,

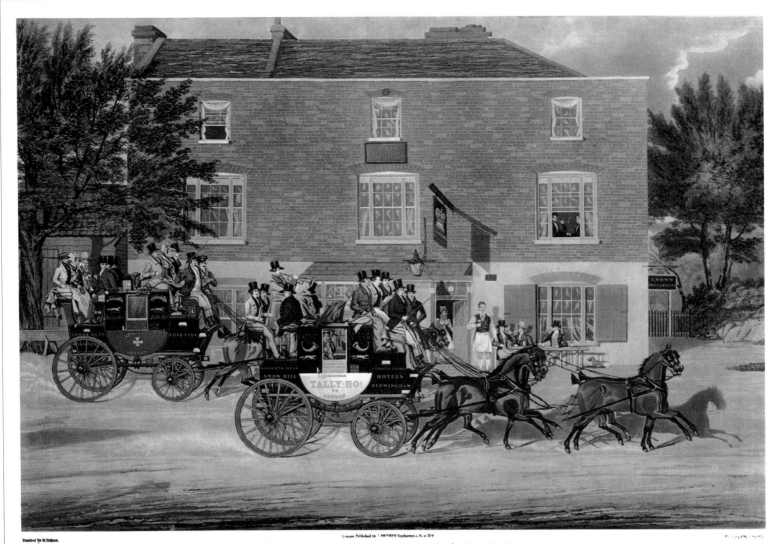

Painted by H. Dillbart.

London. Published by J. MOORE H. Southampton. Row. 1819.

Engraved by ...

THE BIRMINGHAM TALLY-HO! COACHES
PASSING THE CROWN AT HOLLOWAY

PLATE 90

BIRMINGHAM TALLY-HO! COACHES, Passing the Crown at Holloway

C. Bentley after James Pollard, 1828, *coloured aquatint with etched outline*, 50.5 × 76 cm. (19$\frac{7}{8}$ × 30 in.)

In 1823 Mrs Sarah Ann Mountain, of The Saracen's Head, Snow Hill, London, started the Tally-Ho! fast coach, to run the 109 miles to Birmingham in eleven hours. These coaches, and the thirty that left daily for various destinations, were made in a coach factory behind the inn, immortalized by Charles Dickens in *Nicholas Nickleby*, the name and the emblem of a fox and 'Robin Hood' hunting horn emphasizing the link between the country sport of fox-hunting and coach travel.

The sporting name was a great success, soon to be copied by William Horne, of the Golden Cross, Charing Cross, with the *Independent Tally-Ho!* Others followed suit, with furious racing on the London to Birmingham road, leading, not surprisingly, to increased patronage of the more conservative and slower coaches by sensibly cautious travellers.

Here, on as peaceful and pleasant a summer scene as one could wish to see, Mrs Mountain's and William Horne's coaches are bound for London, passing the Crown at Holloway, since rebuilt in unrecognizable industrial surroundings.

Mrs Mountain's guard is playing a triumphant fanfare on his key-bugle as they enter on the last lap of the journey.

From a print in the collection of Mr and Mrs Paul Mellon

PLATE 91

APPROACH TO CHRISTMAS

George Hunt after James Pollard, *c.* 1830, *coloured aquatint with etched outline*, 38 × 52 cm. (15 × 20½ in.)

One of the most sought-after coaching prints on account of its eminently successful and cheerful Christmas atmosphere.

The scene is in the Mile End Road with the Norwich 'Times' coach approaching its destination, the Bull Inn, Aldgate, kept by Mrs Ann Nelson. One of her sons, Robert, is said to be driving and his name appears on the door, although Robert owned the Belle Sauvage, Ludgate Hill, and the mother's business was taken over by another son, John.

As sometimes happened in these conditions, the driver has enlisted the help of a postboy and pair in front, to pull the laden coach through the snow.

Postchaises – the yellow postchaises known as 'bounders' – have been hired to bring boarding-school boys home for their holidays, who are vigorously sniping with their peashooters, oblivious of the cold and an enemy force waiting at the bottom right.

The Bull Inn, Aldgate, was the terminus for Mrs Nelson's coaches on the Eastern roads, as well as a famous old English hostelry, having not only a resplendent mahogany coffee room, decorated with coaching prints, but also a special room for the coachmen and guards, where Charles Dickens was once a guest, and had to admit that he 'could not 'andle a vip'. The eldest son John turned to omnibuses, with great success, when the railways started.

From a print in the collection of Mr and Mrs Paul Mellon

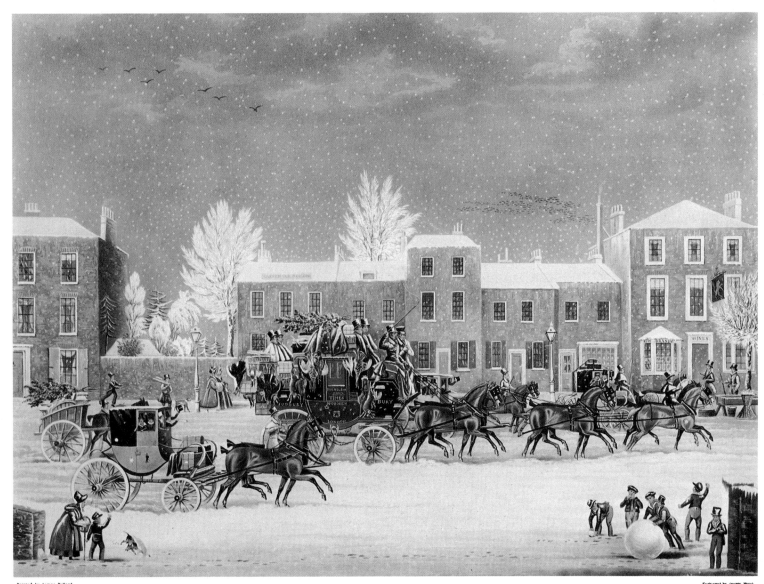

Painted by James Pollard

Engraved by George Hunt

APPROACH TO CHRISTMAS.

London Published by J. Moore at his Picture Frame Manufactory, No 1, Kent St & Upper St Martins Lane.

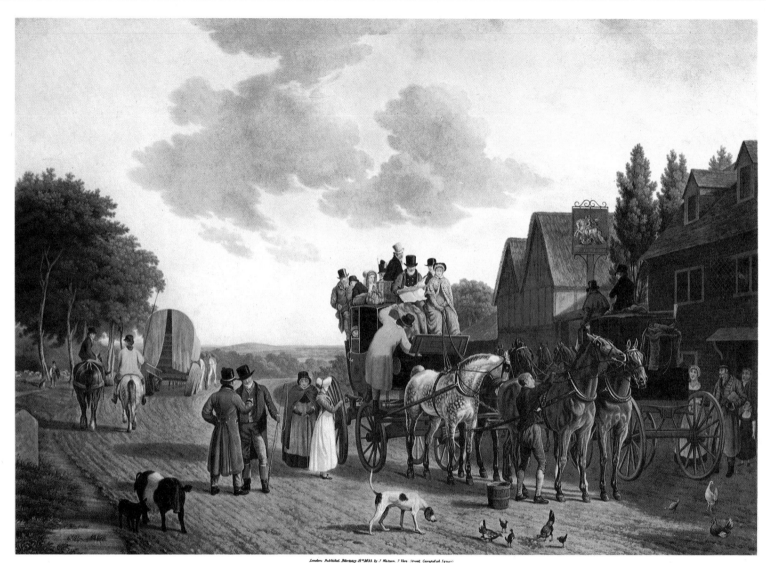

London Published February 15th 1833, by J Watson, 7 Vere Street, Cavendish Square

THE ROAD-SIDE

Engraved by Charles Rosenberg, From an Original Painting by J. L. Agasse

Proof

PLATE 92

THE ROAD-SIDE

C. Rosenberg after J.L. Agasse, 1833, *coloured aquatint with etched outline*, 54 × 77 cm. ($21\frac{1}{4}$ × $30\frac{1}{3}$ in.)

The first state of this plate has the title *The Road-Side*, altered in the second state to *Last Journey on the Road*. It has been said to represent the George and Dragon at Horndean near Petersfield and again the last stage before Portsmouth.

Agasse (1767–1849) was a Genevan, a student of David in Paris, who settled in England because of the Napoleonic wars. He became known as an animal painter and no doubt his earlier experience with the sporting Lord Rivers led him to add sporting and coaching subjects to his repertoire, putting into some of them an element of caricature. This he would have learned from Rowlandson, Henry Alken and other contemporaries.

Bearing in mind the *Mail Coach* after this artist (plate 87), it is interesting to see a lady seated beside the coachman's vacant place and actually holding the reins for him.

From a print in the collection of Mr and Mrs Paul Mellon

PLATE 93

THE NEW LONDON ROYAL MAIL

Charles Hunt, 1836, *coloured aquatint with etched outline*, 32 × 51 cm. (12½ × 20 in.)

Beneath the title of this print are the significant words 'Commenced running January 1st 1836'. It is therefore a picture of a coach belonging to owners refusing to accept the gathering domination of the railways, against which the public was already complaining. The engines were subject to failures and had insufficient power to overcome wet rails. People complained that railway staff were becoming intolerably insolent, sensing they were gaining a monopoly.

A few railways were yet to open or reach their full extent, so some coach proprietors were encouraged to put brand new vehicles on the road.

From a print in the collection of Mr and Mrs Paul Mellon

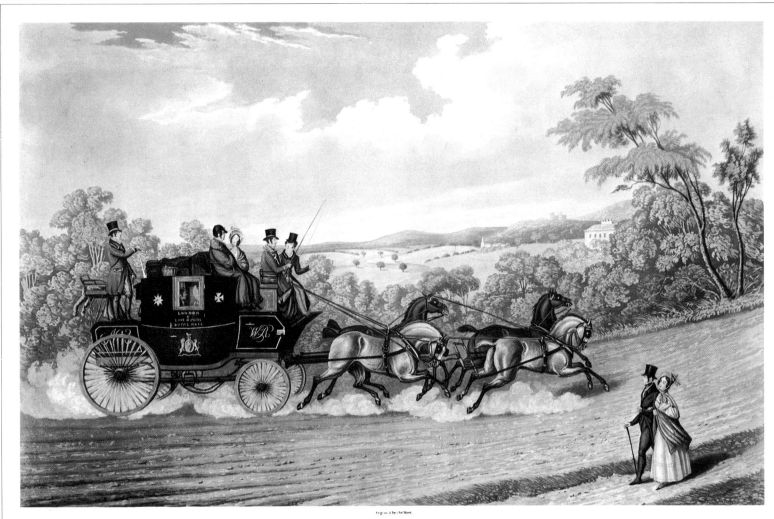

THE NEW LONDON ROYAL MAIL.

Commenced Running January 1st 1836.

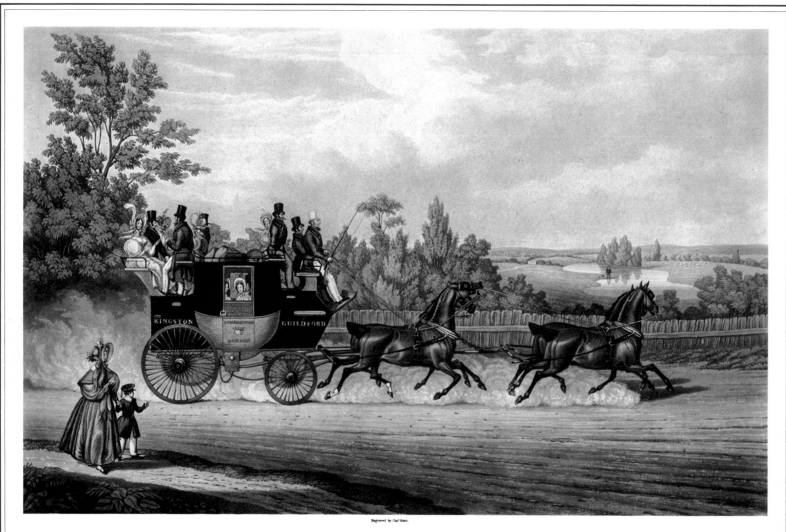

Engraved by Cha⁵ Hunt.

THE RED ROVER, SOUTHAMPTON COACH.

LONDON PUBLISHED AUG⁵¹ᵗ 1836 BY W SOFFE 390 STRAND

PLATE 94

THE RED ROVER, SOUTHAMPTON COACH

Charles Hunt, 1836, *coloured aquatint with etched outline*, 32 × 51 cm. (12½ × 20 in.)

This is a companion plate to *The New London Royal Mail* (plate 93), published in the same year. There were still three or four years to go before the railways took over the Southampton and Portsmouth traffic, and this is another venture of the as yet undefeated smaller owners.

On the other hand, William Chaplin, one of the largest owners, had the foresight to realize the potentialities of the railways and invested his capital in the Southampton Railway (later the South Western), taking an active part in the administration and becoming Chairman.

This plate was reissued in 1851, with the date altered in the publication line and the name of James Pollard added as the painter.

From a print in the collection of Mr and Mrs Paul Mellon

PLATE 95

THE ROYAL MAILS PREPARING TO START For the West of England

F. Rosenberg after James Pollard, 1831, *coloured aquatint with etched outline*, 43.5 × 60.5 cm. ($17\frac{1}{8}$ × $23\frac{3}{4}$ in.)

Pollard has given us a fine record of London's most important mail-coach inn, The Swan with Two Necks, with its old galleried courtyard in Lad Lane, where a number of the coaches destined for the West of England were stabled. From here it was customary to stop outside the Gloucester Coffee House in Piccadilly for more passengers and the mail.

The correctness of detail is exemplified by the fact that the guard is missing from the back of the Bristol coach, because he has already left in a small mail-cart to fetch the mail from the General Post Office and rejoin the coach in Piccadilly. The coaches were owned by the coach proprietors, who had contracts to carry the mail.

The Swan with Two Necks belonged to William Chaplin, the largest of these proprietors. Pollard's pictures can be relied upon for accuracy and there is no doubt this is how the courtyard appeared at the time, though underground were stables for 200 horses. Chaplin owned other inns, with nearly 70 coaches and 2000 horses.

From a print in the collection of Mr and Mrs Paul Mellon

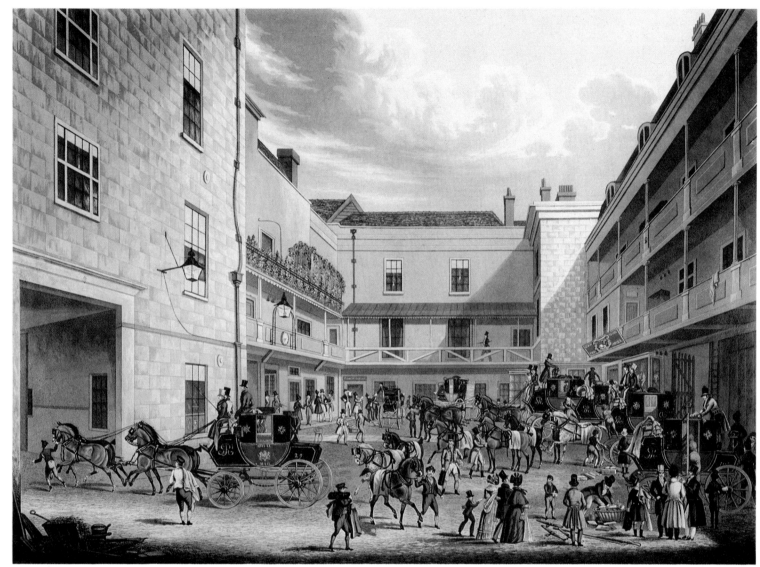

Painted by J. Pollard. Published June 1 1831, by J. Watson, Printseller, 7 Vere Street, Cavendish Square, London Engraved by F. Rosenberg.

THE ROYAL MAILS PREPARING TO START
For the West of England.

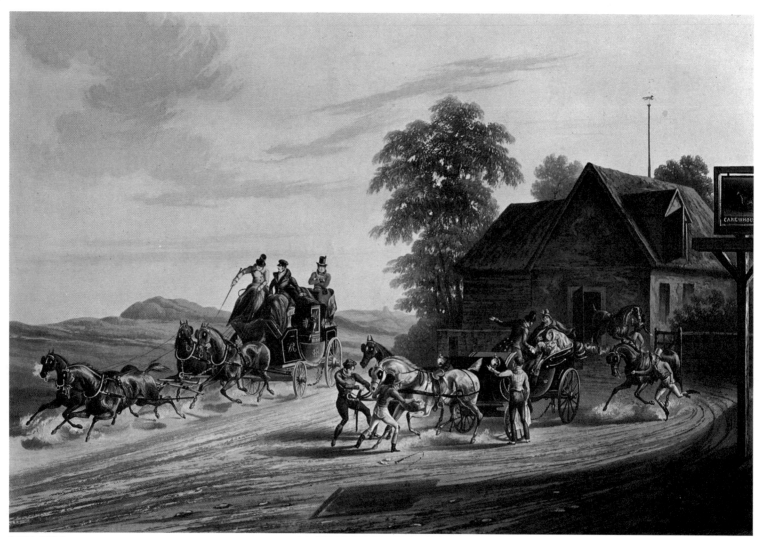

Painted by C. B. Newhouse.
London. Published Feb.* 1838. by J. Watson 7, Vere Street. Oxford Street.
Engraved by R. Reeves.

A FALSE ALARM ON THE ROAD TO GRETNA.

'tis only the Mail!

PLATE 96

A FALSE ALARM ON THE ROAD TO GRETNA

R.G. Reeve after C.B. Newhouse, 1838, *coloured aquatint with etched outline*, 27.5 × 41 cm. (10$\frac{7}{8}$ × 16$\frac{1}{8}$ in.)

'Tis only the Mail!' says the sub-title, as the ostlers and postboys are hurriedly changing the horses of the little travelling four-horse barouche.

It was recorded that 'The Gretna Green marriages were a fruitful source of revenue to postboys at this period; as the fugitive lovers paid on a higher and higher scale in their fervour the nearer they approached the shrine.'

A certain Jack Ainslie was a postboy with a *penchant* for 'love jobs' and a sworn foe to parents and guardians. If all else failed, he favoured doubling them up with a dig in the ribs, and, according to 'The Druid', 'would have recommended precisely the same treatment in the case of a Lord Chancellor, if he had come "Racing and chasing on Cannobie Lea" after some fair ward of his high court. Jack was perpetually signing his name as witness to marriages, and was in fact quite a consulting counsel to lovelorn knights and damsels. To have him, in his yellow cord jacket, on the near wheeler, was worth as many points to them as it was to an attorney for the plaintiff to retain Garrow or Follett. If he was pushed hard, Jack knew of cunning bye lanes and woods to hide them in, and had lines of gates across farms, and all that sort of geography, in his eye, for an emergency.' Jack was described as 'a civil old fellow, perhaps five feet seven if he was stretched out, and with such nice crooked legs' (*Saddle and Sirloin*).

The companion plate to this print shows the four-horse barouche travelling at speed, the young man standing up waving a purse for encouragement, while the enemy's postchaise has fortunately broken down in the distance.

From a print in the collection of Mr and Mrs Paul Mellon

REPRINTS

Good examples of sporting prints are exremely rare – that is to say, prints of the first edition, in good condition, with the colouring unfaded. This is because they were not considered great art, but rather an amusement or decoration. It is only when bound in books, or preserved in their original wrappers, that they are to be found in their pristine condition.

Reprints, however, are very common, because many of the plates were not destroyed after the first edition and have been continuously printed from ever since. A large number are still in the hands of copperplate printing firms, who issue catalogues and have a legitimate business printing and hand-colouring them in the traditional manner.

Some of these plates are in quite good condition, steel-facing having preserved them from further wear for the last hundred years, though the first years of their life, before they were steel-faced, will have worn away some of the fine aquatint grain. This fine network, giving a tone, should be visible in the clouds and on hills in the distance.

Sporting prints after 1800 are nearly always on Whatman paper, large sheets showing the name and the date, which should correspond with or be close to the date appearing in the publication line on the print. Prints published between 1800 and 1810 are on a similar wove paper but sometimes with different water-marks, such as E. & P.

The two main types of paper are 'laid' and 'wove', the former being made in a mould, the bottom of which consists of fine wires laid closely parallel, crossed at right angles every inch to inch-and-a-half by wires holding them together (laid- and chain-lines or wire-lines). These can be seen, like watermarks, when the paper is held up to the light: fine close lines.

Wove paper shows no lines at all, and Whatman paper of this type was begun in the 1790s. Practically all genuine sporting prints of the first half of the nineteenth century are on this wove paper, usually made by Whatman, showing no watermark lines, only the name and date on each full-size sheet. The name will not show on all small prints.

All prints of this period should have a publication line, giving the name and address of the publisher, as this was the law, unless it has been cut off. If the platemark (the indentation of the plate in the paper) is visible and there is no publication line, it may well be a reprint. A second issue, or a reprint, is often shown by a change in the name of the publisher, though many plates have been reprinted without any alterations being made.

The practice of putting a broad bevel on the edges of plates did not become general till the 1830s or even 1840s. This bevel may be up to a quarter-inch wide, like that put on mirrors and plate-glass; it was done to prevent the edge of the plate cutting the damp paper when printing, and gives two parallel indentations around the edge of the print. Collectors should beware of any print with a broad bevel, purporting to have been published before the 1830s.

Only practice in examining originals and reprints will make the difference between them apparent, but a list of most of the known examples has been appended.

J. L. AGASSE

1820 Mail Coach, by F.C. Lewis. 30 × 38 cm. Reprinted with same (unaltered) publication line, 1820.

1824 Mail Coach, by M. Dubourg. 30 × 37.5 cm. Rep. i. with same pub. line, 1824. ii. with Pollard's name.

H. ALKEN

1813 Fox Hunting (4), by Clark & Dubourg (name spelt Alkin). 34 × 45 cm. Reprinted with 'Hunting Scenes' on tops.

1813 Fox Hunting (4), by R.G. Reeve. 35 × 45 cm. Rep. with publication lines removed.

1813 Fox Hunting (4), by T. Sutherland. 31.5 × 42.5 cm. Reprinted 1818, with Ackermann instead of Inman.

1817 Shooting (4), by T. Sutherland. 34 × 42.5 cm. Reprinted 1823 (Widener sale).

1815 Indispensable Accomplishments (4). 23.5 × 32 cm. Re-issued 1824.

1818 Racing (4), by T. Sutherland. 25 × 64 cm. First issue by Hudson. Reprinted by Ackermann (no date).

1819 Epsom Races (2), by T. Sutherland. 32 × 62 cm. Pub. by S. & J. Fuller. Reprinted with same publication.

1820 National Sports (50), by J. Clark. 23.5 × 24 & 17 × 23.5 cm. Reproduced in chromolithography by Methuen 1903, same size and lettering.

1820 Comforts and Consequences of being drove like a Gentleman (2). Reprinted without publication lines.

1820 Shooting (4), by T. Sutherland. 21.5 × 66 cm. First pub. by John Hudson. Rep. by Ackermann (no date).

1820/1 Fox Hunting (4), by T. Sutherland. 35 × 55.5 cm. First pub. by John Hudson. Rep. by W. Deeley, 1839.

1821 Specimens of Riding (18), soft-ground etchings. Reissued 1824.

1821 Fox Hunting (4), by T. Sutherland. 20.5 × 41 cm. Reprinted with same pub. line: 1, August, 1821.

1821 High Mettled Racer (6), by T. Sutherland. 27.5 × 37.5 cm. There are deceptive reproductions, the same size and with same publication lines.

1821/2 The Right Sort (6), by C. Hullmandel, lithographs. There are deceptive copies. On 'Some of the Right Sort doing the Thing', the pub. line in the copy is slightly longer on the left than the title and the same length on the right, whereas in the original the pub. line is shorter than the title at both ends.

1823 Fox Hunting (4), by G. Hunt. 27 × 40.5 cm. Reprinted with same pub.: Thomas McLean.

1824 Leicestershire Covers (4), by T. Sutherland. 21.5 × 71.5 cm. Reprinted. There are also deceptive reproductions.

1824 Fox Hunting (4), by T. Sutherland. 13.5 × 61 cm. There are deceptive reproductions. Also modern copies by A. Tallberg with titles 'Leicestershire Covers 1820'.

1824 Racing (4), by T. Sutherland. 13.5 × 59.5 cm. Reprinted with titles only, without artists' names or publication lines.

1827 Leicestershire (4), by T. Fielding. 30 × 48 cm. Reprinted with same pub.: . . . Jan 7, 1827, by J. Watson . . .

1828 Fox Hunting (4), by C. Bentley. 27 × 42.5 cm. Rep. with same pub.: Octr 1, 1828, by S. & J. Fuller. . .

1829 Hunting Qualifications (6). First issued by Ackermann. Reprinted with London: Published at 31, Ely Place, E.C.

1829 Hunting Recollections (6). Reissued ditto.

1830 Grand Leicestershire Steeple Chase (8), by C. Bentley. Reprints: Plate IV has flaw in plate in 4th square of rails from left.

1831 My Stud (6). First pub. by Ackermann. Reprints: London Published at 31, Ely Place, E.C.

1832 A Steeple Chase (6), by C. Bentley. 39 × 47 cm. Reprinted with same pub.: London, Published March 1832 by S. & J. Fuller.

1833/47 Sporting Anecdotes. Reprints have London: Published at Ely Place, E.C.

1835 Quorn Hunt (8), by F.C. Lewis. 32 × 52 cm. Reprinted with same pub.: Ackermann 1835. Plates in the possession of Messers Fores Ltd. Also copied with titles, but without the lines of description (extracts from an article by Nimrod).

1835 Fox Hunting (4), by R.G. Reeve. 26.5 × 37 cm. Reprinted i. by Brall & Sons. ii. by Landou. iii. with no publication lines.

1835 Partridge Shooting (4), by C. Bentley. 21.5 × 27.5 cm. Reprinted with same pub.

1836 Aylesbury Grand Steeple Chase (4), by C. Bentley. 25.5 × 42.5 cm. Reprinted with dates altered to 1866.

1837 Sporting Illustrations (4). 33.5 × 46 cm. Reprinted by Sheldon, with 'Sheldon's National Sports' above.

1837 Right and Wrong Sort (2), by E. Duncan. 23.5 × 29.5 cm. Reprinted, as in first issue, by Fuller, but no date in publication lines, and address altered to 61, Pall Mall.

1839 First Steeple Chase on Record (4), by J. Harris. Reprinted by Ben Brooks.

1841 Shooting (4), by Pollard. 18.5 × 27 cm. Reprinted with unaltered pub. lines (by Laird), also with no pub. lines.

1841 Fox Hunting (4), by and after Alkin (sic). 18.5 × 27 cm. Rep. with unaltered pub. lines (by Laird).

1841 Fox Hunting (4). 17.5 × 25 cm. Rep. with unaltered pub. lines (by Laird).

1844 Rather Varmint! and Something Slap! (2), by C. Hunt. 27 × 37 cm. First published by Tregear. Reprinted i. by Laird. ii. by Tregear & Lewis. iii. Lewis & Co.

1851 One of the Flowers of our Hunt (4), by J. Harris. Reprinted with same pub. (Ackermann).

n.d. 'Melton Hunt' – All horse Hunters, who never see the Hounds but once in the day (6). 11.5 × 55 cm. Reprinted, watermark 1863.

n.d. Fox Hunting (4), by Gleadah, Reeve, Lewis and Phelps. 30.5 × 50.5 cm. First published by J. McCormick. Reprinted i. by Tregear & Co. ii. with 'The Pytchley Hunt' on the tops. There are also deceptive reproductions.

n.d. Hunting Incidents (6). 21 × 33 cm. Reprinted with and without publication lines.

n.d. Fox Hunting (5), no engraver's name. 21.5 × 28.5 cm. Reprinted.

SAM ALKEN

1851 Cambridgeshire Stakes (2), by C. N. Smith. 35 × 53 cm. Reprinted 1853, by John Moore.

G.H. ALKEN junior

n.d. A Hurdle Race (4), by C. Hunt. 28.5 × 45 cm. First pub. by Tregear. Reprinted by Lewis & Co.

1833 A Hunting Phaeton (2), by C. Hunt. 24 × 37 cm. First pub. by Tregear. Reprinted by Lewis & Co.

1844 The Bet; The Leap (2), by C. Hunt. First pub. by I.W. Laird. Reprinted by Lewis & Johnson.

1839 The Grand Leicestershire Fox Hunt (4), by Hunt. 37 × 50 cm. Published 1839 by I.W. Laird. Reprinted with same pub.

1832 A Steeple Chase (4), by C. Hunt. First published by Tregear. Reprinted by Lewis & Co.

n.d. Fox Hunting (4), by C. Hunt. 29 × 42.5 cm. First pub. by Tregear. Rep. by Lewis & Co.

n.d. Last Grand Steeple Chase (4), by C. Hunt and Reeve. 40 × 57 cm. First pub. by Lewis & Co. Reprinted with 'Steeple Chasing Illustrations' on tops.

R. ANSDELL

1842 Waterloo Coursing Meeting, by S.W. Reynolds. Caledonian Coursing Meeting, by ditto.

J. BARENGER

1823 Earl of Derby's Stag Hounds, by R. Woodman. 48.5 × 60 cm.

W. & H. BARRAUD

1852 The Pytchley Hunt, by W.T. Davey. 42.5 × 73.5 cm.

1849 C. Davis on 'Traverser', by E. Hacker. 37 × 49.5 cm. Rep. i. by Sheldon. ii. without pub. line.

1849 Will. Long on 'Bertha', by E. Hacker. 37 × 49 cm. Rep. by Sheldon.

1847 Meet at Badminton, by W. Giller. 43.5 × 73 cm.

T. BENNETT

Fox and Cubbs, by C. Turner. Rep. without pub. line.

H. BERTHOUD

1829 Poachers (2). Rep. without pub. line.

T. BLAKE

Interior of the Fives Court, by C. Turner.

H. CALVERT

1855 Wynnstay Hunt, by W.T. Davey. 49 × 81 cm.

1842 Cheshire Hunt, by C.G. Lewis. 49 × 81 cm.

R.B. DAVIS

1841 Road Riders, or Funkers; The Few, Not Funkers, by C. Hunt. 27.5 × 76.5 cm. Rep. same pub. lines.

1851 B.B. Colvin and R. Dyson, by W. Giller. 43 × 58.5 cm.

M. EGERTON

Racing (4), by G. Hunt. 19 × 53.5 cm. Rep. with only the titles.

Spreading, by G. Hunt. 17.7 × 17.9 cm.

J. FERNELEY

1833 Count Sandor's Exploits (10), by E. Duncan. 27 × 35 cm. Rep. with Hunting Recollections on tops.

SIR R. FRANKLAND

1813 Shooting (8), by R. Woodman. 12.5 × 18.5 cm. Rep. by Laird 1836.

1823 Delights of Fishing (6), by C. Turner. 20.5 × 26.5 cm. Rep. by Laird.

J. GOODE

1853 Old Berkshire Hunt, by P. Thomas. 44 × 62 cm. Rep. by John O'Malley & Son.

SIR F. GRANT

1839 Melton Breakfast, by C.G. Lewis. Rep. i. same pub. ii. with names engraved below.

1839 Sutton & Quorn Hounds, by F. Bromley. 52.5 × 88.5 cm. Rep. by John O'Malley & Son. Also reproduced 43 × 72 cm.

1840 Meet at Melton, by W. Humphreys. 43 × 72.5 cm. Rep. without pub. line.

H. HALL

1848 Merry Beaglers, by J. Harris. 42 × 71 cm. Rep. reduced in size 10 cm. on right.

1854 Great Match, by C. Hunt. 53 × 108 cm. Rep. National Sports on top.

T. HAND

1808 Fox Hunting, by C. Knight & H. Merke. 50 × 66.5 cm. Rep. with Morland's name substituted for Hand's.

R. HAVELL

1824 Shooting near Uxbridge and Windsor (4). 21.5 × 30.5 cm. Rep. i. by Dean & Co. ii. without pub. lines.

Reading Telegraph Coach passing Salt Hill. 32 × 51 cm. Rep. i. title London & Birmingham Tally-Ho! ii. with Somers's Coaching Incidents on top.

M.A. HAYES

1836 Car-Travelling in the South of Ireland (6), by J. Harris. 20 × 33 cm. Rep. with date altered to 1856.

H. HEATH

1841 Great Fight between Broome & Hannan, by C. Hunt. 46 × 66.5 cm. Rep. same pub.

COOPER HENDERSON

1837 The Taglioni, by J. Harris. 31.5 × 46 cm. Rep. by Sheldon.

1837 Changing Horses; French Diligence. 28 × 38 cm. Rep. pub. by Sheldon.

Half Way; Opposition Coaches. 25.5 × 37 cm. Rep. pub. by Sheldon.

1842/6 Fores's Coaching Recollections, by J. Harris, etc. 45 × 68 cm. Pub. as set of five. Rep. 1883 with sixth plate added. Rep. Messers Fores Ltd.

1834 English Post-Boys; French Postilions. 27.5 × 38.5 cm.

1847 Going to the Moors; Going to Cover (2), by J. Harris. 45 × 68 cm. Reprinted. Plates in possession of Messrs Fores Ltd.

1843/8 Fores's Coaching Incidents (6), by Harris and Duncan. 32.5 × 60 cm. Reprinted. Plates in possession of Messrs Fores Ltd.

1839 Returning from Ascot Races, by E. Duncan. 37.5 × 81.5 cm. Reprinted. Plate in possession of Messers Fores Ltd.

n.d. A Hunting Morning, by E.G. Hester and P. Rainger. 44 × 67.5 cm. Reprinted. Plate in possession of Messrs Fores Ltd.

1842 Fores's Road Scenes: Going to a Fair (2), by J. Harris. 22.5 × 60.5 cm. Reprinted. Plates in possession of Messrs Fores Ltd.

J.F. HERRING

1854 Herring's Fox-Hunting Scenes (4), by J. Harris. 44 × 78 cm. Rep. i. 1864. ii. 1867. iii. 1874. iv. without pub. lines.

1839 Grand Stand, Ascot, by C. Hunt. 51 × 75 cm. Rep. 1852 by Barnett Moss & Company.

1840 Doncaster Great St Leger, by C. Hunt. 51 × 75 cm. Rep. i. 1852 by Barnett Moss & Co. ii. 1870 by Brall.

1852 Fores's National Sports, Racing (4), by J. Harris. 53 × 104.5 cm. Rep. by Messrs Fores.

1857 J.F. Herring's Senr. Fox Hunting (4), by Harris, etc. 35.5 × 51.5 cm. Rep. by Brall.

1845/7 Start for the Memorable Derby of 1844, by C. Hunt. 54 × 107.5 cm. Rep. with title The Start for the Derby (no date).

 Steeple Chase Cracks, by J. Harris, Rep. Messrs Fores.

 Herring's Sketches on the Road (3), by C. Hunt and Huffam. 56 × 76 cm. Rep. by A.J. Isaacs.

1845/6 The British Stud (6), by J. Harris, etc. 45.5 × 70 cm. Rep. by Messrs Fores Ltd.

1855/6 Fores's Series of the Mothers (9), by Harris, etc. 25 × 30.5 cm. Rep. by Messrs Fores Ltd.

1856/7 Fores's National Sports, Racing (4), by Harris, etc. 53 × 106 cm. and smaller set. Rep. by Messrs Fores Ltd.

1845/51 Fores's Racing Scenes (2), by Harris. 45 × 70 cm. Rep. by Messrs Fores Ltd.

1844/6 Fores's Stable Scenes (4), by J. Harris. 44 × 68.5 cm.

 St Leger and Derby Winners. Messrs Fores list 59 of these plates in their catalogue of reprints.

W.P. HODGES

1834 Chase and Death of the Roebuck (2), by Reeve. 32.5 × 51.5 cm. Rep. same pub.

C. HUNT

1836 Red Rover, Southampton Coach. 32 × 51 cm. Rep. i. 1851, by B. Moss & Compy. ii. the word 'late' added before London; sometimes with Pollard's name.

1836 New London Royal Mail. 32 × 51 cm. Rep. 1851 by B. Moss & Compy, sometimes with Pollard's name.

1845 Herefordshire & Monmouth Grand Hunt Steeple Chase (2). 37 × 52 cm. Rep. with same pub. line.

1841 Cheltenham Annual Grand Steeple Chase (4). 40 × 60 cm. Rep. with same pub. line.

n.d. The Birthday Team; The Roadsters (2). 32 × 55 cm. Rep. by Lewis & Co.

1839 Grand Stand, Goodwood. 51 × 74 cm. Rep. i. 1853. ii. 1870 by Brall.

1841 Grand Military Steeple Chase (4). 37 × 51 cm.

1841 Northampton Grand National Steeple Chase 1840. 41 × 61 cm. Rep. same pub. line.

1838 Fox Hunting (4). 32 × 44 cm. Rep. same pub. line.

1856 Ackermann's Series of National Steeple Chases: The Worcester (2). 37.5 × 51.5 cm. Rep. i. with pub. line. ii. without pub. line.

1847 The Derby, 1847. 51 × 76 cm. Rep. as Blink Bonney Winner of the Derby & Oaks, 1857.

1839 Liverpool Grand Steeple Chase, 1839 (4). 46 × 69 cm.

1856 Ackermann's Series of National Steeple-Chases: The Dublin, 1856 (2). 37 × 53 cm. Rep. with and without 'late' at commencement of publication line.

J.C. IBBETSON

1790 Shooting (6), by Dodd and Simpson. 30 × 37 cm. Reissued by Colnaghi 1800.

G. JONES

1825 Dog and Fox, by H. Pyall. 21 × 28 cm. Rep. by Dean & Co.

1828 Rencounter in a Farm Yard; Pheasants in Danger (2), Rep. by Dean & Co.

S.J.E. JONES

n.d. Smugglers Alarmed, by G. Hunt; Smugglers Attacked, by C. Hunt (2). 53 × 42.5 cm. Rep. same pub. lines.

n.d. Horses Watering; Horses Going to a Fair (2), by W. Fellows. 36 × 44 cm. Rep. with and without pub. line.

1829 Gamekeepers Refreshing, by H. Pyall; Gamekeepers Returning, by G. & C. Hunt (2). 35 × 44 cm. Rep. without pub. lines.

S.S. JONES

1828 Stabling, by G. Hunt. 35 × 44 cm.

–. JONES

1833 May, Fly Fishing; October, Evening, by H. Pyall. 12.5 × 29 cm.

1827 Shooting (4), by H. Pyall. 34 × 45 cm. Rep. 1845 by S. Hollyer.

E.F. LAMBERT

1829 Sportsman Preparing; Sportsman's Visit, by G. & C. Hunt. 35 × 43.5 cm. Rep. with and without pub. lines.

Galopin, winner of Derby 1875, by C. Hunt. 31.5 × 43 cm. Rep. artists' names and pub. line erased.

G.H. LAPORTE

1854 Hunting (2), by H. Papprill. 32 × 57 cm. Rep. A.J. Isaacs, 1860.

1860 Racing (2), by H. Papprill. 31 × 56.5 cm.

1839 Liverpool Grand National Steeple Chase (4), by Reeve. 36.5 × 58 cm. Rep. date altered to 1853.

BEN MARSHALL

1812 Game Cocks (2), by C. Turner. 48 × 40 cm. Rep. i. T. McLean 1835. ii. with titles Peace and War. iii. 1885, by Faultless.

1805 Earl of Darlington, by J. Dean. 48 × 60 cm. Rep. without pub. line.

1809 F. Duckinfield Astley, by R. Woodman. Rep. without pub. line.

Thomas Oldaker, by R. Woodman.

A. A. MARTIN

1842 Bedale Hunt, by W. H. Simmons. 42.5 × 72.5 cm.

C.B. NEWHOUSE

1832 Opposition Coaches, by F. Rosenberg. Rep. with same unaltered pub. line.

1838 One Mile from Gretna; and False Alarm (2), by Reeve. 27.5 × 41 cm. Rep. by B. Moss & Co., and Leadenhall Press.

1834/5 Scenes on the Road (18), by Reeve. Vignettes. First printed on grey paper. Reissued on white.

Roadsters Album (16). Vignettes. Rep. by Messrs Fores Ltd.

Queer Place; and Midnight Disaster. Rep. 1844, by Laird.

1839 Express Extraordinary (6), by C. Hunt. 27 × 39.5 cm. Rep. by Lewis & Co.

1837 Scottish Election (2), by C. Rosenberg. 24.5 × 38.5 cm.

SIR J. DEAN PAUL

1822 Trip to Melton (14 scenes on 12 strips).

1825 Leicestershire (4). 22.5 × 56 cm. Rep. without pub. lines.

S. PEARCE

1872 Ashdown Coursing Meeting, by C. Mottram. 16 × 40 inches. Rep. Messrs Thos. Ross & Son.

1876 A.W. Hall & Mrs Hall, by J. Scott. 45.5 × 66 cm. Rep. John O'Malley & Son, with title The Heythorp Hunt, and Messrs Thos. Ross & Son.

1868 H.M. Curteis, by C. Mottram. 46 × 63 cm.

Charles Barnett, by J. Scott. Rep. Messrs Thos. Ross & Son. Mr Stratton, by C. Mottram. Rep. Messrs Thos. Ross & Son.

J. POLLARD

1818/9 Epsom, Ascot and Newmarket Races (3). 30.5 × 45 cm. Rep. by J. Moore.

1819 Stage Coach & Opposition Coach in Sight. 31 × 45 cm. Rep. R. Lambe & Son.

View on the Highgate Road, by G. Hunt. 40 × 51 cm. Rep. by J. Moore, 1851, with 'Pollard's Coaching Incidents' on top.

1838 Four-in-Hand Club, Hyde Park, by J. Harris. 35.5 × 55.5 cm. Rep. by Dean & Co.

1821 H.M. King George IV Travelling, by M. Dubourg. 31 × 45 cm. Rep. 1831, with name altered to William IV.

1822 Moses, racehorse. 31.5 × 45 cm. Rep. with same pub.

1822 Fox Hunting (4). 11.5 × 35.5 cm. Rep. with 'Sold by Wm. Potter, Wrexham'.

1823 North-Country Mails at the Peacock, Islington, by T. Sutherland. 54 × 77.5 cm. Rep. 1838, by T. Helme.

1823 Emilius, racehorse. 31.5 × 45 cm. Rep. with same pub. line.

1823 Barefoot, racehorse. 31.5 × 44.5 cm. Rep. with same pub. line.

1824 Royal Mail Coach, toll-gate on left. 31 × 44.5 cm. Rep. by R. Lambe & Son.

1824 Jerry, racehorse. 31 × 44 cm. Rep. with same pub. line.

1825 Mail Coach Changing Horses, by Reeve. 28 × 41 cm. Also reproduced as 'The Bedford Times . . . 1830'.

Liverpool Umpire, by G. Hunt. 34.5 × 43.5 cm. Rep. with same pub. line.

1825/7 Mail Coach Travelling (in a Drift of Snow etc.) (4), by Reeve and Rosenbourg. 28.5 × 41 cm. Rep. with same pub. lines.

Cambridge Telegraph, starting from the White Horse, Fetter Lane, by G. Hunt. 40 × 53 cm. Rep. with 2 inch scratch starting downwards to left of rear hub; also reprinted with the scratch burnished out, leaving light streak.

Highgate Tunnel, by G. Hunt. 40 × 51 cm. Rep. with same pub. line.

1826 Elephant and Castle, by T. Fielding. 54 × 77 cm. Rep. 1838, by T. Helme.

1827 Matilda, racehorse. 31 × 44.5 cm. Rep. with same pub. line.

1828 Hyde Park Corner, by R. & C. Rosenberg. 42 × 61 cm. Rep. as The Grand Entrance to Hyde Park, 1844.

Birmingham Tally-Ho! Coaches, by C. Bentley. 51 × 76 cm. Rep. with date 1828 at end of pub. line.

1828 West Country Mails at the Gloucester Coffee House, by C. Rosenberg. 52.5 × 74.5 cm. Rep. with same pub. line.

1829 Tom Moody (4), by G. Hunt. 40.5 × 56 cm. Rep. 1854, by B. Moss & Compy.

1828 Anticipation; and Possession (2), by H. Pyall. 21 × 28 cm. Rep. by Dean & Co. (n.d.).

1829 New General Post Office, London, 1829. 35.5 × 65 mm. Rep. 1849, by Laird.

1830 Royal Mails Departure: Day and Night, by Reeve. 42.5 × 62 and 63 cm. Rep. 1836, by Soffe.

1831 G. Osbaldeston Esq. Extraordinary Match of 200 Miles against Time, by J. Harris. 32 × 44 cm. Rep. i. by B. Moss, 1852. ii. without engraver's name or pub. line.

1831 Mail behind Time. 35.5 × 46 cm. Rep. with name of R.G. Reeve added as engraver.

1831/3 Fishing (4), published by T. Helme. 34 × 44 cm. Rep. without pub. lines.

Fishing (2), by G. Hunt. Pub. by J. Moore. 34 × 44.5 cm. Rep. without artist's and engraver's names. Plates with Messrs Thos. Ross & Son.

1832 Mail Changing Horses. 35 × 45 cm. Rep. 1851, by T. Helme.

1832 Coach and Horses, Ilford. 32 × 44.5 cm. Rep. 1851.

1832 Eagle, Snaresbrook. 31.5 × 44 cm. Rep. 1851.

1832 North East View of the New General Post Office, by H. Pyall. 38 × 58 cm. Rep. by Messrs Fores (n.d.). Cabs, including a hansom, appear in the second issue.

1832/3 Doncaster Races (2), by Smart & Hunt. 34.5 × 60/63 cm. Rep. with same pub. lines.

1834 Epsom Races (2), by Smart & Hunt. 35 × 61.5 cm. Rep. with same pub. lines.

1837 Chances of the Steeplechase (8), by Rosenburg and Hunt. 34 × 48 cm. Rep. i. by Tregear & Lewis. ii. by Lewis & Johnson. iii. the date 1826 added after Lewis & Johnson's address. iv. publication lines erased.

1835 Quicksilver Royal Mail, by C. Hunt. 34.5 × 44 cm. Rep. i. with same lettering and pub. line. ii. with Somers's Coaching Incidents on top.
Edinburgh Express. 34.5 × 45.5 cm. The first issue has no title. Rep. with title.

1836 Aylesbury Grand Steeple Chase (4), by J. Harris. 35 × 50 cm. Rep. with same pub. lines.

1836 British Horse Racing: Goodwood, Doncaster, Ascot and Epsom (4), by Reeve. 27 × 37 cm. Rep. by B. Moss, 1852.

1836 Epsom (6), by C. Hunt. 30 × 46.5 cm. In the first issue plate II The Betting Post, is dated 1835. Rep. i. Plate II is dated 1836 like the rest. ii. Published by Messrs Fores (n.d.). iii. Pub. lines altered to the same as first issue: London, Published Feby. 1st 1836, by Ackermann & Co 96 Strand.

1836 Race for the Gold Cup at Goodwood. 31.5 × 45 cm. Rep. by B. Moss, 1852.

1837 Doncaster Races (4), by J. Harris. 38 × 63.5 cm. Rep. with same pub. line.

1836/7 Scenes during the Snow Storm, Dec. 1836 (4), by Campion. Rep. 1837 by Bowdon & Sons, with Bowden's Coaching Recollections on the tops. Lithographs.

1837 St Albans Steeple Chase (4), by Reeve and C. Hunt. 35 × 47.5 cm. Rep. i. with same lettering. ii. without artists' names.

1838 St Albans Grand Steple (sic) Chase (4). 31.5 × 43.5 cm. Rep. with same pub. lines.

1838 Scenes on the Road, or a Trip to Epsom and Back (4), by J. Harris. 33 × 50 cm. Rep. with same pub. lines.

Race for the Derby Stakes at Epsom, 1839. 33 × 46 cm. Rep. i. by B. Moss, 1852. ii. without the pub. line.

Race for the Great St Leger Stakes at Doncaster, 1840. 32.5 × 44.5 cm. Rep. by B. Moss, 1852.

1840 Jolly Old Squire (4), by H. Papprill. 38 × 53 cm. Rep. with date 1840 altered to 1846.

1842 Derby Pets (4). 30.5 × 44 cm. Rep. with same pub. lines.

1842 Derby Day, Tits & Trampers, by J. Harris 24.5 × 35.5 cm. Rep. plate with Thos. Ross & Son.

Race for the Derby Stakes, 1839; Great St Leger . . . 1840; Gold Cup at Goodwood, 1836; and Gold Cup at Ascot (4). 31.5 × 45.5 cm. All rep. by B. Moss, 1852.

Live-Bait Fishing for Jack; Fly-Fishing for Trout (2), by Reeve. 23.5 × 31 cm. Rep. with same pub. lines, J. McCormick.

Four-in-Hand. 35 × 44.5 cm. Pub. by T. Helme. Rep. same pub.

Ascot Heath Race for H.M. Gold Plate; Epsom Race for the Great Derby Stakes (2). 33 × 64.5 cm. Rep. same pub. lines, J. Moore.

Shooting (4). 32.5 × 42.5 cm. Rep. with titles only, other lettering erased.

Old Birmingham Coach. 35 × 43.5 cm. First issue has no title. Rep. with title.

F. SARTORIUS

1770 Racehorses, by June. Line engravings. c. 15.5 × 26 cm. Reprinted.

J. SEYMOUR

1755/6 Set of Twelve Portraits of Celebrated Horses, after Seymour and Spencer, mezzotints, with ornamental line borders around, coats-of-arms on top. c. 22 × 29 cm., not including the borders. Reprinted.

1761 Fox Hunting (4), by T. Burford, mezzotints. 33 × 51 cm. Rep. 1787, by R. Sayer.

1766 Fox Hunting (6), by T. Burford, mezzotints. 24 × 35 cm. Rep. 1787, by R. Sayer.

W.J. SHAYER

Coursing (4), by J. Harris. 46.5 × 36 cm. Rep. with pub. line removed.

1867 Down Hill, The Skid; Up Hill, Springing 'em (2), by H. Papprill. 40 × 60 cm. Rep. same pub. Plates belong to Messrs Fores Ltd.

1845 Lord William, trotting horse, by J.R. Mackrell. 45 × 60 cm. Rep. by Geo. Newbold.

1840 Brighton Day Mails, by C. Hunt. 45.5 × 71.5 cm. Rep. with date removed. Plate belongs to Messrs Fores Ltd.

1841 Duke of Beaufort Coach, by C. Hunt. 45 × 60.5 cm. Rep. with same pub. line.

1867 Age Brighton Coach, by C. Hunt. 45.5 × 66 cm. Rep. Plate in possession of Messrs Fores Ltd.

C. LORAINE SMITH

1826 Smoking Hunt (6). 24 × 33 cm. Rep. Plates in the possession of Messrs Fores Ltd.

J.W. SNOW

1840 Meet at Blagdon, by T. Lupton, mezzotint. 47 × 75.5 cm. Rep. with no pub. line.

C.R. STOCK

 Cock Fighting (6). 15.5 × 20.5 cm. Rep. by W.C. Lee (n.d.).

G. STUBBS

1768 The Spanish Pointer, by W. Woollett. 39 × 53.5 cm. Rep. by R.H. Laurie (n.d.).

1804 Eclipse, mezzotint. 23.5 × 35 cm.

 Several racehorses after Stubbs, particularly those by his son, G.T. Stubbs, published 1794/6, were reissued in 1817, but these are not regarded as reprints.

J. STURGESS

1878 Fox Hunting (4), by W. Summers. 50.5 × 108.5 cm. Plates in the possession of Messrs Thos. Ross & Son.

1874 Punchestown, Conyngham Cup, 1872 (4), by E.G. Hester. 40 × 76 cm. Plates ditto.

1875 Restive at the Post; Now They're Off (2), by Hunt & Son. Plates in the possession of Messrs Thos. Ross & Son.

1871 Impending Danger; A Match (2), by C. Hunt. 41 × 35.5 cm. Plates ditto.

TOWN (Charles Towne?)

1807 Bulldogs and Badger, by R. Earlom, mezzotint. 46 × 58 cm. First published with the artist's name 'Nelson'.

F.C. TURNER

 Moore's Shoeing Scene, The Veterinarian, by J.R. Mackrell. 42.5 × 53 cm. Rep. with no pub. line.

1844 Female Equestrians (4), by C. Hunt. 50 × 65 cm. Rep. 1878, by Brall. Plates in possession of Messrs Thos. Ross & Son.

 Bachelor's Hall (6). 27 × 36 cm. Plates in possession of Messrs Thos. Ross & Son.

1836 Moving Accidents by Flood and Field (4), by N. Fielding. 27.5 × 36.5 cm. Rep. by Dean & Co.

1830 Celebrated Tom Thumb, by H. Pyall. 37.5 × 50 cm. Reissued 1831. Reprinted with this date.

1834 Southerly Wind & Cloudy Sky (4), by C. Hunt. 36.5 × 48 cm. Rep. i. 1857. ii. with no pub. lines.

1838 Start for the Derby; Coming in for the Derby (2), by C. Hunt. 50 × 73 cm. Plates in the possession of Messrs Thos. Ross & Son.

 Vale of Aylesbury Steeple Chase (4), by G. & C. Hunt. 33.5 × 56 cm. Rep. same pub. lines: J. Moore, (n.d.).

1836 Nonpareil, trotting, by G. Hunt. 32.5 × 55 cm. Rep. same pub. line: J. Moore.

1837 Dying Fox Hunter, by C. Hunt. 35 × 45.5 cm. Rep. 1844, by I.W. Laird.

1837 Leamington Grand Steeple Chase (4), by C. Hunt. 37 × 60 cm. Rep. with same pub. line: Thos. McLean.

1838 Loyal Fox-Hunters, by J. Harris. 20 × 30 cm. Rep. with no pub. line.

1838 Artaxerxes, by Reeve. 41.5 × 57 cm. Rep. I.W. Laird.

1839 Liverpool Great National Steeple Chase (4), by J. Harris. 40 × 65 cm. Rep. with date altered to 1852, by Barnett, Moss & Co.

1842 Moore's Tally-Ho! to the Sports: The Noble Tips (4), by Hunt and Mackrell. 43.5 × 61 cm. First issue 1842/3. Rep. dates altered to 1852/3.

 Hawking (4), by Reeve. 39 × 31 cm. Rep. by Laird, with date 1839.

1841 Conolly on Coronation, by Mackrell. 45.5 × 60 cm. Rep. with same pub. line.

1841 Young English Fox Hunter (4), by C. Hunt. 40 × 60.5 cm. Rep. i. with same pub. lines. ii. with no pub. lines.

1841 Ghuznee, Winner of the Oaks – 1841, by Mackrell. 45 × 59.5 cm. Rep. with same pub. line.

1842 Scott on Satirist, by Mackrell. 45.5 × 59 cm. Rep. with same pub. line: Ackermann & Co.

1841 Shooting (6), by Hunt. 37 × 49 cm. Rep. same pub. lines: by I.W. Laird.

T.N.H. WALSH

1890 Badly Down; and others. Plates in the possession of Messrs Thos. Ross & Son.

1878/9 Dodson's Hunting Incidents (4), by E.G. Hester. 30 × 45. Rep. without Dodson's Hunting Incidents on tops. Plates with Messrs Thos. Ross & Son.

1878/9 Dodson's Hunting Incidents (4), by E.G. Hester. 30 × 45. Rep. without Dodson's Hunting Incidents on tops. Plates with Messrs Thos. Ross & Son.

1881/3 Dodson's Coaching Incidents (4), by C.R. Stock. 37.5 × 75 cm. Rep. without Dodson's Coaching Incidents on tops. Plates with Messrs Thos. Ross & Son.

1887 Dodson's Racing Incidents (4), by C.R. Stock. 21.5 × 35.5 cm. Plates with Messrs Thos. Ross & Son.

T. WEAVER

1814 John Corbet and Hounds, by R. Woodman. 47 × 61 cm. Rep. 1833, by John Eddowes.

S. WILLIAMS

1883 Hunting Incidents (4), by E.G. Hester. 15 × 11.5 cm. uprights. Plates with Messrs Thos. Ross & Son.

D. WOLSTENHOLME

1817 Fox Hunting (4), by T. Sutherland. 21.5 × 66.5 cm. Reissued by Ackermann (n.d.).

1823 Hunting (4), by T. Sutherland. 25 × 32.5 cm. Rep. with unaltered pub. lines.

1823 Shooting (4), by T. Sutherland. 25 × 32.5 cm. Rep. Dean & Co.

1823 Coursing (4), by T. Sutherland. 25 × 32 cm. Rep. Dean & Co.

1832 Death of Tom Moody (2), by D. Wolstenholme junior. 21.5 × 27.5 cm. Rep. without artists' names.

D. WOLSTENHOLME junior

1834 Pigeons. Plates in the possession of the family.

J. ZOFFANY

 Colonel Mordaunt's Cock Match, by R. Earlom, mezzotint.